Playthings

and

Pastimes

in

Japanese

Prints

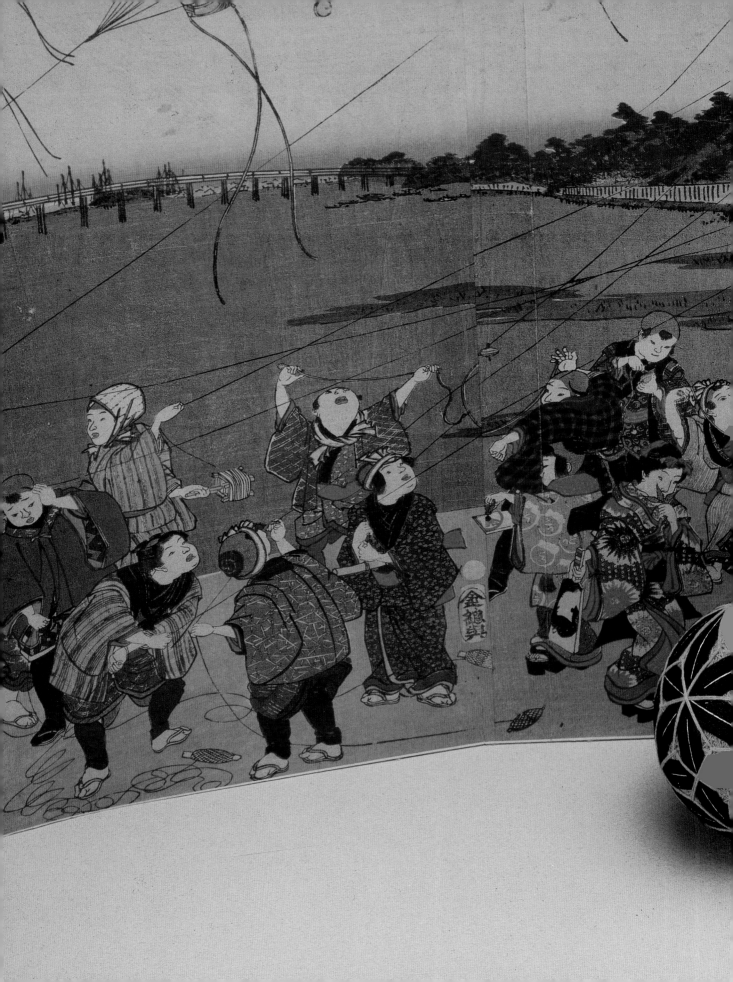

Playthings and Pastimes
in Japanese Prints

LEA BATEN

Shufunotomo • Weatherhill

To Mary and Jack Hillier
Although I am only a trespasser in your garden,
I place these few wild flowers
at the foot of the impressive monument
you have built to your respective interests,
playthings and prints.

Photography: Herman Van Hoey and
 Eugeen Vangroenweghe of Verne Studio
Cover Design: Mariana Canelo Francis
Book Design: Toshiaki Suzuki

Copyright © 1995 by Lea Baten

First edition, 1995

Published jointly by Weatherhill, Inc.
568 Broadway, Suite 705, New York, N.Y. 10012
and Shufunotomo Co., Ltd.
2-9, Kanda Surugadai, Chiyoda-ku, Tokyo, 101 Japan

Printed in Japan

ISBN 0-8348-0344-5

Baten, Lea.
Playthings and pastimes in Japanese prints / by Lea Baten.
p. cm.
ISBN 0-8348-0344-5: $39.95
1. Toys in art. 2. Games in art. 3. Color prints, Japanese - Edo period,
1600–1868. 4. Color prints, Japanese - Meiji period, 1868–1912.
5. Ukiyoe. I. Title.
NE1326.5.T68B38 1995
769'. 497901'0952 – dc20 95-43737
 CIP

So speaks Wisdom in the Book of Proverbs:
"The Lord possessed me in the beginning of his ways,
before he made anything from the beginning.
I was set up from eternity,
and of old before the earth was made...
I was with him forming all things: and was delighted every day,
playing before him at all times; playing in the world.
And my delights were to be with the children of men."
(Douay version, Proverbs, viii, 22-3, 30-1)

CONTENTS

LIST OF ILLUSTRATED PLAYTHINGS

IN GRATITUDE

A mother who writes is selfish: deaf to the telephone, blind to the world's needs. She works too long and sleeps too late, she neglects the numerous tasks that are normally hers—she has to, or the writing would never be done. For the helping hand and the many times they uncomplainingly took over the daily routine, my first and heartfelt thanks go to my husband and two daughters, Ann and Jo.

Words, however descriptive, are enhanced by their visual reflection, so I am lucky to be blessed with friends-photographers Herman Van Hoey and Eugeen Vangroenweghe, who, with delicacy and taste, translated into photographic language the subtlety of playthings and the many different prints. Yu-Ying Brown of the British Museum I gratefully acknowledge for answering questions perhaps outside the 20 minutes limit. To Shunichi Kamiya, a special thank you; he is surely the most patient editor in the world. He was capably seconded by Catherine Meech, who never lost her good humor, worked hard, and looked after the finishing touches.

For many years, dolls have been my ambassadors of goodwill, for through them I have met or corresponded with many kind and dedicated people, friends it is a privilege to have. Those friends have enriched me by their belief that dolls and toys, from works of art to unpretentious folk toys, can give meaning to life. I mention here Prince and Princess Takamado for their invitation and permission to photograph dolls and doll *netsuke* in their collection; Wendy Makino, whose friendship makes possible many things; Harumi Yoshizawa, who unties my translation knots; the dear, departed but unforgettable Kosei Yamasaki, maker of my *karakuri* doll; Shigeo and Shizuko Suwa, whose lovely Shimotsuke dolls have been designated an Intangible Cultural Asset—their spontaneous gift of a doll is one of my greatest treasures.

Marie-Thérèse Verhoef, a Dutch pen-friend, lives on the faraway Netherlands Antilles and makes her own versions of Japanese child dolls. Sidney Gulick is the grandson of that great pacifist Gulick who promoted the 1927 "Dolls of Friendship" exchange between the United States and Japan; Tokubei Yamada represents the 11th generation of a prestigious dollmaking family, and is a living encyclopedia of doll lore. Robert Thijs of the Museum of Ethnography in Antwerp I thank especially for his cordial aid, patience, kindness, and collaboration, virtues too rarely found in the great museums of the world.

All these people have a mutual meeting point, all have been made greater and more humane through the doll. For them, as for me, trinket or treasure, these little figures radiate friendship, peace, and playfulness, inherent values that ever transcend time and place.

NOTES ON JAPANESE PRINTS

Sizes of Japanese prints differ, depending on the format and division of the handmade paper used, and so they are only ever approximate. Furthermore, many prints were trimmed, more or less carefully when new, then re-trimmed later to remove wear or damage such as tears, stains, wormage, or binding holes. In the Meiji period (1868-1912), this unfortunately resulted in the elimination of the publisher's address and the printing and publication dates, since these were in the margins.

Multiples were usually composed of two, three, or more *oban* (the standard size) but were often so designed that each single sheet could stand alone and be sold separately. *Surimono*, fan prints, and book pages have varying dimensions. Indicative sizes of the most current formats are given below.

No two authors and no two books on Japanese woodblock prints being in unquestionable harmony concerning pre-Meiji dates, readers may expect some variations on the theme. The Japanese dated according to the lunar calendar and the era names of emperors' reigns (*nengo*). Even after the solar Gregorian calendar was adopted in 1873, the practice of dating according to emperor reign continued. By contrast, most Western countries have dated by the Gregorian calendar since 1582. (Great Britain changed from Julian to Gregorian in 1752, while Russia became the last to adapt in 1918.) Also, a person's year of birth already counted as a full year of age in Japan, another cause of discrepancies between calculations.

All names of Japanese persons, including modern artists' names, are given in Japanese style: family or artistic school name first. The given name or the professional name by which an artist is most commonly known (*go*) is printed in capital letters. Artists are featured in approximate chronological order. Except where credits are given, prints and objects illustrated are from my own collection. Any errors are also mine.

AIBAN:	34 x 23 cm
BAI-OBAN:	46 x 34 cm
CHUBAN:	26-30 x 19 cm
CHU-TANZAKU:	38 x 13 cm
HASHIRA-E:	70-75 x 12-15 cm
HOSOBAN:	33 x 15 cm
KAKEMONO-E:	76 x 23-25 cm
KOBAN:	21-23 x 15-17 cm
NAGABAN:	50 x 23
OBAN:	38 x 25 cm
SHIKISHIBAN:	20 x 18 cm
XL OBAN:	58-60 x 30-32 cm

PLAYTHINGS, PASTIMES, AND PRINTS

Playthings are usually associated with happy events like birthdays and Christmas mornings, but for me, toys are linked to memories of war. Going back in time, my intense awareness of playthings returns to the moment when a wrinkled old lady wordlessly deposited a worn teddy bear in the arms of a tired and forlorn young refugee disembarking from a Belgian boat. A refugee whose boat had been machine-gunned, hunted by submarines, who had stared in dazed bewilderment at stark masts of torpedoed boats rising from the waves. That refugee still treasures her old bear as a symbol of human kindness and hospitality...

World War II in England. Clothes coupons. Food rationing. The blackout. Endless files of people waiting for anything and everything, from pots to potatoes. Nightly rains of death and destruction from the sky. Nose dives under the table when bomb blasts rocked the house. A repellent, robotlike gas mask carried about everywhere. Children being children, however, it was also used for clowning or playing monster behind the teacher's back!

One day in the storeroom of a temporary home, where odds and ends had been relegated to spiders and oblivion, I discovered a battered doll wearing shabby Oriental clothes. Despite its critical condition of dilapiditis, its indeterminate gender, and the possibility of it being a spy, I adopted that abandoned being. Toys were scarce

then, and those two tired remnants of other children's joys and sorrows were to be my only confidants for five years. Their comforting presence compensated for the brand new playtoys I never possessed, and that unstable setting set the scene for a lifelong search for the essential meaning of playthings of every kind. I am fairly certain that many psychologists would agree that toys help to shape later life — a humorous old jingle says that "the only difference between men and boys is the price they pay for their toys." Between the paper boat and the yacht, the pea-shooter and the automatic rifle, the rag doll and the live Barbie, lie only time, opportunity, and conscience!

After the War, as it was not really mine, my ragged friend was sadly left behind in that same English house. In retrospect, it might have been Chinese, even a European Oriental, but to me it was a Japanese orphan, a true companion and a magic mascot. How I loved that doll and how I have always regretted leaving it behind!

Many years later, during my first visit to Japan, memories of that doll were poignantly revived as I watched a venerable dollmaker's deft fingers working. I realized then that I had never recovered from the consequences of losing a first love. Dazzled by the variety in Japanese doll art, I started collecting all I could find on the subject. I haunted flea markets, antique shops, public libraries, and secondhand book shops, and, purse permitting, I bought prints and dolls. Fate and

flair have now and then been kind in leading me to a modest find at flea markets or out-of-the-way antique shops: a Kobe automaton in working order; a happy *kimekomi* tippler or *shojo* in his original box signed by Matsuzaki Shogyoku, an honored dollmaker; a small but superb *kimekomi* boy on a hobbyhorse made by Hara Beishu, whose technique was designated an Intangible Cultural Asset; a sumptuous old Imari bowl decorated with *tachibina* dolls; a baby's silk *miyamairi* kimono with a pretty pattern of naïve toys. The search can be as stimulating as the unexpected find.

I can also recall delightful, though somewhat problematic, presents of dolls and toys from Japanese friends. Some were in their original, fragile glass cases; others contained a bell mechanism which sent out chimes at the least movement. Once, a last-minute gift at the airport consisted of two ancient and enormous solid wood *kokeshi* dolls in a flimsy paper bag. At every customs counter I passed, they were keenly scrutinized. They caused surprise (what on earth are they?), suspicion (anything inside them?), and hilarity (still playing with dolls?). At least I was well-armed against potential hijackers! With persistence, as well as a strained shoulder, I got them home safely and they are now the proud grandmothers of a flourishing family.

Japanese dolls and toys have adopted me, and I am forever in their debt for revealing a wonderland, where unexpected discoveries never cease to surprise and enchant me. They gave me meanings to see and mysteries to solve, inducing me to explore many facets of Japan's art history. Look carefully, for dolls and toys are often playing a role: they play the *netsuke*, the pouch clasp, the motif on a silk kimono; they peep from the decor of a porcelain cup; they fall out of fireworks; they give a touch of whimsy to the portraits of actors and proud courtesans.

Woodblock prints provided the inspiration for this book, for where can one find more vital ethnographical documentation on Japan than her woodcuts? Specifically, toys are so much a part of the Japanese print that I can think of only one artist who did not represent them. The enigmatic Sharaku never put playthings in his masterly prints, but his child-within was certainly at his elbow, guiding his brush when he painted characters as they were inside; children may not be diplomatic, but they do have a clear view on cheating adults!

I determined to discover how and why different artists used the toy and doll motif. Was it a superficial detail or a mysterious symbol? Certainly, some were aware of its mystery, for an artist, like a child, is more sensitive to life's elusive enigmas. When I look at these prints, I am profoundly moved by glimpses of that never entirely lost make-believe world of childhood, for when an artist works as a child—freely, spontaneously and without hollow devices—he is

showing his secret soul to those who bother to look. Who can fail to be touched by the three spellbound children of Gekko's old puppeteer or the pure, undiluted joy of Korin's caricatural blind man's buff? The concentrated attention of Hokusai's puppeteer makes us hold our breath; we are there, watching his performance. Hiroshige's kites, held fast by invisible hands, gently float above towns and rice fields like scraps of elusive dreams faintly remembered. We hear the joyous shouts of Yoshitoshi's and Shoun's uninhibited youngsters, echoing along the tunnels of time; we feel the protective pride of the prim little miss carrying her new doll. The baby's guileless longing for the fragile toy that is held so high, out of reach, gives our hearts a poignant twist when we remember similar unfulfilled aspirations.

What is this quality that transcends time and place so completely? Is it the quality of being childlike, to think simply and like a child? To see, speak to, and remember the children we were once, the ones we tried to silence—to find it impossible, for the child-within, the child-we-were-once, is prompt to surface at the most inopportune moment, leaving us swallowing repressed laughter when we should be wearing our most solemn mask.

It is not my aim to write a history of Japanese prints and their artists; that has been done sufficiently by more qualified scholars than I. My only ambition is to show toys so that you may remem-ber and perhaps rediscover part of that spontaneous capacity for wonder; children's treasures of dreams are necessarily different from adults' bank-account values. But, honorable connoisseurs of *ukiyo-e*, why must I always look at those same collection and museum pieces consecrated by famous collectors' names? Their qualities are endlessly repeated in many books, the authors of which, like naughty children, oh-so-gleefully trip up their predecessors. Is it so important whether the year of birth is according to lunar months or to the Gregorian calendar? I vouch for the vision, the message, the anonymous master even.

I will not humbly go along with standard opinions that Harunobu is sublime, Hokusai undiscriminating, and Kunisada a decadent. These men worked, often tongue-in-cheek, according to their ideals, their idiosyncrasies, as well as the possibilities of the times, and are all representative of their epoch. As such we must accept them. Great artists have their commercial lows and minor ones their moments of glory. This is a personal view biased by my interest in all aspects of Japanese pseudo-playthings. (I write "pseudo" because all Japanese toys have a treasury of hidden meanings which makes them more than a playtoy in the Western sense.) My priority is interesting documents showing dolls, games, and playthings in the context of their time. I am definitely not an omniscient collector of *ukiyo-e*, but an incorrigible picker-up-of-pebbles of toy and doll illustration.

Initially, I had grandiose ambitions. I wanted the very best for my readers: the greatest artists, the most prestigious prints. I got some, but I encountered pitfalls. A book written is but half the battle won! The most treacherous pitfall was the price of color transparencies and reproduction rights asked by certain Great Museums. You search, write letters, telephone, travel, visit, wait, fill in forms, sign the book, look through files and stocks to make your mouth water, just to be cleanly knocked out of circulation by the price of a modest color transparency plus reproduction rights plus administrative costs. You are further flattened by the cost of an hour's research by museum staff. Playthings are seldom deemed worthy of serious interest. Coming out of deep shock, you realize that you must either give up writing art books and found a photographic society or start a collection dictated by funds, opportunity, and fate.

For me, the latter solution proved the most pleasurable. When original prints were unavailable or too damaged, I made do with late editions, and twice with contemporary woodblock copies. There are also many previously unpublished prints and several rarities: an anonymous "burned picture" (*yaki-e*); a woodblock-printed money envelope (*e-futo*); an extraordinary picture showing toys falling from exploding fireworks; Hasui's doll portraits, extremely curious subjects for a notable landscape artist; a print by Fujita—

tangible proofs that nearly all Japanese artists used the toy-doll-game motif and were aware of its socio-cultural implications. Dolls when cuddled too much, acquire a "love" patina. Similarly, some of the prints are not in perfect condition; they have, in spite of their faults been conserved for their illustrative value and the modest part they played in the larger context of Japanese art history.

Collecting my own documents convinced me that woodblock prints were not limited to cross-eyed kabuki actors and pincushion-headed courtesans. There were also playful prints, and these, for me, were the most telling! I hope that my enthusiasm will be shared by other amateurs of prints and playthings, prompting them to focus on the playful purposes of woodblock artists. The intention of an artist may not always be to make visible, but to lead us to the discovery of the emotion, the humor, the hidden message.

Now I must gather my toy-and-games-related wayward words and random thoughts together and tie them into a tidy bundle for presentation to both indulgent reader and critical collector. Accept this assorted bouquet with my compliments. May I invite you to step back in time—somewhere along the way I am sure you will meet yourself, recognize yourself, and realize that your child-within still exists. And you, too, will weep or smile and remember...

MILESTONES

Not so long ago, a Japanese woman's life and obedience belonged first to her father, then to her husband, and later, to her son. Until the Meiji Restoration of 1868, any attempt by women at independent expression was severely frowned upon. As pictured in Edo and Meiji-period prints, for example, the mother role was only a minor and accessory one, often just a feeble excuse for showing the breasts of pretty young ladies.

The common ideal of feminine expertise ranged from the grace of shrine dancers and the witticisms of tea shop waitresses to the accomplishments of the famed courtesans of the Yoshiwara. In times of famine and extreme poverty, girl children were sold to brothels, while in the late 17th century, when the Edo population had grown to 400,000 inhabitants, unwanted baby girls were simply smothered with wet paper at birth.

A woman's life was not an easy one. It was, however, a life in which toys and dolls played an important part. Japanese toy and doll culture is extremely rich, and these playthings and the customs and beliefs associated with them colored many aspects of women's lives. Some of these customs continue, but many have, alas, been relegated to folklore and are now unknown or ignored.

When a woman married—a marriage arranged by go-betweens, in which she had little or no say—she went to live in her in-laws' home, becoming the household drudge. As part of her dowry, she might take some of her own toys of value—perhaps an *ichimatsu* couple and some Girls' Day dolls—as well as playthings for children of her husband's family to engender goodwill.

It was imperative that she produce male offspring to appease the ancestral spirits and continue her husband's family line, or she was divorced without much ado and sent back to her family. If a desired pregnancy was not rapidly forthcoming, the woman and her husband might make pilgrimages to shrines and temples famed for their fertility-inducing properties. They would offer money and buy a specific talisman, such as a dog, a horse, or a clay monkey. Fertility symbols par excellence, these were then placed on the *kamidana* (god shelf) at home.

The charms work, and the happy news is announced. On the Day of the Dog, in the fifth month of her pregnancy, the dutiful wife is fitted with a textile belt blessed by the local shrine, a gage that she and her future child will be kept safe. The dog is an effective symbol of gratitude, guardianship, and easy childbirth. Soon after birth, the baby is taken to the shrine or temple to be blessed and is presented afterwards with an *inu-hariko*, a playful papier-mâché dog wearing a basket on its head or carrying a drum on its back. Friends and relations usually supply luck and health-bringing toys. The gentle Jizo, depicted as a shaven Buddhist monk, is the protector of children, travelers, and pregnant women, so he comes in for his share of red caps and bibs. It is a

deeply moving sight indeed to see a child's grave-stone representing Jizo provided with food, toys, and baby clothes.

Superstition reigned, and dolls and toys were imbued with various powers, good and bad. If a woman wanted revenge on a faithless husband or lover, for example, she made a nightly pilgrimage to a temple at the Hour of the Ox (between 1 a.m. and 3 a.m.) and nailed a straw effigy to a tree or pierced a seaweed figurine with a needle and threw it in a well. In the case of two deaths in a family in the same year, a small straw doll (*wara*) was buried in a miniature coffin to prevent a third death. At times of illness and epidemics, summary silhouettes cut from wood or paper (*hitogata*) were bought at shrines or temples, marked at the place of pain, and burned or thrown in the sea or river.

Babies and young children were believed to be especially vulnerable to evil spirits and the illnesses they caused. There are therefore many protective toys for children at an early age, the basic criteria being they should be red, move, make noise, or have a ferocious expression to frighten away evil spirits. From the Heian period until the end of the Edo period, babies had protective fetishes known as *hoko*, a white silk stuffed doll, and *amagatsu*, a cross-shaped stick doll, which served as proxies for the child, absorbing any evil threatening its life. Small children were given a cloth stitched-up monkey (*saru ningyo* or *kukuri-zaru*), a simple, featureless little talisman which was thought to be greatly feared by the evil spirits causing illness. Large clothed versions, now extremely rare, were also made as protective playthings.

Toys and dolls are also presented to children as they reach specific stages in their lives. As might be expected, the toys differ according to the sex of the child. At their first New Year celebrations, girls are given a decorative battledore (*hagoita*), and boys a quiver with two miniature bows and arrows (*hamaya* or *hamayumi*). Older girls play the badmintonlike game of *hanetsuki* with their *hagoita* battledores and *hane* or play ball games with *temari* thread balls, while boys play with tops and kites.

For a child's first birthday, grandparents and other family members buy gifts: court dolls for the Doll Festival (Hina Matsuri) for girls, and, for boys, warrior dolls for Boys' Day (Tango no Sekku). On November 15, at the auspicious Seven-Five-Three Festival (Shichi-Go-San), boys of age five and girls of three and seven are dressed in festival finery and once more taken to their tutelary shrine to give thanks for their progress in life. At this time, the child's grandparents might present an *ichimatsu* or *yamato* doll, a boy or girl doll dressed in the same festival finery as the child and usually kept in a glass case.

Of course, toys, dolls, and games purely for fun accounted for another large proportion of playthings. In the past, poor children sometimes received woodblock prints (*omocha-e*) of toys, masks, cards, festival dolls, shadow puppets, and

household utensils to be cut out and assembled. There were also many amusing woodblock-printed games, such as *fuku-warai*, in which the features of the jolly Okame had to be placed while blindfolded, and *sugoroku*, a board game showing the stages of the Tokaido Road. Even for adults, dolls and toys were the usual prizes at *yaba* and *fukiya* halls, where beautiful professional lady archers lured male customers to arrow and blowpipe shooting tournaments. Even in schools today, children are taught to make folded paper dolls called *anesama* (elder sisters) and to fold paper into many ingenious shapes using origami techniques.

Although less than before, toys and dolls still undoubtedly play a more important role in contemporary Japan than in any other country. For school outings, for example, when good weather is of the utmost importance, a *teru-teru bozu*, a summary white cloth or paper doll is hung up and promised a dip in saké if the sun is shining on the proper day. At examination time, the numerous shrines of Tenjin, the god of learning and calligraphy, come in for pressing pilgrimages from students who want to maximize their chances. An offering of money and the purchase of an image of the great statesman should sensibly increase the chances of good results! Papier-mâché *daruma* dolls are also believed helpful, and, after one eye is painted in, they are promised a second eye in exchange for a granted wish. The painting in of this second eye by the triumphant winners of

political elections, for example, is often televised.

Dollmaking also continues to thrive. The 47 Japanese prefectures produce their own toy and doll souvenirs, while shrines and temples sell charms and amulets at New Year and other festivals. Men and women make dolls and playthings, whether professionally or as a hobby, and there are schools for both amateur dollmakers and aspiring teachers of the craft.

Indeed, dollmaking has officially been elevated in status since the Nitten exhibition (Nippon Bijutsu Tenrankai) of 1936, when a unique, aesthetic doll acquired the status of an artwork. Three eminent doll artists, Hirata Goyo (1903-1981), Ms. Hori Ryujo (1897-1984), and Kagoshima Juzo (1898-1982), were designated Living National Treasures, the highest honor in the Japanese art world (the first two in 1955, the last in 1961), while the ancient or exceptional techniques of others have been acknowledged as Intangible Cultural Assets. A sincere salute also goes to Tsujimura Jusaburo, probably the most original, versatile, and unbelievably imaginative doll genius of contemporary Japan.

Playing, I have forgotten the time.
"What is the reason for such foolishness?"
Even if I replied, they would not understand.
Look around! There is nothing besides this.

Daigu (Great Fool), the Zen monk Ryokan (1758?-1831)

Unsigned

First Visit to a Shrine
Miyamairi

Chu-tanzaku / Two small unread seals in lower right corner

By former Japanese standards, the birth year counted as a complete year of age, thus a child was one year old when born, and if born on December 31, two years old the day after. This is a picture in poem card format of a baby's first outing. It is customary, 31 days after the birth of a boy and 33 for a girl, to take the baby to the local shrine to be blessed,

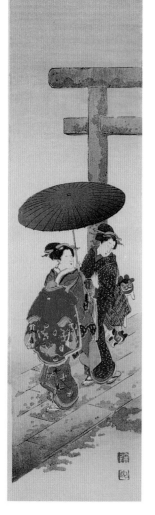

to thank the gods for an easy delivery, and to pray for the future health and happiness of the child.

The *torii* gate in the background proclaims this a Shinto shrine, where just passing through the gateway is an act of purification. The rich clothes and expensive tortoiseshell hair ornaments, the solicitude with which the sunshade is so graciously held over the first woman by her companion show them to be ladies of the upper class, perhaps the child's mother and grandmother. The baby is carefully carried against the body, for its fragile and unformed spirit is easily frightened away. The back of the tiny head is just visible above the too-large draped *miyamairi* kimono with hanging sleeves, which is tied round both woman and child, as tradition requires. It is symbolically decorated with precious things, a hope that the baby's future life will be

prosperous. An old Japanese superstition says that to protect a child from convulsions, one should hang up together from the ceiling a toy basket, a miniature umbrella, and a papier-mâché dog, all of which must have been purchased in the Nakamise, the row of shops leading up to the gate of the Kannon Temple at Asakusa. A playful touch is added by the artist, who was certainly aware of the customs, for the women look back in surprise at two forgotten *inu-hariko*. The small papier-mâché dogs, toy guardians of the child, come tumbling along on short legs, intent on fulfilling their protective duties.

Dolls: These twin paper dolls, boy and girl, were made by Motegi Atsuko and represent *uizan ningyo* (processional dolls). They were taken along to the shrine to be blessed together with a child of the aristocracy. They wear typical costumes, with pompoms on the wide trousers and the original, elegantly tied coiffures of *chigo* (court pages).

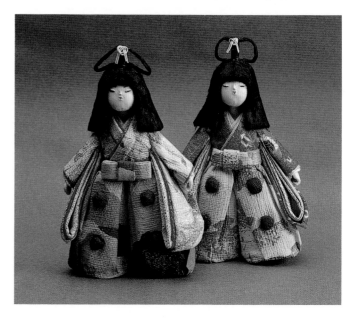

Ogata KORIN 1658-1716

Blind Man's Buff

Me kakushi

Double page from the book *Korin gafu* (Paintings by Korin)
Publisher: Omiya Yohei / Kyowa 2 (1802)

This page could be mistaken for a delicate water-color sketch; it comes from a surprisingly innovative and beautiful book made by Nakamura Hochu at the start of the 19th century. Either inspired by Korin's manner or based on his original paintings, the two-volume publication was instrumental in reviving interest in Rinpa-style painting and illustration. Initiated by Koetsu (1558-1637), an all-round artist, potter, and lacquerer, and his collaborator, Sotatsu (?-1643), who was particularly famous for his calligraphy, Rinpa art was brought to an unsurpassed flowering by the audacious Korin. Rinpa advocated a totally fresh and uninhibited vision of life and nature. It was bold, it was brilliant,

it was an abbreviated language of line and color. It was alive and humorous, and, contrary to the classic arts of the time, it was subtly experimental in scope. The daring search for and manifestation of new elements and directions in Japanese art which Rinpa involved raise it far above the merely "decorative" label ascribed to it. This lone caricatural book page of jubilant children playing Blind Man's Buff (*me kakushi* or "eye hiding") contains as much rapture and freedom as are packed into the 80-odd world-famous *Children's Games* of another great individualist, Pieter Breughel. It is a striking re-creation of a universal theme: children's utter and undiluted joy at play. It is Korin's recreation.

Suzuki HARUNOBU 1725-1770

Beauties of the Green Houses

Ehon seiro bijin awase

Illustrated by Suzuki Harunobu, with *haiku* poems by the 167 courtesans depicted,
those for the frontispiece by the compiler, Kasaya Saren
Engraver: Endo Matsugoro / 1918 reprint

Harunobu is generally credited with the elaboration of the true multicolor print, the *nishiki-e* (brocade picture). He clearly saw and used the full potential of his art, bringing the woodcut to one of its finest flowerings. The original series is one of the first true masterpieces of color book printing in Japan; it is at the same time Harunobu's swan song, for he died in the year of its publication, 1770.

The series is a comprehensive work, consisting of five volumes showing 167 illustrious courtesans of the Yoshiwara, the licensed pleasure quarter of old Edo. The "Green Houses" was a fashionable epithet for the Yoshiwara brothels, which were grandly named after their Chinese counterparts, identified by their green-painted fronts. No, no, the Green Houses were not used for green tea drinking as some historians of the Yoshiwara have so demurely assumed! Harunobu's fragile little ladies, all with equally pure and vacant expressions, sporting stylish kimono and dashing hairdos and fluttering their impossibly tiny fingers, are represented in their daily doings, which, judging by the pictures, consisted of highbrow and genteel occupations much like those of the wives and daughters of rich merchants and the nobility. What is of infinite value in these books is the treasury of information they reveal concerning textile patterns, pet and toy animals, musical instruments, furniture, and the various toys, games, and pastimes bound to seasonal and annual festivals. The book titles follow the *goko no keibutsu*, the five seasonal subjects to which all the *haiku* poems relate:

volume 1: Cherry (*sakura*) for spring
volume 2: Cuckoo (*hototogisu*) for summer
volume 3: Moon (*tsuki*) for autumn
volume 4: Reddening leaves (*koyo*) for autumn
volume 5: Snow (*yuki*) for winter

The series was a very ambitious project for the time; Harunobu had been working on it for two years before his death, and the publisher, Funaki Kanosuke of Suruga Street, had possibly shared the printing costs with the Edo booksellers Maruya Jinpachi of Tori Abura Street and Koizumi Chugoro of the Yoshiwara bookstore. Their respective addresses, where the series was available, are mentioned in the colophon, although it is probable that the girls and their houses sponsored a goodly part of the advertising—*noblesse oblige!* The series is an idealized critique of the most outstanding courtesan members of Green House society, who are not distinctive personalities but a unique species, giving a dreamlike impression of duplication in an endless gallery of mirrors. For identification purposes, each picture has the name of the girl and a *haiku* verse of her composition. Harunobu refused to make flattering portraits of "riverbed beggars" (*kawaramono*), as actors were slightingly known, but he gave the inhabitants of the Green Houses the role of fairy princesses.

As no other artist before or after, Harunobu succeeded in creating an imaginary world of elfin, fragile child-women, who even when masquerading unconvincingly as courtesans, keep their youthful grace. They live in a limpid world where it is not surprising, and even normal, to see them lost in reverie, playing innocently with toys and dolls. Vice and depravity seem never to have touched the inner core of their being. They embody the immortal child in all mankind.

I. A courtesan is pictured looking at shells from *kai-awase*, a shell-matching game. As the bi-valve clam only fits its other half perfectly, it has sexual connotations and is a symbol of fidelity and true love. A luxurious set of requisites for this game was included in the dowry of every highborn lady when she married. The two halves of the shells were beautifully decorated with identical detailed, miniature scenes from classic poetry or literature, using bright vegetable and mineral colors and gold leaf over built-up relief patterns. The 360 shells were divided in two halves, one set (*jigai*) being placed face downward on the ground, the other (*dashigai*) taken one at a time, face up, from the container. Players then tried to find the matching shell by turning over the shells alternately, the aim being to gather as many matching pictures as possible. The two storage boxes (*kaioke*), richly lacquered with classic landscapes or courtly scenes, are seen in the background.

Game: A large Edo-period painted shell from the game for adults and two intricately lacquered miniature boxes for the Girls' Day doll display, also containing tiny gilt-decorated shells.

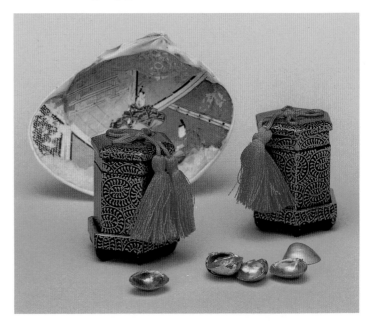

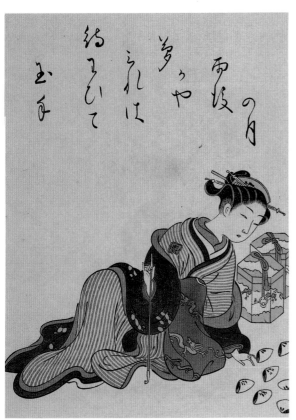

II. The Portuguese who came to Japan in 1543 introduced playing cards, the Japanese word *karuta* deriving from the Portuguese *carta*. Suspected of spreading gambling and foreign influence, they were banned in the late 17th century and replaced by typical Japanese sets. First there were hand-painted cards, followed by woodblock-printed games, and in the Meiji period, by many varieties of machine-printed kinds for children, such as the *uta* (song or poem), *hana* (flower), and *i-ro-ha* (syllabary) cards. The most popular card game of the Edo period was a Hundred Poems by a Hundred Poets (*hyakunin isshu*), based on the anthology compiled by Fujiwara no Teika in 1235. The set consists of 200 cards, half of them representing a poet and the opening line of his poem, the other half the closing line (calligraphy only). The opening line is read aloud by a reader, while the players try to find both the poet and the closing line among the cards laid out on the ground, the player with the most pairs being the winner. This pastime

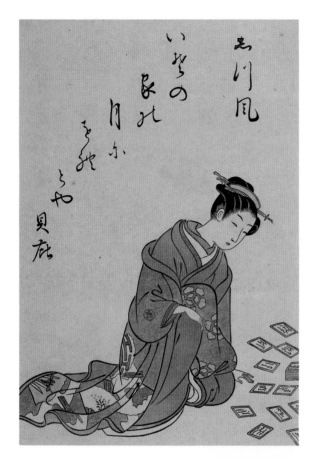

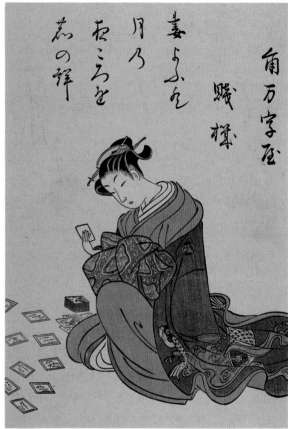

proves that the residents of the Green Houses were not wanting in literary and poetic inclination.

Game: Woodblock-printed cards with portraits of some of the hundred famous poets and their poems: (*above, left to right*) the Japanese Don Juan, Ariwara no Narihira; Kakinomoto no Hitomaro; (*below, left to right*) the court lady and famous writer Sei Shonagon; Semimaru; and the priest Sojo Henjo.

III. The pretty young girl is carefully dressing a doll in this touching print. It reminds us that the brothels procured their human merchandise from a very tender age, when promising children were kidnapped or bought from poor families. Two were given to established courtesans as maids (*kamuro*) to learn their trade.

A doll was a status symbol in the Yoshiwara, and if their mistress was kind and had rich admirers, the little maids would perhaps receive a doll or *hagoita* (battledore) on some special occasion, such as New Year, as a reward for their services. This is, however, an older girl who is lavishing such tender care on her doll, and it seems obvious the little figure is filling the role of the child she will never have.

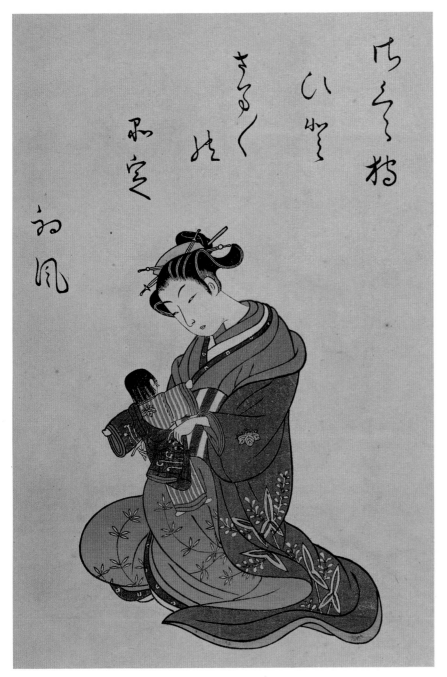

IV. A girl named Sonoume is holding a decorated *hagoita*, so it is easy to deduce that it is New Year, when *hanetsuki*, a Japanese equivalent of battledore and shuttlecock, is played. The game originated in China and was known in Japan as early as the Heian period. At first it was a pastime reserved for the nobility, and beautifully gilded and painted *hagoita* were presented by carpenters and other tradesmen to their patrons at New Year. In prints, dolls, *hagoita*, and thread balls are often seen as attributes of *kamuro* (young maids) and were part of the festive paraphernalia taken along at New Year, when their mistresses went out on an imposing public parade to thank the go-between teahouses for sending customers. That *hagoita* were decorated with aus-

picious symbols possibly led to their being made and sold at shrine and temple festivals as lucky charms and protection against fire and, of all odd things, mosquitoes! Playing initially served as an exorcism rite, becoming a girl's game in the Muromachi period (1333-1568). The shuttlecock (*hane*) was made of a hard soapberry (Sapindaceae family) with a few feathers inserted. The aim was for the two or more players to bat it back and forth without touching the ground. The player who dropped the *hane* was given a dab on the face with *sumi* (black ink) if she did not pay some gage. The game could also be played by a nimble solitary player.

Toy: The earliest *hagoita* were flat, delicately painted and gilded on both sides. By the end of

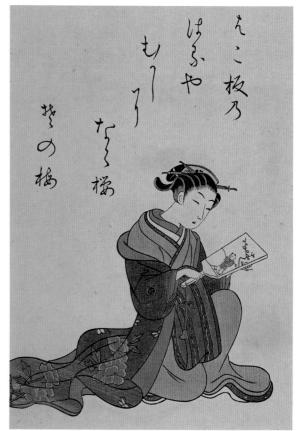

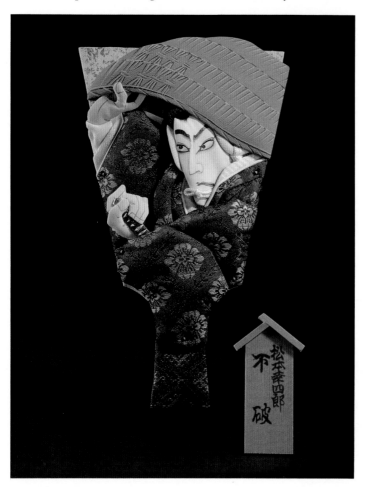

the Edo period, one side was flat and painted, while the other side bore the flamboyant portraits of kabuki idols, their costumes made of silk and brocade in the *oshi-e* (padded picture) technique. These were perhaps inspired by the many *ukiyo-e* prints of actors in *hagoita*-shaped reserves. Flat ones of plain wood, summarily painted in folk art style, were believed to be of talismanic value and were bought at shrine and temple festivals to bring luck for the year.

V. Lovely young Matsushima is absorbed in the intricacies of an *itomari* (thread ball), also named *temari* (handball). It was first made of a round core of tightly rolled paper, cotton, or silk scraps, wrapped with plain cotton thread, and then given a colorful and complicated outer geometrical pattern with multicolored silk threads. While they were being worked to form the pattern, the

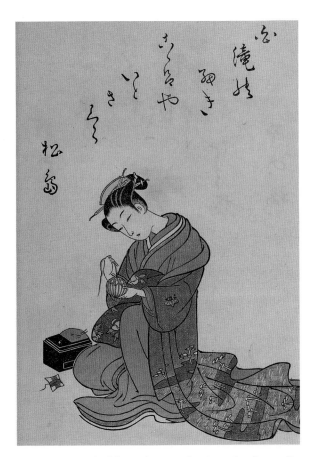

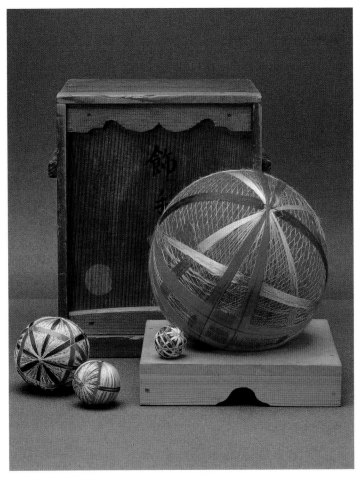

threads were held in place with pins. As the ordinary handball did not bounce, it was used only for throwing and catching games, accompanied by sing-song ditties as in the West. Their sizes ranged from miniature to exceptionally large, the latter being professionally made and sold as decorations for festive occasions. There are also embroidered balls and ones made using the *kimekomi* method. In the Edo period, prints show girls bouncing balls on the ground; these were tightly filled with sponge. Real rubber balls were imported from Germany around 1890 and replaced traditional ones.

Toy: A large silk ball in its original box, surrounded by smaller ones. More than for play, such oversized balls were used for decorating shop windows or the *tokonoma* of a home at New Year.

VI. This young courtesan seems to be engaged in a serious dialogue with a large *daruma*. As this tumbler toy always returns to an upright position no matter how often it is pushed down, it is evident that the pair have something in common. A lady of the night was often called a *daruma* or "push-over geisha." *Daruma* was familiarly known as *okiagari koboshi*, or the "little-monk-who-gets-up-easily." Daruma (or Bodhidharma) was the Indian monk who brought Zen Buddhism to China in the sixth century, from where it reached Japan in the 12th century, and he is credited with many exceptional feats, real and legendary. While the Japanese artists treat him with extraordinary levity, caricatures abound, and he is often shown walking happily with a beautiful courtesan with whom he has exchanged clothes, proof that

appearances can be deceptive and that enlightenment is accessible to saint and sinner alike. However, it is possible that the toy alludes to a sporting practice of the time known as *kipparai*, not paying the bill after a night of pleasure. These guilds (*kumi*) would arrive at a brothel richly dressed, order the best of everything, and then steal away at dawn without settling the exorbitant expenses. One notorious society known as Daruma-gumi, whose members had the figure of Daruma tattooed on their arms, were known for the disarmingly easy and natural way that they handled their "pleasure business." There is also a pun on Daruma's name, for *o-ashi no nai* ("being without any honorable legs") can also be interpreted as "being without any honorable cash."

Here, the girl and the *daruma* toy seem to be in a contemplative mood, eyeing each other warily, understanding mutual weaknesses and conscious of common thoughts. Examined carefully, it becomes apparent that the two sides of Daruma's face are totally different. Is it possible that our "two-faced" personage has a split personality?

VII. A courtesan with implements for the incense game (*ko-awase*), a game played by two or more persons. This aristocratic pastime had its origin in the refined culture of the 11th-century Heian period and comprised many luxurious lacquered boxes and silver and ivory accessories. Tiny slivers of costly and fragrant tree resin which had hardened in the ground for many years were placed on a thin piece of mica and warmed over charcoal in an incense burner. The players wrote the name of the fragrance on a ballot and placed it in a box. The player with the most correct answers at the end of the game was the winner. Different games were played, and to keep count of the scores, a board with small doll figures was sometimes used. These dolls were advanced with every

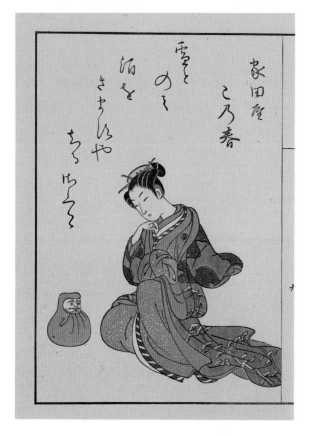

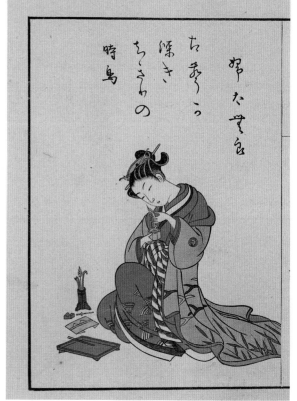

point gained, so that the player who reached the middle of the board first was the winner. Wrestlers, warriors, lovers, dancers, horses, and football players were used on the scoreboard; the figures could be costumed or carved from plain wood.

VIII . A pensive courtesan sitting by a *go* table (*goban*). *Go*, or to give it its ancient name, *igo*, is together with *shogi* and *sugoroku* one of "the three board games" (*sanmen*). *Go* is thought to be the oldest game in the world—about four thousand years old. Introduced from China to Japan by Kibidaijin in the eighth century, it was originally played by the nobility only and was limited to the Kyoto court for 300 years. The rules were standardized in the Muromachi period (1333-1568), and it became a very popular game among all classes.

Go is played by two people using 181 black and 180 white round, slightly convex stones, making a total of 361, as many as there are intersections on the board. The weaker player uses the black stones and has the advantage of starting. The stones are played alternately and placed where the lines intersect, the aim being to surround the other player's stones. The board and the matching containers for the stones were made from precious woods or were beautifully lacquered. It is a game with simple rules but with a clever and complicated strategy. Courtesans who had been trained in the social graces since childhood played this game well, both to alleviate their boredom and to make an impression on their more intellectually minded customers. One of Noble Prize winner Yasunari Kawabata's most hallucinatory novels is built around a day-to-day *go* match between an old master and his challenger. Even the master of chess Emanuel Lasker described *go* as a cosmic game, saying it has "something unearthly" and adding that "if there are sentient beings on other planets, then they play *go*."

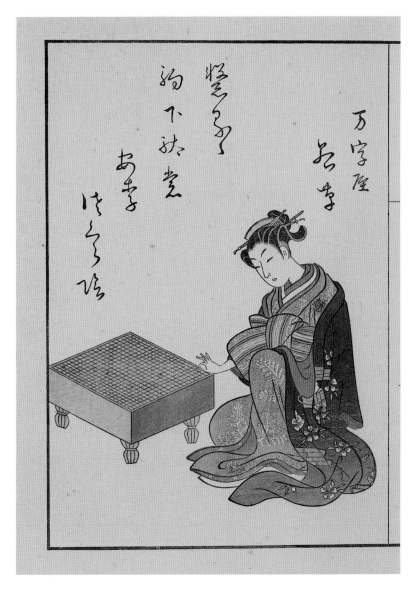

IX. Sitting hunched up against a wall, Hatsukaze of the Wakana-ya house is attentively playing with a yoyo, carefully holding her long sleeve aside, out of the way. Although it seems a very ordinary toy, known all over the world, the yoyo is not often seen in Japanese prints. It is credited with a Chinese origin but is depicted on ancient Greek earthenware, too. Despite its simple construction, many unbelievably complicated tricks and figures can also be performed with this unpretentious little toy. Nowadays, there are even yoyos with batteries which illuminate the toy as it flies up and down—perhaps for the insomniac enthusiast?

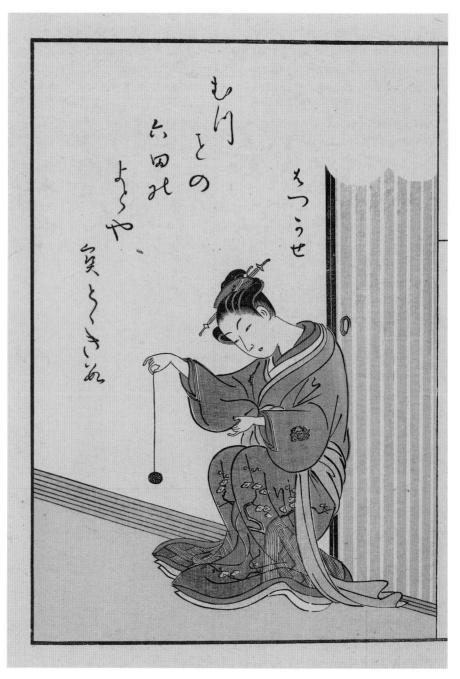

X. A game rarely seen in woodblock prints is this dart or arrow tossing game known as *toko*. Of Chinese origin, it supposedly originated as an amusement of soldiers, who tried to throw arrows into an upturned helmet. In his book *Games of the Orient*, Stewart Culin refers to the game as *tsubo uchi* (pitch pot) and attaches great importance to arrows as the ancestors of divination sticks and playing cards. "Arrow toss" possibly dates back to the Chou dynasty (1100-221 BC), when it was used for divinatory purposes. It had already been modified into a formal game when it reached Japan in the eighth century, and some game requisites of that period are preserved at the Shoso-in repository in Nara.

The requisites were simple: a plain wooden cylindrical vase on a heavy foot with two rigid metal rings on each side and two similar but smaller containers without rings for the blunt arrows. The player who could throw the most arrows into the vase was the winner. As demonstrated by the print, the ladies of the Yoshiwara also contributed to the conservation of this ancient game, all but forgotten today.

XI. The standing courtesan Shigezuru wears an *uchikake* overrobe draped over her kimono. It is decorated with pine twigs and folded paper (origami) toy cranes, symbolic of luck and longevity. The cranes (*zuru*) are also an allusion to her name. This print is a good example of how textile motifs were cleverly used to reveal the names of fashionable courtesans or kabuki actors. The allusion would have been immediately recognized by admirers.

Suzuki HARUNOBU 1725-1770

Horseriding

Umanori

Chuban / Signed: Suzuki Harunobu ga (Drawn by Suzuki Harunobu)
Courtesy of Tokyo National Museum

Most woodblock prints show the hobbyhorse as a stick with a horse's head, with or without a small wooden wheel at the base. This horse, however, is a more sophisticated and costly version, and was used for the game of Warriors (*musha asobi*). Doubtless made to order, it is designed to look like a real horse down to the four legs, saddle and bridle. But the boy's legs still provide the motive energy for his sturdy steed! The name *umanori* can also be interpreted as a "carrying or hanging horse," indicating that the toy is being carried by the child, fastened round his waist or suspended from his shoulders. Judging by his clothes and hat, the boy must be the son of a rich samurai family. The girl accompanying the boy is holding the sunshade more over him than over herself, so she is perhaps a young nursemaid (*komori*), specially hired to look after him. Here again, the straight and curving lines are remarkably opposed. The stark geometrical lines of the wall serve as a strikingly effective background for the figures. The flowering cherry branches in the upper right corner add a softening touch to the careful composition.

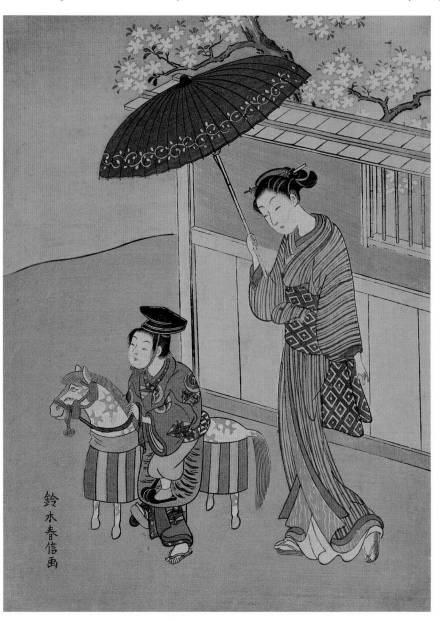

Doll: A superb *kimekomi* doll with hobbyhorse made by the long-lived Hara Beishu (1894-1989), whose technique was designated an Intangible Cultural Asset. By the well-made toy horse, rich clothes and court cap, it is apparent that this is an aristocratic child. The clothes are made using the *kimekomi* method, which, roughly translated, means pushing fabric into cuts to form a pattern. On dolls made of wood or a molded sawdust and glue mixture, deep cuts are made to form the outlines of clothes. Multicolored silks and brocades are then cut to size and pushed deep into the cuts.

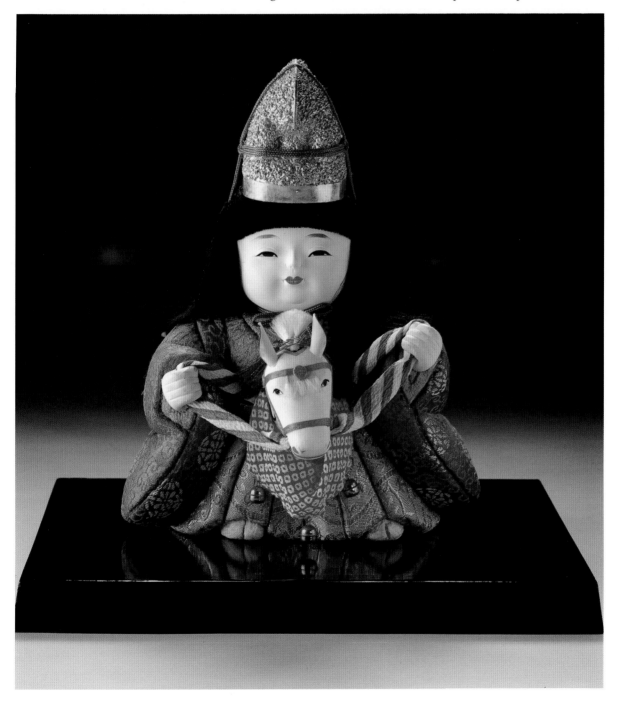

Suzuki HARUNOBU 1725-1770

Playing Cat's Cradle

Ayatori

Chuban / Unsigned / Courtesy of Tokyo National Museum

A beautiful print showing two girls playing *ayatori* (cat's cradle) with a piece of string. The game is known the world over, but in Japan each stage has a specific name: the first pattern seems to be a domestic cat (*neko*), transforming itself into the second, a wild mountain cat (*nekomata*); the third is a musical instrument (the *koto*) or the two pieces of wood under the sole of the traditional Japanese footwear (*geta no ha*); then comes the fourth, the horse's eye (*uma no me*); and last, the hand-drum (*tsutsumi*).

In a peaceful room reflecting the exquisite taste of its inhabitants, two young girls are enjoying the comfortable warmth of a *kotatsu*. This charcoal brazier and its surrounding frame, covered by a quilted coverlet, form the table over which they are playing. The interior, soberly arranged with a simple plant in the *tokonoma*, has a screen painted in the manner of the Kano school at the back. The girls are elegantly dressed, one in a delicate beige shell-and-spray patterned kimono with a stark black and orange squared *obi*, the other in a dark gray kimono patterned with pines and a meandering river and offset by a soft pink

floral *obi*. The geometrically decorated walls of the *tokonoma*, the wood grain visible at the base of the alcove, and the lovely flowing lines of the textiles countered by the vertical lines of the background elements justly make this one of Harunobu's world famous and most representative prints.

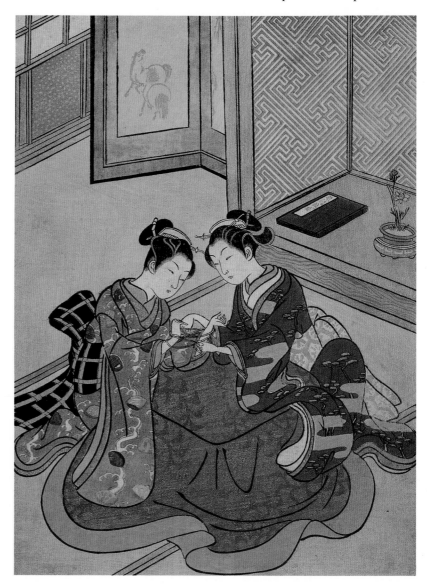

34

Kitagawa UTAMARO 1753-1806

Woman Blowing a Popping Toy

Oban / Series: *Fujin sogaku juttai* (Ten Types of Women)
Publisher: Tsutaya Jusaburo / c.1790 / Contemporary copy

One of Utamaro's best-known series contains this *bijin* (lovely lady), done in the half-length portrait style on a mica background. She must be a "playful type," for like a child, she blows on a *poppen*, an ingenious toy-clacker of the Edo period. The trinket is made of blown glass with a hollow stem and an extremely thin and delicate glass membrane covering the outer end. When gently blown, the flexible membrane expands, and when the air is released or sucked back into the mouth, it returns to its original position, making the distinctive "pop" sound for which the toy is named. The whole breathing exercise must not be done too enthusiastically or the result is a shattered membrane and a useless plaything! Glass (*garasu*) was a foreign importation, so the toy was probably not cheap. The *poppen* was first introduced through Nagasaki, where both Chinese and Portuguese are credited with the first glassblowing importations. As the toy is not seen in the West but can still be found in Chinese shops, there is a greater possibility of a Chinese origin.

Toys: A collection of glass *poppen* as they are still made today. The *poppen* is found in craft shops and is a special souvenir of Fukui and Nagasaki. This fragile bauble exists in different sizes and can be decorated by painting or by multicolored glass overlay. It sometimes has a ribbon-and-bells attachment, adding music to the prosaic "pops."

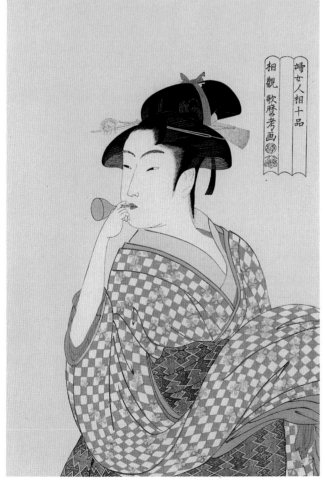

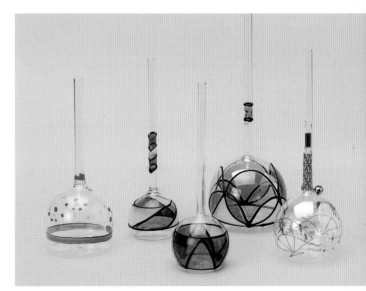

Tachibana MINKO Fl. c. 1764-1772

The Potter

Double page from the book *Saiga shokunin burui*
(Colored Pictures of Classified Artisans) / 1770

Molded clay figurines and turned shallow dishes, typical potter's merchandise, are spread on boards to dry before firing. With keen attention, the potter turns a more elaborate piece, a footed bowl. His wife brings a basket of clay pellets, while a small boy tries to help carry the heavy burden.

A fine artist and follower of Harunobu, Minko produced prints, picture calendars, humorous books, and "readers." He is little known except for this interesting and beautiful book, which shows a range of different craftsmen at work. These depictions feature 28 handicrafts that were well-known and respected at the time, including the "modern" and imported craft of glassblowing.

The illustrations were colored by an unusual and rarely used stencil technique called *kappazuri*, supposedly invented by the artist. (This is possible as Minko first worked in the textile industry as an embroiderer, and must have been familiar with the various dyeing and decorating techniques.) Through the years, the book was highly regarded for its documentary value, and it was reprinted in 1784 with a preface by Shokusanjin, a famous writer of the day. In 1916, another beautiful facsimile edition in the Japanese manner was produced by Hayashi, and based on this edition, yet

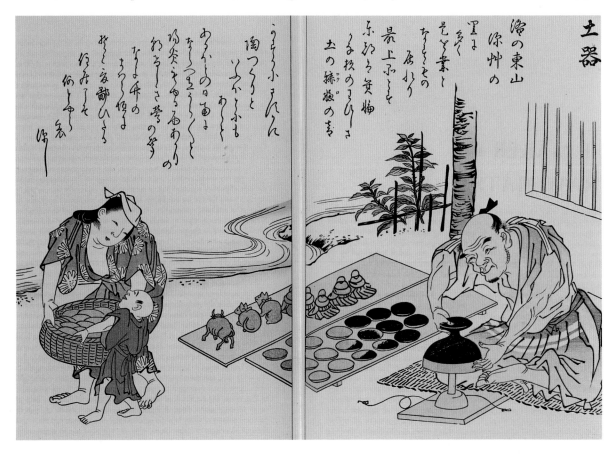

another was published in 1967 by Walker/Weatherhill. It is interesting to note that makers of playing cards, clay dolls, footballs, and latheworkers who probably made tops and *kokeshi* dolls as a sideline are included among the more highbrow makers of swordblades, court caps, and *noh* masks.

Doll: The young girl holding her favorite toy is a classic model in the clay doll repertory. More for decoration than for play, beautifully finished examples are produced in Hakata, Kyushu, the most famous production center of clay dolls nowadays. In Japanese, clay dolls are known as *do*, *doro*, and *tsuchi ningyo* and are usually folk toys.

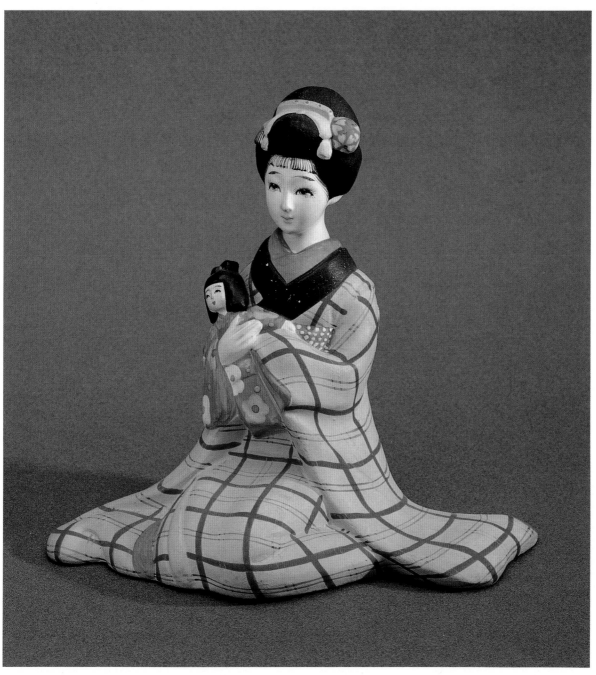

Kitagawa UTAMARO 1753-1806

The Picture Box
O-karakuri

Oban / Series: *Furyu kodakara awase* (Gallery of Fashionable Children)
Signed: Utamaro hitsu (Painted by Utamaro) / Publisher: Izumiya Ichibei
c.1802 / Courtesy of Tokyo National Museum

A beautiful print showing that the greatest artists were aware of the toy novelties of their time and exploited them with keen psychological insight. An optical box has been placed on a *go* table for greater height. The woman is evidently amused by the antics of the two children, one peering through the opening with great concentration, literally and figuratively unmoved by his small companion's efforts to push him aside.

The *o-karakuri*, a large optical box or frame commonly known as the "peep show," was introduced to China from the West, then imported to Japan from there. Another model based on the same principle can be seen in an earlier print by Harunobu, showing that the amusement was known and appreciated in Japan from at least the 18th century. Harunobu's print perhaps inspired Utamaro to give his version of a popular fad of the period. *Karakuri* means "to trick" and is a term more often applied to moving dolls and festival automatons. The prints used are *megane-e* (eyeglass pictures), designed in reverse. The relief is strengthened by a magnifying glass and a mirror slanted at an angle of 45°. In Kyoto, the painter Maruyama Okyo (1733-1795) was one of the first artists to study Western perspective and to pro-

duce a series of Japanese *megane-e* for optical boxes, popular attractions at festivals. Later, in the Meiji period, the imported toy kaleidoscope was called a five-colored eyeglass (*go-shiki megane*).

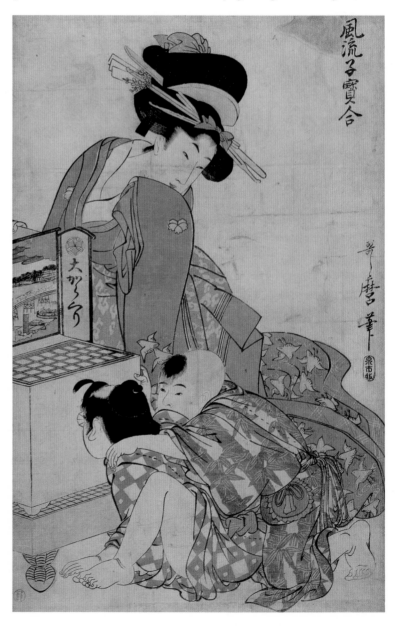

Katsushika HOKUSAI 1760-1849

The Fish Cart
Tai-guruma

Page from the book *Isuzu-gawa kyoka-guruma*
(A Cart of Humorous Odes of the Isuzu River) / 21cm X 16cm

"Even as a ghost
　I'll gaily tread
　　the summer moor."
This, the last poem of "the old man crazy about painting," is a nostalgic tribute to Hokusai's sense

of humor and humanity. He was an artist of world status, who, at the age of 89, pleaded with the gods to give him five more years of life, so that he could become a "true" artist.

This picturesque page comes from the book of *kyoka* verse *A Wagon of Humorous Odes of the Isuzu River* (1802). Subtitled *Fifty Fanciful Poets*, it features one poem by each. A *kyoka* was a playful poem of 31 syllables, known as "crazy verse." As *kyoka* poets tended to exaggerate clothing and accessories to give an eccentric image, this poet seems to be playing with a roll-up-and-out blow toy and a child's *tai* fish cart. It was customary to bring some peculiar object or "treasure" to *kyoka* club meetings as subject matter, so these must be the inspirational pieces of the moment.

A miniature version of this fish cart was a very popular wheeled toy for children. The fish shown here is either a pulltoy or a very freakish headdress. Made of a curly reed, the blow toy is symbolic of the fishing pole with which the god Ebisu catches the lucky red *tai* fish, a charm that brings riches and keeps away illness and evil spirits.

Katsushika HOKUSAI 1760-1849

The Candy Blower
Ameya

Double page from the book *Yama mata yama* (Range upon Range of Mountains)
22cm X 16cm / Publisher: Tsutaya Jusaburo / 1804

This serene composition beautifully balances background and figures. A man and two stylish ladies are about to enter a temple compound. A vendor who makes blown-sugar toys sits to the right. This unusual craft, resembling that of Venetian glass-blowing, can still be seen on sunny Sunday mornings at the entrance to the Asakusa Kannon Temple in Tokyo. Using heat, a sugary mix, and a few simple tools, an artisan with deft fingers fashions all manner of tiny white animals on sticks, embellished with a few touches of color. The fragile creations can be eaten or kept for a short time.

Hokusai, the giant of Japanese woodblock printing, the genius of the living line, the keen observer of life's fancies and foibles, has left some original views of playthings scattered through his work. They range from luxurious *surimono* prints, to unobtrusive details such as in this poetry album, to lively sketches in his *Manga*, a 15-volume monument to the everyday life of Japan and an enduring witness both to his own profound humanity and his obsession with art. Louis Gonse notes, with good reason, that Hokusai had drawn a complete history, a picturesque encyclopedia of a people. The *Manga* books contain several toy-related drawings, among others, a *wara* (straw fetish doll), an *izume-ko* (child-in-a-basket doll), and an amusing scene of children making funny faces on the ground with pieces of string. The *kyoka* album *Yama mata yama* describes as mountains the slightly hilly northerly suburbs of Tokyo. It is considered one of the best produced by Hokusai and was the last illustrated book to leave Tsutaya's shop. The blocks were bought by the German collector Philipp Franz von Siebold, taken to Europe in 1830, and are now in the Leiden Museum.

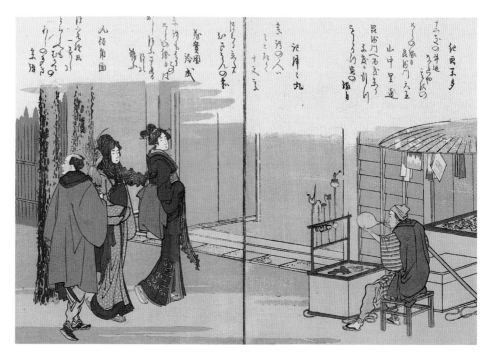

Katsushika HOKUSAI 1760-1849

The Puppeteer and the Spear Dancer

Surimono shikishiban / 21cm X 18cm / Signed: Hokusai aratame Katsushika Iitsu hitsu
(Painted by Hokusai changing his name to Katsushika Iitsu) / Year of the Dragon, 1820

Another marvelous picture filled with allusions and double meanings, *The Puppeteer and the Spear Dancer* is printed in vibrant colors on a gold background and with deep blind printing effects giving relief and texture, techniques which are unusual for Hokusai. Well-known puppeteers were sometimes called to the houses of the moneyed class to give private showings on festive occasions.

Here, a puppeteer dressed in formal clothes is kneeling behind an improvised stage consisting of a *goban*, the massive table on which the game of *go* is played, while, with the intense concentration of his art, he manipulates a female puppet through the intricate steps of the Spear Dance. This dance was performed by the kabuki actor Mizuki Tatsunosuke (1673-1745) in a female role which constituted one of his greatest claims to fame. The poem is in praise of the actor, who is likened to a "flowering young tree" (*mizuki*) and alludes to the Dragon (*tatsu*) year.

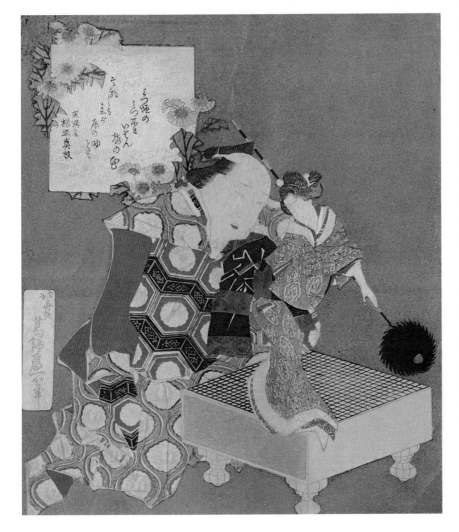

This print is one of the rare examples which permit dating of Hokusai's name change to the Katsushika signature on the occasion of his 60th birthday (1820). He had completed an entire zodiacal cycle (60 years) and was recommencing at age one (*iitsu*).

The imposing and beautifully costumed puppet must be of a complicated and mobile make, for the bare arm shows jointing at fingers, wrist, and elbow. Was this impressive figure perhaps made by Yanagawa Shigenobu (1784-1832), a clever puppet maker who was first Hokusai's pupil and later became his son-in-law?

Utagawa TOYOKUNI I 1769-1825

Benkei Puppet

Benkei ningyo

Oban / Signed: Toyokuni / Round *kiwame* (approved) seal

Toyokuni's father was a carver of wooden figures and puppets (*kibori ningyo-shi*), and many of his prints carry reminiscences of his father's art. This kabuki actor is playing with a Benkei puppet toy, a specialty of Nagoya. The mechanized Yoshitsune-Benkei pair are shown acting the Goyo bridge episode on a festival float at the Nagoya Toshogu Festival on 16 and 17 April.

Toyokuni was the most talented pupil of Toyoharu, the founder of the Utagawa school. He began as a book illustrator, soon producing an eclectic collection of styles and subjects. He is, however, best known for his theatrical prints and his actor portraits, which he designed in an amazing variety of types, going along with the fashions of the time and blatantly borrowing from his contemporary colleagues. He was one of the most popular artists of his day. For an interesting print by Toyokuni (c.1798) showing the famous kabuki actor Matsumoto Koshiro and two courtesans being entertained by a miniature *karakuri* wrestling match, see the endpapers of Mary Hillier's book *Automata and Mechanical Toys*.

SHUNKIN Fl. 1810s

Courtesan's Maid Carrying Doll

Oban / Publisher: Shioya Chobei
Courtesy of the Ethnographic Museum, Antwerp, Belgium

Except that he was a pupil of Shunkosai Hokushu (Fl. 1810-1832), not much is known of the Osaka print artist Shunkin. In this unidentified kabuki play, the actor Nakayama Yoshio performs the role of the courtesan Komurasaki. She is accompanied by her two young maids (*kamuro*), one carrying a doll. The textile pattern of the maid's costume may indicate an *ichimatsu* (checkered) doll. There are

quite a number of prints showing *kamuro* carrying dolls and *hagoita* when the *tayu* or *oiran*, courtesans of the highest rank, went on an outing or paraded through the streets with all the members of their retinue. A well-made and richly dressed doll was a status symbol and reflected the prosperity of a house and its inhabitants. Dolls would undoubtedly be given by a courtesan to her young apprentices as a reward or by an admirer to win the favor of both maid and mistress.

This picture is a prime example of the high quality and lavishly filled *oban* format of the first typical Osaka actor-prints. Careful registry, coloring, burnishing, and printing tend to make the overall impression of an Osaka print more static, more mannered than its Edo equivalent. While most Edo prints were less refined, they were indubitably more lively. This picture possibly dates from 1815, when Nakayama was playing for the Kado theater of Osaka.

Katsushika TAITO II Fl. c. 1810-1853

The Playful Hotei

Page from the book *Banshoku zuko* (Pictorial Studies for Various Crafts)
18cm X 13cm / Publisher: Kawachiya Mohei, Osaka / 1827-1850

Two portrayals of the rotund Hotei, one of the seven gods of luck, who is accompanied, as usual, by his joyous band of Chinese children. In the top picture, Hotei has turned the tables on one of the teasers and transformed him into a string puppet (*ayatsuri ningyo*). Or could it be that the marionette is just another toy for a good child? Or that play is the most important occupation of the god of happiness? At bottom, a laughing Hotei is offering his huge sack as shelter and transportation for the happy group.

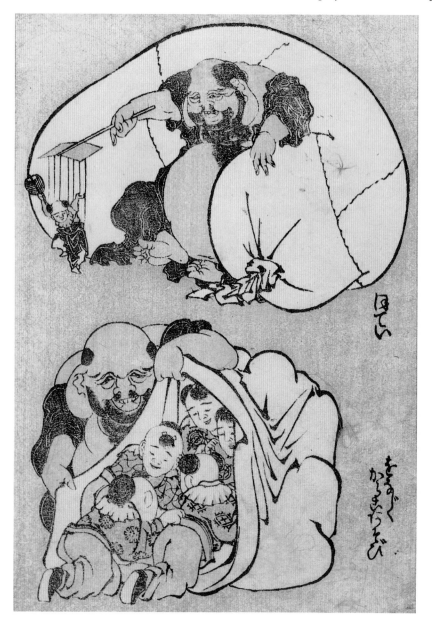

Taito II was a pupil of Hokusai, who gave him the name Taito, one of his own discarded art names around 1820. He was an all-round draftsman, working as a painter, print designer, and book illustrator, and he was endowed with at least a dozen art names (*go*). He spent the last decade of his life working in Osaka.

The influence of Hokusai's *Manga* is visible in many aspects of Taito's work; it can be seen here in the strength of the sure *sumi* outline combined with soft coloring. Drawings contained in manuals such as these served as models for various craftsmen, including *netsuke* carvers and metalworkers. Although Taito may rightly be recognized as a typical member of the Hokusai school, he was

essentially a copyist. Over the course of his life, he followed his master's style so slavishly—even to the point of simulating his signature—that he was mockingly known as the "Dog Hokusai."

Doll: As befits the god of happiness, a fat and ever-cheerful Hotei bestows a broad smile on the world. His protruding abdomen represents largeness of soul, while his long earlobes, like the Buddha's, symbolize wisdom and spiritual wealth. He carries one of his attributes, a flat Chinese fan, and, instead of his usual ragged clothes, he is dressed in the *kami-shimo*, a formal, wide-shouldered garment. His rich attire suggests that in his younger days, he must have made a welcome present for some happy occasion, whether a birthday, a wedding, or the birth of a son.

Of the seven gods of luck, Hotei is the one most often associated with playing children. In his eyes, they can do no wrong.

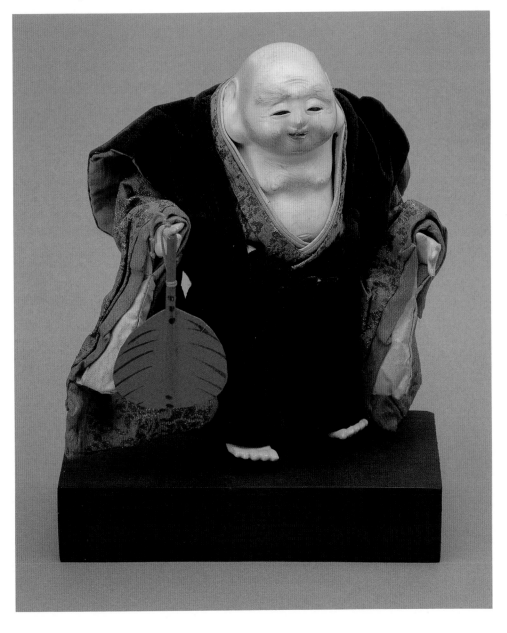

Name Unread
Pilgrimage to Ise
Oban / Artist of the Shijo School / c.1830
Courtesy of the Ethnographic Museum, Antwerp, Belgium

Throughout Japanese history, pilgrimages to Shinto shrines and Buddhist temples have been exceptional and exciting events in the life of people both rich and poor. Eagerly awaited, they provided an excuse for traveling or fulfilling some vow, such as visiting the Great Shrine of Ise or the 33 Kannon temples. In country villages, participants were designated by a lottery and were required to bring back sufficient lucky toy-amulets for family and friends. Needless to say, many pilgrims took the opportunity to combine duty and pleasure, for the lively festivals at all the sacred places gave opportunity for much carousing and merrymaking.

The Great Shrine of Ise is the chief shrine of Shintoism and is dedicated to Amaterasu Omikami, the Sun Goddess, protective deity of Japan, and first ancestress of the imperial line. Every Japanese aspired to at least one trip to Ise in a lifetime. These three happy tipplers dance along the way, reveling in their freedom. They brandish their banner on high, dippers for water (or saké) carried in their belt. The leader wears a wig and the jolly mask of Okame, whose comical, suggestive dance made the assembled deities roar with laughter, thereby luring the Sun Goddess from the cavern where she had retired in anger, plunging the world in darkness. Witty and intriguing, it is also a puzzling print, something of a trompe l'oeil, for it is cleverly disguised as a fragment of an *emakimono*, a horizontal picture-scroll with text and pictures telling a story as the scroll was unrolled.

Doll: This rare 19th-century figure of a pilgrim (32 cm high) was made to order for the German doctor, scholar, and botanist Philipp Franz von Siebold (1796-1866). In 1830, von Siebold brought back to Europe a collection of costumed dolls representing people from all walks of life. (Two more, a peasant and a townsman, are shown in Jack Hillier's *Source-books for Japanese Craftsmen*, p.9). The figure has an expressively modeled middle-aged face covered with a layer of *gofun*, a mixture of calcined, pulverized oystershell and glue which takes a soft sheen when polished. He is dressed in a cotton costume of homespun, pre-dyed blue-and-white *kasuri* fabric, trimmed with white, and wears the strong straw-woven *waraji* sandals which were often left behind, worn-out, at the last temple of the series visited by pious pilgrims as proof of their long journey and devotion. Tied around his neck is a string necklace with small wooden strips, possibly bearing the names of the sanctuaries he has visited.

Courtesy of the National Museum of Ethnology, Leiden, The Netherlands

Totoya HOKKEI 1780-1850
Playing Sugoroku
Sugoroku asobi
Surimono shikishiban

Hokkei was a specialist in *surimono,* commissioned, limited edition prints of different sizes. The category includes special occasions, New Year wishes, announcements of name changes, ingenious calendars (*e-goyomi),* and pictures and poems printed for poetry clubs. *Surimono* were printed on thick, expensive *hosho* paper and often embellished with gold, silver, lacquer, and blind printing.

First a fishmonger, Hokkei became interested in the woodblock medium, turning out to be a natural talent. His still-lifes are among the most subtle works of the Japanese woodcut. He admired and studied under the versatile Hokusai, soon becoming one of his senior pupils. It is possible that he was one of the few artists who carved his own blocks and printed his own pictures. This perhaps explains the rather unnatural perspective of the *sugoroku* board and the poorly drawn profile and narrow forehead of one girl, a default found in other Hokkei prints.

Two luxuriously attired girls are playing *sugoroku* (double sixes), a game resembling backgammon or Indian *pachisi.* Together with *go* and *shogi,* it is one of the three popular board games most often seen in woodblock prints as pastimes of courtiers and ladies of the licensed quarters. There were two kinds of *sugoroku:* the one depicted (now obsolete) was played with dice and counters on a special wooden table, the other on a woodblock-printed paper diagram representing famous people, topical events, or stations of the Tokaido. Although not one of Hokkei's best, the print gives a comforting impression of warmth and coziness.

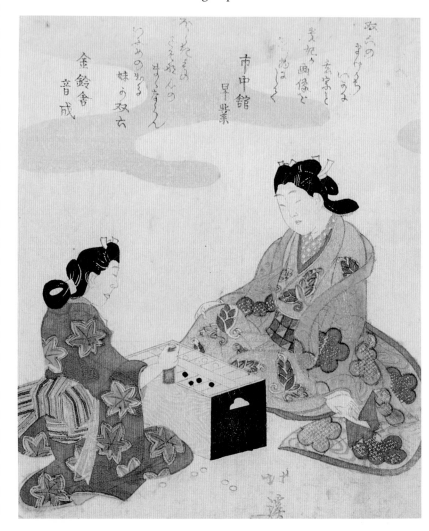

Utagawa KUNISADA 1786-1865

Tanabata Game
Tanabata asobi

Oban / Series: *Five Fashionable Festivals: Tanabata*
Signed: Kochoro Kunisada ga (Drawn by Kochoro Kunisada)
Publisher: Sanoya Rihei / Censor seal of Tanaka Heijiro (used 1843-1845)

A graceful lady ties *tanzaku* (poem cards) to the branches of a bamboo bush, while looking over her shoulder at the chubby little child helpfully holding up a gourd-shaped poem paper. Of Chinese origin, the Tanabata (Star Festival) is one of the five great festivals of Japan. Celebrated on the seventh day of the seventh month, it is the day of the Weaving Princess and the Herdsman. The Weaver (Altair) and the Herdsman (Vega) were so much in love that they neglected their duties; the gods had no clothes, the Herdsman's ox grew thin. Separated by the angry deities, they were placed on opposite sides of the River of Hades (the Milky Way).

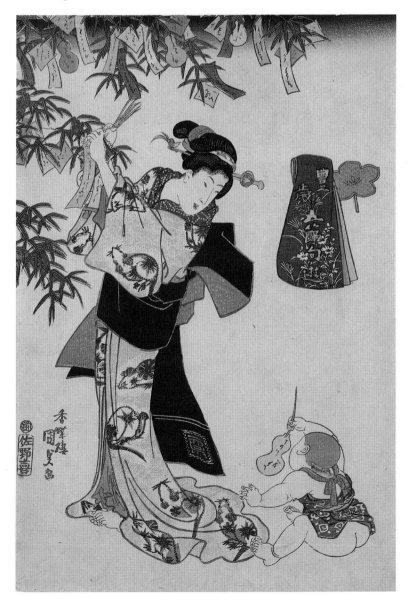

Once a year, but only if the weather is fine, all magpies must fly to heaven and form a bridge for the lovers to cross. Any magpies seen on the ground neglecting their duty are pelted with stones. Children and adults write poems in honor of the starry couple, petitioning them for attainments in weaving, needlework, and calligraphy. In *The Five Sacred Festivals of Ancient Japan*, U. A. Casal writes that the poem cards were formerly folded in two and cut in the shape of simple human figures and that they were the ancestors of the *teru-teru bozu* (fair weather doll). As sunny skies are a precondition both for the success of the Tanabata Festival and the happiness of the loving pair, he may well be right in this assumption.

Utagawa KUNISADA 1786-1865

Woman with Bullfinch
Kameido umemi

Oban / Signed: Kunisada aratame nidaime Toyokuni ga
(Drawn by Kunisada changing his name to Toyokuni II)
Censor seal: Tanaka Heijiro (used 1843-1845)

A soft blanket of snow covers the ground and the twisted branches of ancient plum trees unfold their first fragile blossoms. A well-dressed woman returns home from some festival at the beginning of the year, an occasion to admire and be admired. Suspended from sticks over her left shoulder, she carries two toys representing a tortoise and a limp, puppetlike little man, possibly alluding to the legend of Urashima Taro, the Japanese equivalent of Rip Van Winkle. Where has she been? The carved wooden bullfinch held in her right hand clearly gives her away and reveals a winter outing to the Kameido Tenjin Shrine. Kameido, an eastern suburb of Edo, is famous for its shrine and its seasonal plum and wisteria blossoms which attracted crowds of people for *hanami* (flower viewing). A festive and popular event, the sale of these luck-bringing bullfinches (*uso*) is still held on January 25.

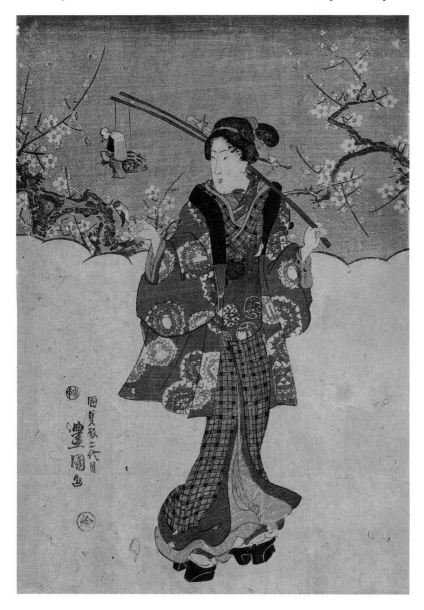

The print is perhaps a *mitate-e* (parody picture). The lady may have had an amorous rendezvous with a lover who lied to her and did not turn up, for the bird is a pun on the Japanese word *uso*, meaning "lie" as well as "bullfinch." As Kunisada spent part of his life in a house situated near the *monzen* ("before the gate") of Kameido Shrine, this particular image indicates that he keenly observed visitors to the shrine, and that minor human

dramas and comedies served as his inspiration. This old print, although in poor condition, remains a delightful picture with many fine details: the toys, the textile patterns, and the elaborate tortoiseshell hairpins, one amusingly and delicately decorated with a cat clawing at a ball.

Toys: The *uso* with curly tails are from Dazaifu, the simple one from Kameido. The bird is a potent talisman on condition that it is brought back to its shrine of origin and "exchanged" every year. The old bird is given back to be burned and a new one bought to replace it. The Bullfinch Exchange Festival (*usokae*) originated in 1820. Prizes could be won by specially marked birds.

*Some time after the death of Toyokuni I in 1825, his pupil and adopted son, Toyoshige, took the name Toyokuni II. Kunisada, the leading artist of the Utagawa studio, disputed this decision and also called himself Toyokuni II. Among the people, Toyoshige became known as Hongo Toyokuni and Kunisada as Kameido Toyokuni, after the Edo districts where they lived.

Following the death of Toyoshige in 1835, Kunisada received official permission to use the Toyokuni name from his master's family in 1844 and gave notice of the event on some prints of this period. Kunisada, however, is now universally known as Toyokuni III.

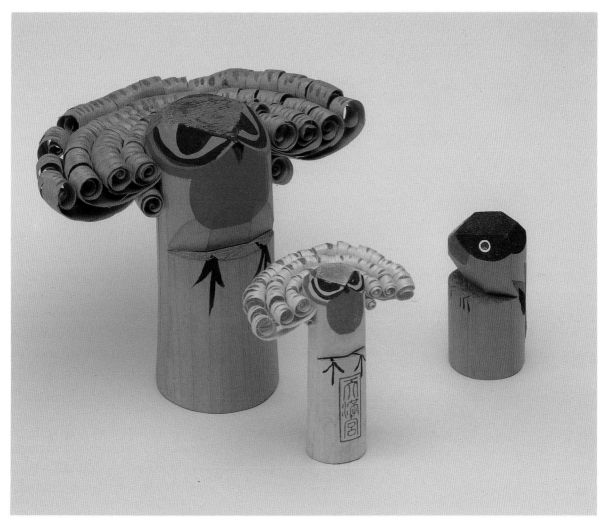

Utagawa KUNISADA 1786-1865
Woman with Kintaro Doll
Oban / Series: *Five Fashionable Festivals: Boys' Day*
Signed: Kochoro Kunisada ga (Drawn by Kochoro Kunisada) / c.1843

A stylish lady wearing a large-patterned kimono, holds up a doll miniature representing Kintaro, the boy Hercules of Japan. He playfully threatens a bear with his large axe, while Shoki, a confirmed women-hater, casts a baleful glance at the standing beauty from his partly unrolled banner.

Kunisada is generally underestimated by collectors due to his large output of prints, the largest number in the history of *ukiyo-e.** Although some are mediocre, this is a fine print which may be compared with the best. The kimono is supple and flowing, the color scheme bold and well-balanced.

Some essential attributes of Boys' Day are presented in an innovative way: the typical green textile used for the formal dais serves as background for the impromptu display, the Shoki banner is yet to be unrolled and hung up, while the large carp streamer will soon be flying from a bamboo pole in the garden. The iris, emblem of Boys' Day, decorates the draped textile cartouche in the upper left corner. We have, however, caught clever Kunisada in the (accepted) act of borrowing elements from an earlier colleague. Except for the woman, this print is not an original creation. Kunisada had undoubtedly seen the doll and background idea on a *surimono* by Katsukawa Shun'ei (1762-1819) (see *Ukiyo-e: Images of Unknown Japan*, p.151, no.190).

Kintaro, also known as Kintoki, the strong boy, was the son of Sakata Kurando, a samurai turned *ronin* (masterless), and Yaegiri, an abandoned plebeian lady. Kurando committed suicide, and the grieving Yaegiri fled to the solitude of Ashigara mountain to give birth to

her son. Some sources say she, too, took her life, and that the baby was adopted and brought up by Yama-Uba, a strange, uncouth old crone who lived in the mountains. She raised the child among the wild animals of rivers and forests, making them his only playfellows. Other sources say that Yama-Uba was another name for Yaegiri. Legend gives a more graceful role to Yama-Uba, the Old Woman of the Mountain, making her a fairy who scatters snow on mountain summits in winter and strews the first fragile blossoms in spring.

A fearless boy of herculean force, Kintaro is a popular subject for prints. Wood-block artists delight in showing him riding bears, fighting with boars, capturing giant carp, umpiring wrestling matches between animals, and shaking the wicked *tengu* (winged demons) out of the trees to use them as kites. Discovered by Watanabe no Tsuna, he became one of the four retainers of Minamoto no Yorimitsu, or Raiko, and was involved in many blood-curdling adventures with ghosts and demons. One of the favorite Boys' Day dolls because of his strength and valor, he is usually represented as a ruddy, half-clad child. He is known both as the Red Boy and the Golden Boy.

Doll: This decidedly healthy and ruddy Kintaro wears a *haragake*, a small child's dress, and a lacquered court cap, a sign of aristocratic birth. He has captured a huge carp, symbolic of Boys' Day. The carp is honored for courage and perseverance, since it dies without flinching and fights its way upstream against strong currents.

*Experts have been unable to reach a unanimous conclusion concerning the number of Kunisada's prints, and their estimates vary between 15,000 and 50,000 during a 60-year career. The latter figure would imply that Kunisada began working independently at approximately 19 years of age, producing 2.28 designs per day (including leap years) until his death. A famous artist in his heyday, he had numerous pupils and followers who undoubtedly helped to furnish many of the prints signed in his name.

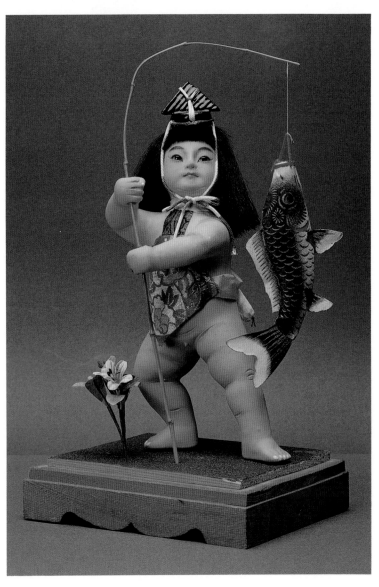

Utagawa KUNISADA 1786-1865

Nursemaid

Komori

Kakemono-e / Signed: Kochoro Kunisada ga / oju
(Drawn by Kochoro Kunisada / by request) / c.1830

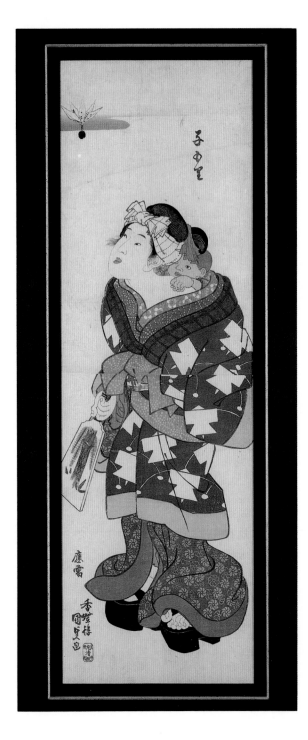

Hanging scroll pictures (*kakemono-e*) were the merchant-class equivalents of the expensive hand-painted scrolls used to decorate the *tokonoma* (picture alcove) of aristocratic dwellings. Designed to the specific order of a customer or publisher, they were rarer and more costly than current prints. While the separate parts of diptychs and triptychs were often designed to stand alone and be separated for easier sale, this was impossible with these long vertical prints which were made in two pieces and horizontally joined in the middle.

At top right is the title of the print, *Komori* (Nursemaid). Hardly more than a child herself, this nursemaid plays with a *hagoita* battledore while carrying an interested little spectator who peeps over her shoulder. Both child and baby are well protected from the cold by the thick padded coat, decorated with a bold *mamezo* balancing toy design, an almost abstract motif lending originality and movement to the whole composition. It is the New Year season, for the battledore and shuttle-cock game was only played at this time of year. Battledores were also presented to families which had celebrated the birth of a baby girl in the previous year, while a decorative lacquered *hamayumi*, a miniature quiver containing two bows and arrows, was given for a boy, as a symbolic talisman to shoot or "expel" demons.

A *komori* was usually a country girl between 12 and 16 years of age and from a poor family with too many mouths to feed. For a small sum of money, she would be hired out to a rich city merchant. Innocently happy, oblivious to the cold and the weight of the baby on her back, this enraptured child has food, warm clothes, and an exciting game to play.

Toy: The balancing toy used on the child's coat as a decorative motif was one of the most popular playthings of the Edo period. Possibly of Korean origin, it was known and sold all over Japan as Mamezo (presumably a famous acrobat and rope-walker of the Edo period) or Yajirobei. (Yajirobei and Kitahachi were the comical Don Quixote-type heroes of Jippensha Ikku's* novel *By Shank's Mare on the Tokaido* (Tokai dochu hiza-kurige). This original toy was made from various materials and was available in different versions and sizes.

* Ikku (1795-1831) kept the comical element alive even on his deathbed. His last wish was to be cremated in the clothes he was wearing when he died. Standing around the funeral pyre, his assembled mourners were suddenly treated to an astounding series of explosions from fire-crackers and fireworks concealed in his clothing!

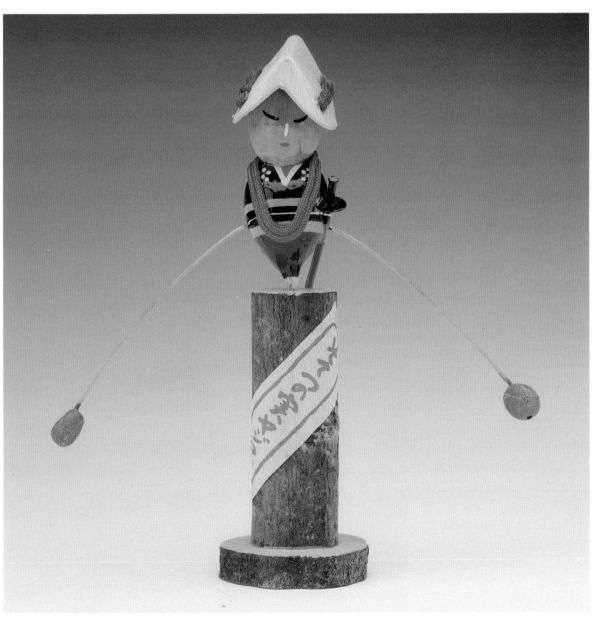

Utagawa KUNISADA 1786-1865

Flower-Viewing Month
Hanamizuki

Oban / Series: *The Twelve Months* / c.1851-1853
Signed in *toshidama* cartouche: Toyokuni ga (Drawn by Toyokuni)
Two censor seals: (L) Watanabe Shoemon, (R) Mera Taichiro

One of the series *Twelve Months* showing a richly dressed couple looking at a male *tachibina* doll. The 12 prints parody scenes from Murasaki Shikibu's classic novel, *The Tale of Genji*, and are identifiable by the incense game signs (*Genji-mon*) by which the chapters are known. As this print carries the symbol for chapter three, it suggests the third day of the third month, when the Doll Festival (Hina Matsuri) is celebrated. The title of the print is the poetic name for the third month, *hanami-zuki* (flower-viewing month or moon), and is a play on words referring to *hana mizuki* (flowering young tree), a euphemism for an adolescent. *Hana mizuki* is also the name of the flowering dogwood (Cornus florida), a fine-grained wood from which *kokeshi* dolls are made.

In the story, Genji, the Shining Prince, brings dolls and a dolls' house to Violet, the lovely young child he is keeping in his house with the intention of making her his mistress later. Violet makes *tachibina* (paper dolls) representing her hero, Genji, and herself as his wife. (The

prefix *tachi*, meaning "standing, upright," may be a risqué double entendre, as the immature maiden is hiding a smile behind her sleeve!) Many different versions of this episode exist by Kunisa-

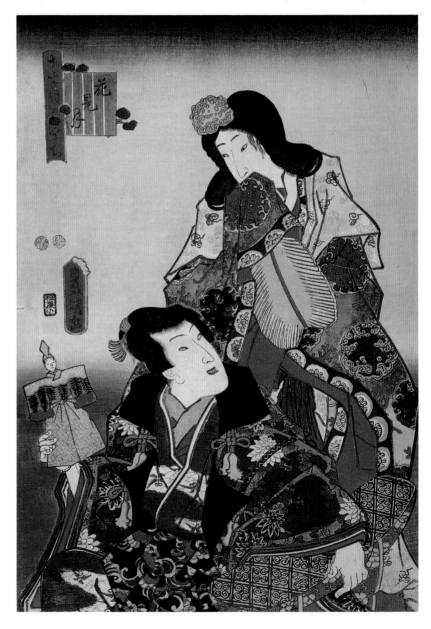

da and others, along with illustrated and adapted booklets (*gokan*) which had erotic overtones. Kunisada alone produced illustrations for 38 volumes comprising 76 parts of the series *A Counterfeit Murasaki, a Provincial Genji* (Nise Murasaki inaka Genji), a parody of *The Tale of Genji* by Ryutei Tanehiko (1783-1843), published between 1828 and 1842 by Tsuraya Kiemon. It enjoyed great popularity, because it was a thinly veiled poking of fun at the shogun of the time, Ienari, and his extensive harem. After Ryutei's death, the profitable series continued until 1857 under different names and by different publishers, still illustrated by Kunisada and his pupil Kunisada II, bringing the total number of volumes up to well over one hundred.

Dolls: *Tachibina* made of paper or textile-covered paper are among the oldest known dolls of Japan. They are linked to ancient Chinese purification rites (which, in Japan, were assimilated into Shinto practices) of rubbing a crude wooden or paper figure over one's body and then either burning it or throwing it into the sea or river to drive all evil and illness away. *Tachibina* are invariably made and sold as a male-female pair, the simplified cylindrical female doll always being considerably smaller than the imposing male with his outstretched arms. Some male dolls carry the tiny female doll in their belts. The couple have ancestral, protective, and fertility connotations. The custom of setting similar paper dolls, known as *nagashibina*, afloat is still observed in Tottori Prefecture. In 1992, *hitogata*, the oldest ancestors of the *tachibina*, were excavated at Nara. Thought to date from the seventh century, they were the first bronze figures used for exorcism purposes to be found.

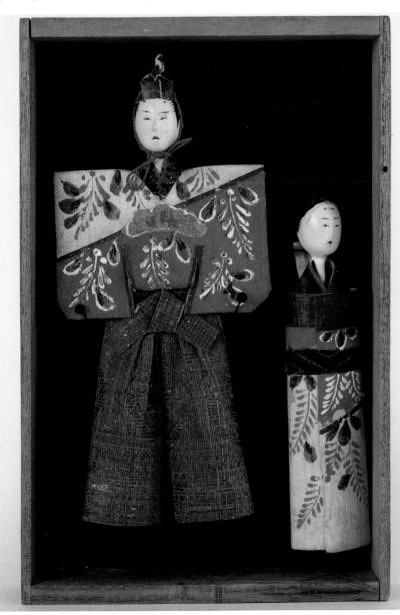

Utagawa KUNISADA 1786-1865

Umbrella Ghost

Bangasa obake

Oban / Series: *Shichi henge no uchi* (Among Seven Transformations)
Signed: Toyokuni ga (Drawn by Toyokuni)
Publisher: Ebisuya Shoshichi (Terifurichi Ebisuya)
Round *aratame* (examined) seal / Oval date seal for 1857

Two curious prints from the *Seven Transformations* series take us to the *hengemono*, spectacular dances at the kabuki theaters of Japan's great cities, in which many different characters were portrayed by the same actor. The dances were veritable tours de force, comprising up to 12 roles, both male and female. Difficulties were expressly sought; some actors even played double roles, with half of their bodies differently costumed

and a fan bearing a painted face to hold in front of their own face. Beside the richly dressed heavenly being (*tennin*) holding a bamboo-pipe mouth

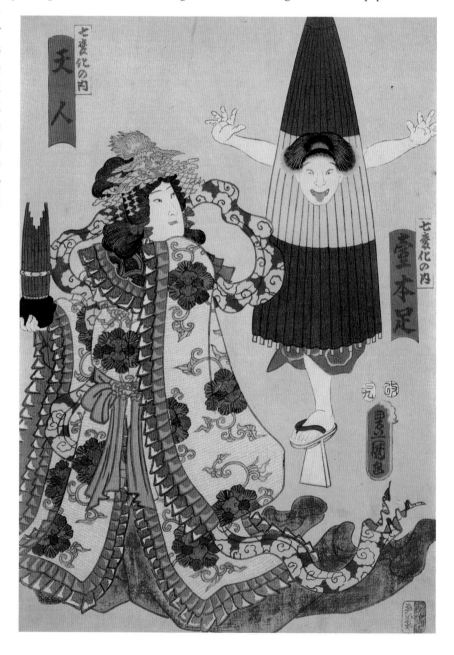

organ (*sho*), another supernatural spirit is suspended—an umbrella ghost with only one leg, waving arms, and a stuck-out tongue! The intention seemed to be to amuse rather than to frighten. This comical one-legged performance must have been extremely demanding. In Japan, even inanimate objects supposedly possessed a life of their own, so it is not strange to see drums, lanterns, tea-kettles, and umbrellas depicted as phantoms with good or bad intentions. A few versatile impersonators, such as Ichikawa Kodanji and Nakamura Utaemon III of Osaka, were famous for extraordinary acrobatic acts and quick changes of costume.

Toys: Still sold today, the *bangasa obake* (*below left*), the umbrella ghost or one-legged doll, is an amusing toy souvenir of Saitama Prefecture. Made of papier-mâché, it has a mobile head mounted on a wire, which bobs in all directions when the toy is hung up in a slight breeze.

The idea of an inanimate object being alive or playing ghost can sometimes be found in the comical little Kobe toys. Exemplifying this idea, the phantom drum (*below right*) has pop-out eyes on ivory pegs. He indubitably does not enjoy being beaten by the percussionist!

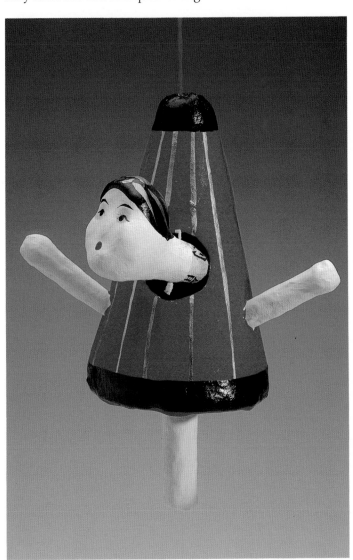

The second print shows a *sanbaso* dancer, who appeased the gods by his dance at the beginning of a new year. He also introduced the start of a new kabuki season, so that the gods would be favorable and bring good fortune to the actors. His impressive costume shows crane feathers and pine branches, symbolic of luck and longevity. These two prints prove that startling effects and pure playfulness were often included in the kabuki repertory.

The sitting boy holding a plate of tofu (bean curd) has many toys on his clothes: a papier-mâché Azuma (a poetic name for Edo) dog, a pinwheel, a cluster of bells, a thread ball, a bat-

tledore and shuttlecock, a *tai*-fish cart, and a hand-drum. All these toys had a significant role in the life of a child as protectors against illness, accidents, and evil spirits, as well as bringers of luck and prosperity for the future. They made popular kimono motifs for children, young girls, and traveling entertainers, an instance of ancient protective symbols surviving in the form of design motifs.

Textile: This sleeve of a young girl's red silk kimono shows many different toys. The red of the background and the *tai*-fish cart protects against evil; the treasure boat filled with precious things promises wealth; while the cranes (real and paper ones) symbolize longevity. The *daruma* toys are an encouragement always to try again despite adversity, while the Azuma dog is a fierce and faithful guardian of youth.

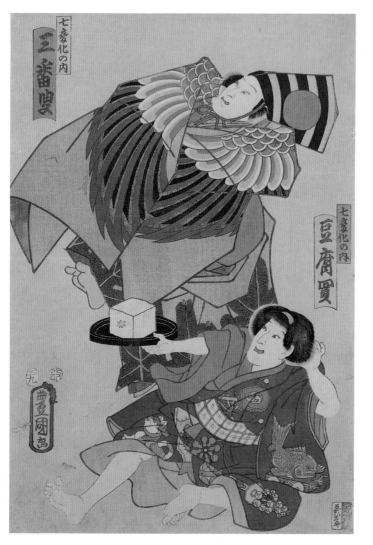

Utagawa KUNISADA 1786-1865

Woman with Sumo Doll

Sumo ningyo

Oban / Signed: Kunisada aratame nidai Toyokuni ga / oju
(Drawn by Kunisada changing his name to Toyokuni II / By request)
c.1844 / Seal: censor's *aratame* (examined) seal Mura Heiemon
Courtesy of the Ethnographic Museum, Antwerp, Belgium

An unusual print showing a beautiful lady holding a stick puppet in the form of a sumo wrestler. The title in the circle reads "sumo dolls and flowers (courtesans) matched." The famous heavy-weight wrestlers of the Edo epoch, having money to spend, frequently visited the fashionable ladies of the red-light district. In return, the courtesans, who were enthusiastic sumo fans and supporters, were not above placing a sporting wager on their favorites. In this complete series, the women were possibly well-known rivals in beauty and their particular art, as the real-life wrestlers who inspired

the puppets they are holding, rivaled each other in sport and strength. A print by Shunko (1743-1812) mirrors the mentality of the time, depicting the three most popular idols of Edo as a courtesan, a sumo wrestler, and a kabuki actor, respectively Kasen of the house Ogi-ya; Tanikaze, who was a *yokozuna*, the highest rank in sumo; and Ichikawa Ebizo of the celebrated Danjuro family.

Toy: An amusing game in which tops disguised as sumo wrestlers jostle each other out of a wooden ring.

Utagawa TOYOKUNI Ⅲ 1786-1865
Utagawa HIROSHIGE 1797-1858
Kawanabe KYOSAI 1831-1889

Famous Products of Edo
Edo no meisho

Oban / Harimaze-e / Round *aratame* (examined) seal

As in the painting ateliers of Europe, it was not uncommon for artists to cooperate when designing prints, with one drawing the background landscape, while the other drew the personages, as in a *Genji* parody series for which Hiroshige drew the landscapes and Kunisada the figures, producing a harmonious duet. It was also possible that a famous artist permitted a pupil to draw the small cartouche, which often acted as a counterpoint to the main design, or to sign a scroll or screen serving as decorative detail on a print. Kuniyoshi let his daughter Acho design (and sign with her *go* or art name, Yoshitori-jo) the small landscape insets in his famous series *Qualities of Seas and Mountains*.

A *harimaze-e*, however, is a collection of pictures by one or more artists, assembling two or more different subjects on the same sheet. This *Famous Prod-*

ucts of Edo series reflects kabuki actors, landmarks, and typical products of Edo. Toyokuni Ⅲ specialized in portraits, and here he gives a humorous rendition of the actor Sawamura Sojuro Ⅲ (1753-

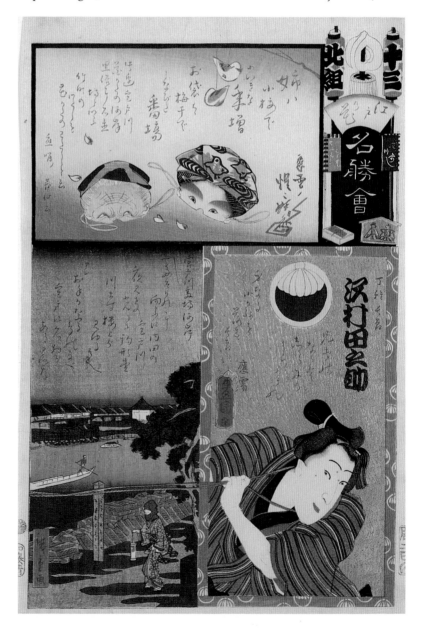

1801), who is engaged in a game of *kubi-hiki* with an invisible adversary, perhaps a rival actor, the cord around his neck leading out of the picture to the left. *Kubi-hiki* was a game of strength—the two players sat cross-legged on the ground, joined by a looped cord around the neck, and tried to drag each other off balance by pulling with the neck only. The top print by Kyosai shows two small toy birds attached to sticks, a stylized toy thunderbolt, and two paper half-masks with very lifelike expressions, trinkets from a shrine festival. Kyosai, a pupil of Kuniyoshi, was known for his original and humorous book illustrations. However, his caustic caricatures did not escape the eye of vigilant censors, and Kyosai was thrice imprisoned during the last years of the Shogunate, and even in the more tolerant climate of the Meiji Restoration, the incorrigible critic was once more jailed for lampooning the emperor. The evening view of Edo is by Hiroshige.

新版大和錦繪

Toy: These cut-out masks were immensely popular with children and were a feature of every fair and festival. They were also sold at toy and *ukiyo-e* shops, as well as by itinerant toysellers.

The masks were fun to cut out, fun to wear, and allowed children to change character when playing games. They could be young or old, hero or bandit, beautiful courtesan or famous kabuki actor—a whole world of make-believe for a tiny coin. What more could a child wish?

Dance of the Spring Pony
Haru-goma shosa

Oban / Signed: Eisen ga (Drawn by Eisen) / Publisher: Izumiya Ichibei

A bold and dynamic print in both color and composition, it shows two children vigorously dancing, holding horses' heads on sticks. This popular street and indoor amusement has often been depicted in prints of the Edo period. It was performed in the famous kabuki play *Furisode kisaragi Soga*, in which the Soga brothers, Juro and Goro, are the interpreters of the Dance of the Spring Pony (*haru-goma shosa*). It was also a feature of the Niwaka Festival, a costumed carnival held in the Yoshiwara, the brothel district of Edo, in the eighth month. Male and female prostitutes, the courtesans of different houses and their young apprentices all dressed up in extravagant costumes, with women disguised as men. Flat wheeled floats with performers dancing, singing, and playing musical instruments were pulled along the streets. The Dance of the Spring Pony is characterized by the green-and-white striped clothes and headscarves. The cherry blossom pattern relates to a song, which says that if you tie a horse to a flowering cherry tree, it pulls and makes the petals fall.

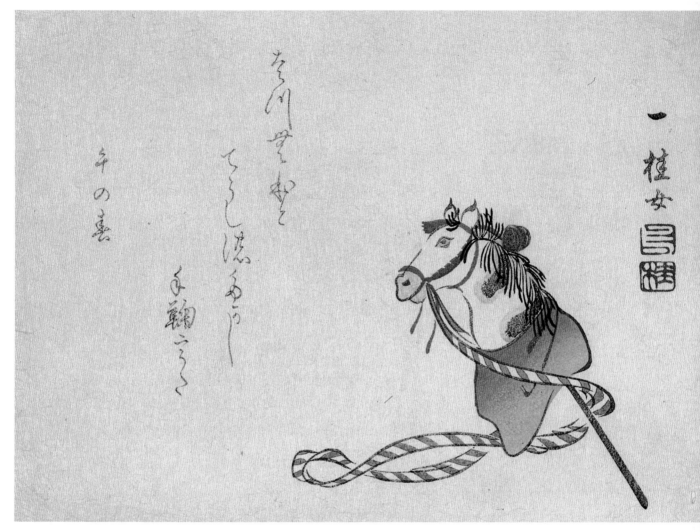

Toy: A *surimono* by the female artist Ikkeijo. Horses' heads are seen in prints in three versions: as toys, hand puppets, or on short sticks. The hobbyhorse has a long stick, with or without a small wheel. All kinds may be considered as toys but they can also be used as dancing accessories, complete with bridle and bells.

Hosoda EISHO Fl. 1780-1800

Hinazuru of the Choji-ya

Oban / Series: *Kakuchi bijin kurabe* (Beauties of the Pleasure Quarter)
Signed: Eisho ga (Drawn by Eisho) / Publisher: Yamaguchiya Chusuke
c.1796 / Contemporary copy

Not much is known of Eisho, one of Eishi's best pupils. Both men were visibly influenced by the work of Utamaro and produced prints of great refinement. Eisho, who in some respects was even better than his master, continued the *okubi-e* (large-head print) tradition in his series of famous courtesans.

A favorite *bijin* subject of many artists, the celebrated courtesan Hinazuru of the house Choji-ya is holding a doll (*hina*), an allusion to her name, making her immediately recognizable to connoisseurs. In De Becker's *Nightless City,* this lady is mentioned as follows: "During the Meiwa era (1764-1771) a woman named Hina-dzuru, belonging to the Choyi-ya, used a pile of five *futon* made of silk brocade, but this was quite unprecedented." Even the most expensive courtesans used only (!) three *futon* mattresses, while the lowest prostitutes walked the streets with a rolled-up rush mat, so five *futon* were certainly a sign of Hinazuru's popularity and

wealthy patrons, as well as a guarantee that her customers would be comfortable. *Tsumi yagu* (heaped bedding) was an Edo-period custom that lasted until the Meiji era. A courtesan's luxurious

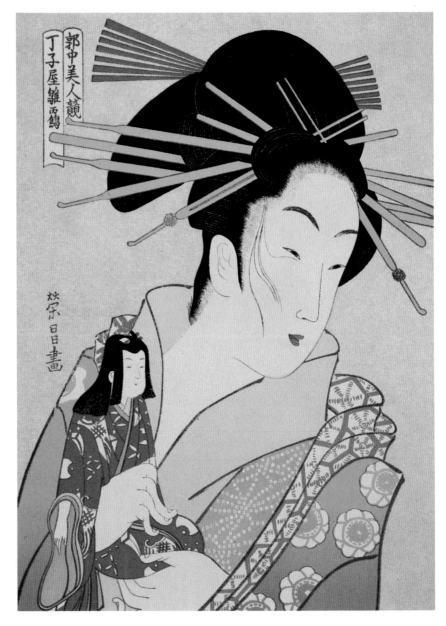

bedding was publicly displayed to impress the populace and to advertise the lady's standing. The well-dressed doll is indubitably a status symbol, an expensive present from a rich admirer, and seems to be either of the *ichimatsu* or wooden *mitsuore* (triple-jointed) type. The latter is jointed at hips, knees, and ankles, making it possible to give the doll many poses. The head can be turned and the arms are attached at the shoulders with cloth, making the doll easy to dress.

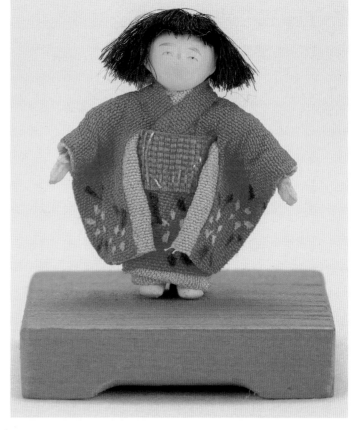

Dolls: A clothed *keshi* doll (*right*). In Japanese toy terms, miniature dolls of all kinds are generally known as *keshi* (poppy-seed dolls).

This is a very special little *ichimatsu* or *mitsuore* doll (*below*) in terms of size (5 cm high) and material (ivory). Its size leads to a diminutive, *ichima*, and a contraction, *mimatsu*, of the two names. This example has three tufts of implanted black hair on the immobile head; the eyes are painted black, the mouth red. The parts of the arms between hands and shoulders are pieces of tex-

tured silk textile. The hips are fixed on a metal pin, and the knees are ingeniously carved and jointed at the back, permitting considerable movement of the legs. It is possible that the head and ankles were once mobile but have now been repaired in a fixed position. Too fragile for play, such a doll would be made as a curio and was sometimes transformed into a fanciful *net-suke* by the addition of two cord holes. Some examples can still be found at the Tekiho Nishizawa Memorial Doll Museum, Saitama Prefecture.

Courtesy of Kunsthandel Klefisch, Cologne, Germany and Prince and Princess Takamado, Tokyo, Japan respectively

Keisai EISEN 1790-1848

Playing in Water
Mizu asobi

Oban / Aizuri-e (blue picture) / Signed: Eisen ga
(Drawn by Eisen) / Part of a triptych

What is more cooling than wallowing in water in the sun's heat? Three happy little boys in varying stages of undress are spending a warm summer day splashing in a shallow stream. A young mother has come to watch and guard the turbulent trio, while the tiny tot she carries on her back peeks over her shoulder with inquisitive eyes. One child, looking both excited and frightened, lies on his back in an improvised boat made from a wooden tub. The two others triumphantly show their captured treasures, a tortoise and some small fish. The unhappy tortoise was usually tied up with a string harness and walked about, like a dog on a leash. To buy and release captured tortoises was considered an act of merit for future

life. The live, string-tied tortoise finds its counterpart in a typical toy from Ise: a red tortoise with a hidden spool and thread mechanism, making it run short distances when the thread is pulled and allowed to rewind.

As one-color pictures are contrary to the accepted idea of *nishiki-e* (multicolored woodblock prints), the blue *aizuri-e* are something of a rarity. Starting in 1829, Eisen became a most prolific producer of them, and he is credited with the first use of *berorin*, the newly imported Prussian blue, for his monochrome prints of contemporary beauties. Eisen was a landscape artist of great power, on an equal level with the best, and his landscapes are a highly regarded part of his oeuvre. Yet his *surimono* and blue pictures also deserve a special mention, since they stopped him from making those multicolor prints of "evilly over-dressed courtesans," in the words of Jack Hillier.

Blue pictures were also printed in response to the notorious Tempo Reforms of the 1840s, a repetition of the Kansei Reforms of 1790, which forbade portraits of actors and courtesans and the sale of *nishiki-e* with their numerous brilliant colors. A century before, during the reign of the Tokugawa shogun Yoshimune, dollmakers had, by another interesting (!) edict of 1741, been forbidden to make dolls larger than 20 centimeters. Needless to say, in all cases, the sumptuary laws were circumvented in various ways, with clever artists designing prints in as many as five different shades of blue, and wise dollmakers making miniatures in costly materials. As the Tempo era lasted from 1830 to 1844, many blue pictures may be dated to that period.

Utagawa HIROKAGE Fl. c. 1855-1865

Snow Daruma and Dog

Oban / Series: *Edo meisho doke zukushi* (Famous Places of Edo with
Comical Scenes) / Signed: Hirokage ga (Drawn by Hirokage)
Publisher: Tsujiokaya Bunsuke / Dated: Ansei 6 (1859)

Not much is known of this artist, whose greatest claim to fame lies in the fact that he was a pupil of Hiroshige. In this series he follows his master's example, the *Hundred Famous Views of Edo*, but gives his version a personal and humorous touch. An amusing snow scene shows a man stooping to adjust his *geta* strap. He has placed a bundle of leeks and a large fish on the rounded stomach of the *daruma*-shaped snowman, while a hungry dog is sniffing at the succulent food with the firm intention of stealing and making off with it, under the eyes of the sympathizing snowman.

Making snowmen and rolling giant snowballs are wintry themes often found in woodblock prints. These pastimes, known all over those parts of the world visited by a white winter, were indulged in by both adults and children. In Japan, *yuki daruma* (snow *daruma*) is the equivalent of our snowman; sculpted snow images of lucky dogs, frogs, and rabbits were other favorites. The tradition continues in present-day Sapporo, Hokkaido, where during the Winter Festival, unbelievably beautiful and complicated sculptures are constructed from ephemeral snow.

Netsuke: A moment of motion and mischief is well carved into this witty little *netsuke*. A snow *daruma* is being pushed over by a laughing child. Judging by his helpless and unhappy expression, this is not to the liking of the fat figure! Ivory with black-stained details for the child's clothes. Signed Masahiro (Fl. 1801-1868).

Courtesy of Kunsthandel Klefisch, Cologne, Germany

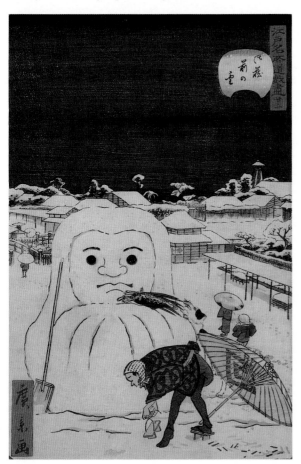

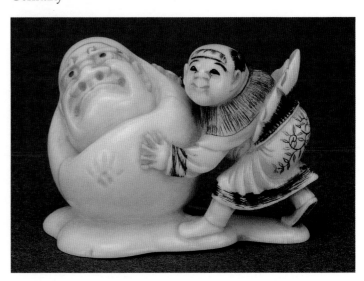

Utagawa KUNIYOSHI 1797-1861

Bubbles, Bubbles!

Tamaya, tamaya

Chuban / *Kingyo tsukushi* (Goldfish series) / Signed: Ichiyusai Kuniyoshi giga
(Drawn for fun by Ichiyusai Kuniyoshi) / Seal: Ichiyusai / Publisher: Murata
c.1830 / Courtesy of Tokyo National Museum

Soapberries, the fruit of the *mokuran* tree (Sapindaceae family), had to be soaked in water for bubble blowing. *Tamaya tamaya* (Bubbles bubbles!) is the name of this print, part of a surprising series showing aquatic creatures in everyday human roles, at work and at play. The vendor-goldfish, standing on its tail is blowing soap bubbles under water, an astonishing activity judging by the attentive audience, consisting of a turtle (a skeptical old woman?), two small goldfishes (some wide-eyed children?), and a frog (a naïve bystander?). Although Kuniyoshi was famous for his tormented battle scenes, he, more than any other, can be considered

as the prime surrealist among woodblock artists. He designed many fantastic prints in which animals of legend and history are substituted for human beings in daily occupations as well as in ghostly activities. He was obsessed by cats and used them in his prints whenever possible. If one looks closely at the bizarre skull patterns on a coat, they suddenly appear as cats in various positions, while *There! I fooled you!* is another of Kuniyoshi's titles. His originality, daring, and delirious fantasy are apparent in his graffiti (*Scribblings on a Storehouse Wall* series), caricatures, satirical prints of mythical beings; facial features in the shape of the 12 zodiac animals; strange tortoises with actors' heads; and portraits with heads and hands composed of nude bodies. One of these has the extraordinary title *Although he looks frightening, he is really very friendly* — a far cry from conventional titles. For all these fascinating inventions and for "drawing for fun," Kuniyoshi is hereby declared an artist whose work was play and who never lost the child within, in spite of all those bloody battles. (After all, he had to earn a living!)

Toy print: A children's print (*omocha-e*) showing different itinerant toysellers.

Utagawa KUNIYOSHI 1797-1861

Mother and Child with Toys

Oban / Series: *Tatoe-gusa oshie hayabiki* (Instructive Reference to Many Proverbs)
Signed: Ichiyusai Kuniyoshi ga (Drawn by Ichiyusai Kuniyoshi)
Publisher: Aritaya Kiyoemon / Censor seal of Takano Shinemon / 1842

A young mother sits on the ground and is about to nurse her child. The child, abandoning its toys, is suddenly more interested in food than in play. It is an interesting print, which gives some idea of the popular knick-knacks and playthings of the time through the selection spread over the ground. The top and string, drum, miniature wooden bucket, cup and ball game, and the small bow with a fish (*pin-pin sakana*) which travels up, down, and round a stretched bowstring are all typical boys' toys.

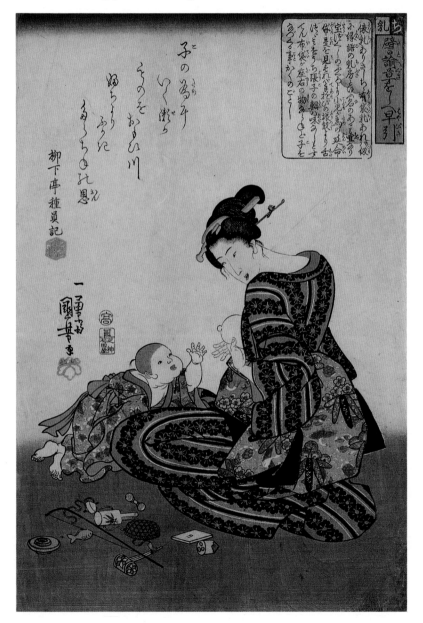

Made in the Tempo era (1830-1844), when it was forbidden to make *shunga* albums (poetically called "pictures of spring," they showed lovers engaged in explicit sexual activities) and prints showing kabuki actors and the beauties of the Yoshiwara, it is also a good example of a picture with erotic connotations. This was termed an *abuna-e*, literally a "dangerous, risqué picture," as the breasts and particularly the exposed nape of the neck were thought to be extremely provocative. Instead of daring depictions of courtesans, the print designers switched to innocent young mothers with bared breasts or taking their bath, which was their way of getting round the ban.

As Kunisada had earlier proclaimed himself the unofficial head of the Utagawa school, Kuniyoshi, who was also a leading artist of the

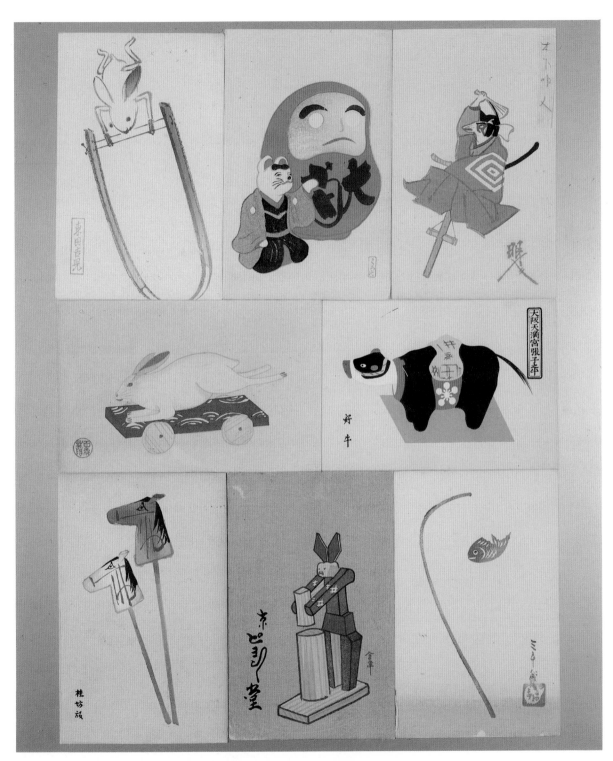

school, ceased using the *toshidama* studio seal and substituted a personal *kiri* seal instead, as can be seen in this print.

Toys: The New Year cards (*nengajo*) show typical and inexpensive toys of the Meiji and Taisho eras (1868-1926) and the pre-war Showa period.

Ando or Utagawa HIROSHIGE 1797-1858
Kite Flying at Fukuroi
Oban / *Vertical Tokaido Series: Fukuroi*
Round (*aratame*) examined seal and oval date seal, 7th month 1855
Publisher: Tsutaya Kichizo / Meiji edition

Of all Hiroshige's prints, none are better known than those of his *Tokaido* series, a collection of some of the finest landscapes in the history of woodblock printing. In 1832, he accompanied a group taking a gift horse from the Shogun to the Emperor in Kyoto. For all time, for all people, he sketched and recorded the wonders of his homeland in their elemental simplicity and splendor. His views of sea, land, and mountains, and their changing aspects under sun, snow, or rain have seldom been equalled or rendered with so profound a feeling for the quintessence of nature. In some of his prints, diagonal kite-lines anchor man to the earth, while linking him also to the sky.

This sober print is from a late edition of Hiroshige's *Vertical Tokaido Series* with the original date seals. The print has binding holes in the right margin and comes from a book of the complete series. About a day's travel apart, there were 53 established resting places along the Tokaido, the highway between Edo, the shogunal capital, and Kyoto, the imperial capital. Tokaido series usually consisted of 55 prints, for Nihonbashi, the starting point in Edo, and Sanjo-Ohashi, the arrival point in Kyoto, were often included. Fukuroi is the 27th station, not including Nihonbashi. This is Fukuroi in the rice-planting season, and while two travelers pass on the road, two kites are flying above the workers in a lightly tinted sky. It was customary to fly kites at planting time,

not only as a game, but to entreat the gods in the sky for good weather and an abundant crop, and again at the gathering season in gratitude for a bountiful harvest. The kite in the upper left corner represents a crane, a symbol of luck and longevity. As shown here, adults also flew kites as a hobby, and the Shogunate issued interdictions against this pastime, saying that "the farmers should not

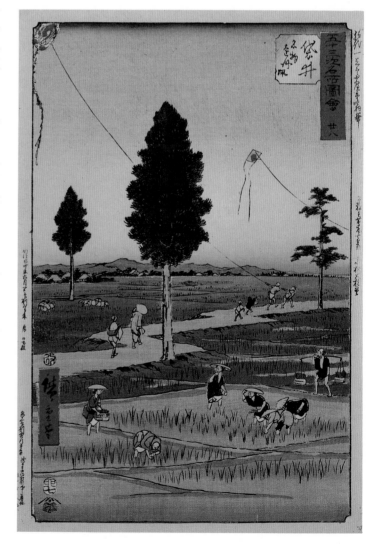

waste time from their work with kite flying." In his *Thirty-Six Views of the Eastern Capital*, Hiroshige used the kite-flying motif for the scene at Atagoyama, and again in his *Hundred Famous Views of Edo* for the Kasumigaseki picture, showing that the game was as popular in the towns as in the villages. Perhaps he felt he had not yet drawn enough lovely sights, as Hiroshige's valiant farewell verse to the world says:

"Leaving my brushes behind in Edo,
I start upon a new journey:
I go to sightsee
All the splendid views in paradise."

Toys: Two striking hand-painted kites, showing the popular heroes Yoshitsune in battle armor (*right*) and Momotaro with a peach on his forehead (*below*). The rectangular kite, made by Hashimoto Teizo, is from Tokyo; the ten-sided kite is a model from Wakayama Prefecture.

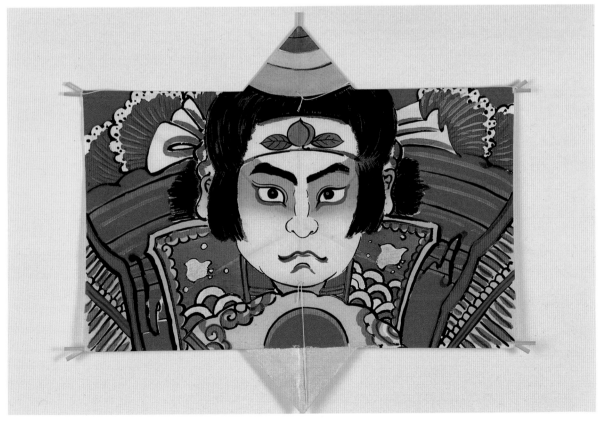

Two Fan Prints
Koban / Signed: Zeshin and seal

Although Zeshin is primarily known as a superlative painter and lacquerer, the presumed inventor of rare "lacquer" paintings also deigned to design woodblock prints, many genially imitating sketchy and spontaneous Shijo-style paintings. He often used folk toy motifs on lacquered objects, adding originality through close-up detail or unusual perspective. Of the splendid set of twelve lacquered *inro* (tiny medicine cases worn as an accessory) in London's Victoria and Albert Museum, the one for the first month is in the shape of a top; a golden shell game box represents the third month; and the simple color-on-black decoration for the fifth month consists of a toy sword and darts.

These two so-called fan prints could, of course, be mounted on the rigid, one-leaf *uchiwa* fan, but happily, some were conserved by collectors to be made into albums. Zeshin's art ranged from sheer sophistication to utter simplicity. Here, with skill and verve, he depicts the playthings of the time, friends from his own boyhood days, a happy and lavish treasury of popular and inexpensive toys that must have been loved and coveted by small children every-

where in Japan. Drums; rattles; pinwheels; tiny buckets; clay figurines; clay and bamboo whistles; somersaulting rabbits; singing birds; butterflies on sticks; floppy string marionettes; headman, hunter, and fox playing *ken*—all are featured, even two ingenious, though cruel, mobile toys consisting of two tiny toy animals glued to the backs of live insects whose legs provided the movement for their fragile mounts. Illuminating these prints is the color red. Symbolic of joy and life, it is believed to protect children from illness and evil spirits.

Toys: Three ingenious bamboo bird whistles (*above right*) with the added attraction of moving parts; the eyes, beaks, wings, and pinwheel are activated when blown.

Children who had to do their calligraphy exercises would not be inclined to look favorably on a writing box, but such a beautiful one as this (*below right*) would surely facilitate the task. It is small and must have been made for a very privileged child indeed. Decorated in Zeshin style, it features the 12 animals of the Oriental zodiac in the form of popular toys. We can see the zodiacal cycle starting with the rat, followed by the ox, tiger, hare, dragon, snake, horse, goat, monkey, rooster, dog, and, finally, the boar. The background is in matt dark green lacquer, the toys in slightly raised gold and colored lacquer. The inside of the lid also hides various playthings, and the superb

miniature water-dropper is shaped like two thread balls.

Courtesy of Kyoto Gallery, Brussels, Belgium

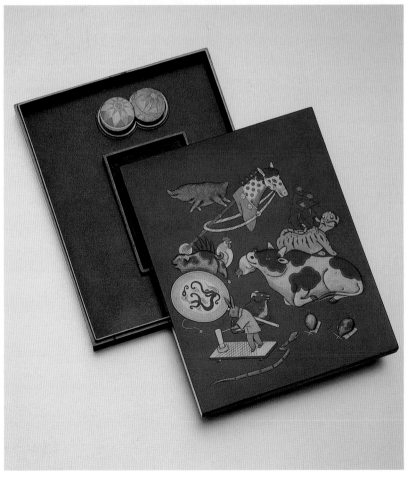

Daruma and Top
Pyrographed picture (*yaki-e*) / Beige *danshi* paper 27cm X 29cm / c.1855

Is this a print, a painting, or a drawing? At first glance, this is a browned ink picture of a rustic subject, the simple lines and subtle shading hiding the consummate artistry which created it. Made using an unusual and rare technique, it is actually a "burned picture." Few existed, and even fewer old examples survive, and this is the only example I have seen. A *daruma* toy and a top and cord are simply outlined with a heated metal stylus on thick *danshi* paper. Pyrogravure is a delicate process which requires the wholehearted attention and dexterity of ink painting, as the drawing must be executed rapidly, and no correction is possible. Because the instrument changes temperature, lines and dark areas must be done when it is hottest, and shading as it cools down. An additional difficulty lies in regulating the pressure so that the paper will not be burned through.

Daruma, the Indian monk who came to China in AD 520, was the founder of the Ch'an (Zen) sect of Buddhism. Many playful portraits exist in male and female versions and in materials ranging from silver to clay. His image in the form of myriad papier-mâché roly-poly toys, which grant wishes and always return to the upright position, are, without the shadow of a doubt, the most popular playthings in Japan.

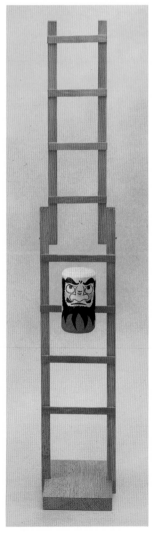

Toy: This *daruma* toy tumbles from top to bottom of the rungs of a ladder. The figure has slits on top and underneath; the distance between the rungs is calculated to the size of the toy, so that it cannot fall off the ladder but descends instead, turning at each rung. Needless to say, the *daruma* is still upright when he reaches the ground, honoring his familiar name, "the little-monk-who-always-rises" (*okia-gari-koboshi*). A double version of this toy also exists, with the two champions racing each other to the ground.

Kaishunsai ANSEN (Kano Takanobu) 1809-1892

Bow and Arrow

Yumi to ya

Shikishiban

Ansen served as court painter (*goyo eshi*) for the Tokugawa Shogunate. This lively picture in the style of the Shijo school of Kyoto, an offshoot of the Kano school, is a good example of another print and painting studio which sought new means of expression. Many artists and amateurs learnt to paint following the example of the Chinese literati (*bunjin*), using Chinese albums and manuals but succeeding only in making copies of copies.

This dynamic print transcends the Kano rules and follows the precepts of Maruyama Okyo, the master of the Shijo school: sketch from nature, eliminate superfluous details, and suggest the mood and movement of a fleeting instant. Three children are playing while running; two with bows and arrows are shooting at a straw-woven target rolling over the ground, while the other plays horse with a bamboo branch and a piece of string. In Japan, riding a hobbyhorse is called *take-uma* (bamboo horse), so there is a pun on the name and the bamboo (*take*) branch. While walking on stilts is also commonly known as *take-uma*, it also goes by the more apt name of *sagi-ashi* (heron legs).

Toy: Two well-made miniature bows and an arrow, the bows embellished with lacquer and brocade. They might be exhibited on Boys' Day or used as playthings, although the needle-sharp tip of the flat arrowhead would make it a dangerous toy.

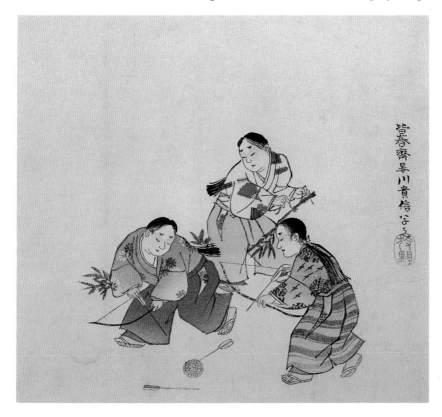

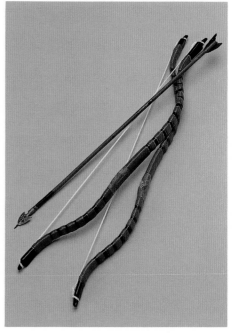

Utagawa YOSHIFUJI 1828-1887

Cut-Out Pictures

Omocha-e

Miniature representations of paper toys / 1910 reprint

A pupil of Kuniyoshi, Yoshifuji specialized in warrior prints and pictures of toys (*omocha-e*). He designed and illustrated numerous children's books, this unusual activity for a print artist earning him the nickname of Omocha Yoshifuji. These *omocha-e*, or *kodomo ukiyo-e* (children's pictures), are generally ignored in books about Japanese woodblock prints, not surprisingly seeing the poor quality, garish colors, and slapdash off-register printing of most. Although made for the masses, cheap and plentiful, they are, however, precious documentation of the games and festivals of the time. Not many have survived, as most were cutouts to be assembled and probably thrown away after play. These printed sheets were the poor child's playthings and, like the expensive dolls of the higher classes, they filled a didactic purpose, showing the heroes of history and legend. But

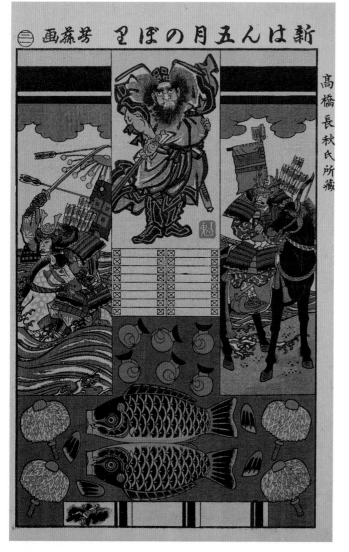

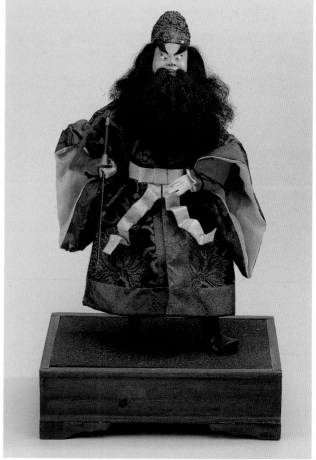

some were just for fun, like the comic faces onto which the features had to be placed while blind-folded, a Japanese version of pinning the tail on the donkey. In the Meiji period, the prints were usually lithographed, a cheaper and quicker process which gave a neater outline than wood-block printing.

The two prints shown here are to be cut out and assembled for Boys' Day. The print below is a cut-out suit of samurai armor and its container (made using a photocopy, it works wonderfully well). The cut-out on the facing page represents Shoki the Demon Queller, a *koi-nobori* (carp streamer), and two larger banners with the popu-lar samurai heroes who raced each other across the Uji river to be the first to meet the enemy forces, Kajiwara Kagesue on the black horse and Sasaki Takatsuna on the white one. All figures and objects have symbolic value: Shoki vanquishes evil in the form of swarms of *oni*, wicked little devils often depicted teasing him; the carp courageously swims upstream, thus struggling against adversi-ty; and the samurai represent a dauntless fighting spirit.

Dolls: A Shoki doll (*facing*) and miniature armor (*below*), both for exhibition on Boys' Day. The rich costume, flat sword, bushy black hair, and beard show that Shoki the Demon Queller is of Chinese origin. He was a a student who had committed suicide on failing his state examina-tions. His restless spirit is said to have appeared to the sick Emperor Genso, chasing away the demons causing his illness. Thereupon the emperor rehabilitated him, causing him to be buried with great pomp. The grateful Shoki promised to free the country of all evil spirits.

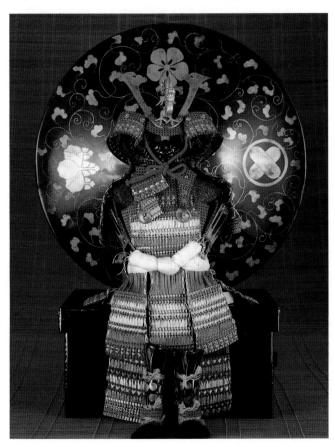

Utagawa SADATORA Fl. c. 1825

Portrayal of Children Today

Oban / Signed Sadatora ga (Drawn by Sadatora)
Round *kiwame* (approved) seal / Publisher: Iseya Rihei

Although a pupil of Kunisada and thus a member of the Utagawa school, Sadatora worked in Osaka, where he was best known for his beautiful women and flower-and-bird prints. This print shows children imitating actors playing famous characters from the popular Soga brothers cycle, a historical tale of the revenge of two young brothers, Juro and Goro, for the murder of their father. Their attempt was successful but cost them their lives. The print is evidently a parody of the scene where Goro, thinking his brother in danger, wants to don his armor and, impeded by Asahina, holds it above his head. Or, in a reversal of roles, is this perhaps an elder brother trying to stop the younger going out to play with kites? The disappointed expression of the sitting lad and the threatening wickerwork bird cage indicates that the standing boy will stop all the birds from flying away.

The picture has an uncommon color combination and is built up in an unusual and dramatic triangular form against an empty background. The standing figure is one of the brothers, Goro, recognizable by the butterfly motif on his clothes; he also has the three concentric rice measures on his costume, the emblem of the great Danjuro line of actors. The crane motif is that of the actor Bando Hikosaburo, but also that of the kneeling strong man, Asahina Saburo; the small hat, long sword, and crane motif are proper to his character. That he is holding two kites bearing his emblem seems enigmatic here, but prints showing this Japanese Hercules flying a man as a kite do exist, so perhaps there is allusion to the true story of an adventurous airborne thief, Kakinoki Kinsuke, who in 1712 tried to steal two solid gold fish from the roof of Nagoya Castle by attaching himself to a giant kite. It seems he harvested several gold scales and got himself boiled in oil for his pains. Kite history also says that, as predecessors of satellites, small men were tied to large kites to spy on enemy camps from the sky.

At the top of this remarkable print, a faintly embossed cherry flower pattern expresses both the tragi-comedy and transience of life, specifically in the case of the two young Soga brothers.

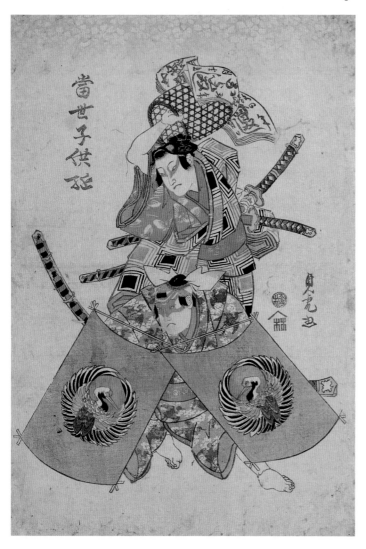

Ichiyusai KUNITERU Fl. mid-19th century

Child with Mask and Toy
Omen

Oban / Signed: Ichiyusai Kuniteru / Two censors' seals: Yoshimura and
Muramatsu (used 1840-1853)

A young girl and an energetic small boy wearing a tiger mask attend a local festival. The boy brandishes an unusual toy attached to a stick; it is a dangling stirruplike platform with seated figures, perhaps a papier-mâché mobile. The print is a *mitate-e* (parody picture), alluding to the legend of a courageous cat killed while defending its mistress against a giant rat, here possibly the play-role of the boy and the subject of the toy.

Saikaku's novel *Five Women Who Loved Love* mentions the traditional spring game in which women and children drew strings for prizes. Are the boy's toy and mask such prizes? The girl car-

ries a bundle of thick threads in her hands. Such sections of twisted paper were used on pilgrimages by those who had vowed to mount and descend the steps of a temple or shrine a certain number of times while praying. The strings were meant to keep count of the upward and downward trips and of the promised prayers. As this is a parody picture, perhaps the winsome lady is keeping count of her lovers or invoking the gods of the Izumo Shrine to tie a fitting marriage knot.

There were four artists named Kuniteru, all pupils of Kunisada, three of whom used the *go* Ichiyusai, so it is nearly impossible to ascribe prints with certainty. In spite of the many namesakes, "Kuniteru" was not a prolific artist but he seems to have possessed an original bent of mind. As decorative motifs, he has placed many seals and names on the banners in the top left corner, among others, the *toshidama* seal of the

Utagawa school to which he belonged. Also noteworthy is the rendering of movement: the banners curve in the breeze and the enthusiastic boy really jumps. He is realistic down to the hole in the sole of his well-worn sandal!

Toy Print: A collection of lithographed masks and various amusing accessories intended to be cut out.

Kawanabe KYOSAI 1831-1889

Horse Day in February

Koban / Fan print / Signed: Kyosai and seal

Kyosai was an individualist, a drinker, and a superlative draftsman. His keen sense of humor, incorrigible tendency for caustic satire, together with his delirious fantasy and inventiveness, were virtues and vices guaranteeing more than a fair share of trouble. Expelled from the Kano school in 1852, he changed his Kano name, Toiku, to Kyosai (Crazy One) and had an art name (*go*) of Shuran-sai or Shojo (Drunkard). He was imprisoned more than once for satirizing first the Shogunate, and later, the Emperor. In spite of his misadventures, he was courageous and somehow lovable, for, like a child, he was "doing his own thing" and taking the consequences. In 1874, he changed part of his name from Kyo (crazy) to Gyo (dawn), so perhaps life appeared in a new light as he matured.

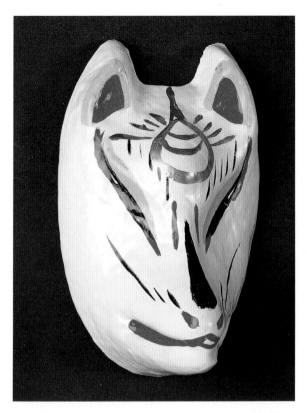

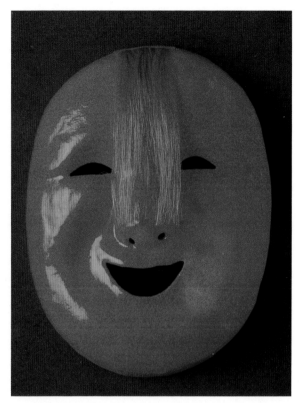

A fine and lively print, the page celebrates the joy, life, and enthusiasm that only children can produce and spread so contagiously. Since children are natural actors, Kyosai uses this print to parody the outing of some rich samurai, proudly riding his horse. Accompanying him are two retainers, one fanning him (or his tired steed), the other holding a state umbrella over the august head crowned with the tall hat of a *sanbaso* dancer. Most likely, it is the First Day of the Horse in February, the festival of Inari shrines, where fox masks and other trinkets are sold. *Aburage* (fried bean curd) is offered to the two fox guardians of Shinto shrines, and a drum is beaten all day to keep the deity attentive to the pleas and prayers of visitors for prosperity and abundant rice harvests. As the white fox is the messenger of the rice god, Inari Myojin, who brings wealth and happiness— and plays tricks on avaricious people—it is normal that he and his rider are treated with great respect!

Toys: A white papier-mâché fox mask (*left*) from Aichi Prefecture and a red *shojo* mask of a drunkard (*right*) from Tottori Prefecture.

Utagawa YOSHI-IKU 1833-1904
Women with Dolls
Two book covers / Series: *Shiranui monogatari* (Tales of Shiranui by
Ryutei Tanehiko) / A woman with a marionette (Vol. 50)
A woman holding a Girls' Day emperor doll

Shiranui was a witch who had a terrible hatred for a rich daimyo and vowed to ruin him. She sent a monster to kill and take the place of his favorite concubine, so causing his death. The tale was a rich source of fanciful interpretations and popular reading matter. The theme was much embroidered on; the term *shiranui* itself means "white needlework." Many covers from the series show dolls and toys imbued with fetishistic meaning readily apparent to Japanese readers, with the underlying theme of a woman playing with a doll as a cat plays with a mouse.

A richly robed entertainer poses with a large female hand puppet held high, a parody of a monster manipulating the murdered concubine. More usually, it was an entertainment combining dance and puppetry. The lady puppeteer (*kugutsume*), usually a beautifully costumed woman, made the puppet perform a famous dance, while she herself executed stylized, formal dance steps.

The mechanism of most figures was quite simple. The head and hands were attached to sticks inserted into a hollow torso or sewn to the clothes and moved by both hands inserted into

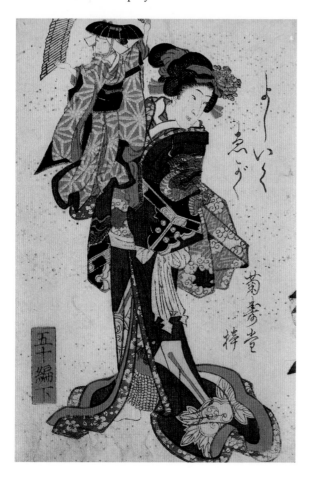

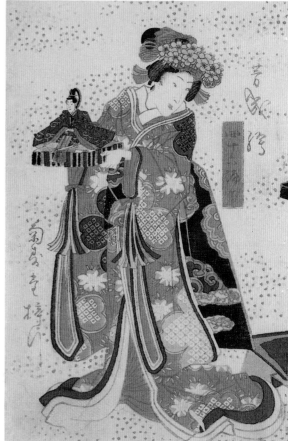

the hollow body. It goes without saying that it took a long time for the dancer to both master her own graceful steps and the movements of the puppet and to harmonize the two.

Yoshi-iku was a pupil of Kuniyoshi, of whom he left a memorial portrait. This was quite a feat, as Kuniyoshi always drew his self-portraits from the back or with his face hidden behind a piece of floating paper! Yoshi-iku was a capable but envious rival of his co-pupil Yoshitoshi, who, it is recorded, he kicked out of his way at the funeral of Kuniyoshi. The son of a teahouse proprietor in the Yoshiwara, he lived among the customs and festivals of the red-light district and was in an ideal position to observe the courtesans and entertainers. After the Meiji Restoration, he adapted his art to the changing times and became popular as a book and newspaper illustrator.

Doll: A *kimekomi* child dressed in rich brocade holds the emperor and empress, a tiny pair (1 cm high) of wooden Girls' Day dolls in Nara style.

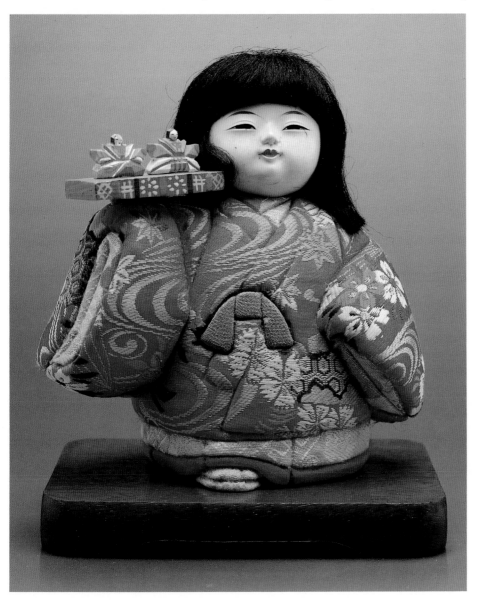

The Actor Nakamura Fukusuke

Oban / Signed in *toshidama* seal: Kuniaki ga (Drawn by Kuniaki)
Round *aratame* (examined) seal

Kuniaki was a pupil of Kunisada, as can be seen by his name in the *toshidama* cartouche of the Utagawa school. The *toshidama*, literally a "year jewel," is a conventional symbol of a New Year gift. Round or rectangular, it was the emblem of the Utagawa school, which was founded by Toyoharu and made famous by his pupil Toyokuni I. Kuniaki, although not a particularly prolific artist, did some standard work in the field of kabuki actors, sumo wrestlers, and the now rare Yokohama prints.

He obviously had a sense of humor certain to bring a smile to the faces of his contemporaries. He presents his actor in an innovative way, looking out of a wide-open (pawnshop?) window and framed by the thick shutters. On the wall, well in view, a young Hokusai has exercised his artistic talents, leaving graffiti representing an *ai-ai gasa* (love umbrella). Symbolic of a love affair, this is the equivalent of the heart pierced by Cupid's arrow and "Tom loves Mary" of Western wall culture. In this case, the horse is a symbol of virility. A thought-provoking document proving that children (?) the world over indulged in the

deeply ingrained practice of leaving their genial drawings and literary masterpieces in public places for posterity, whether posterity approved or not. Also universal proof that since prehistoric

cave painting, men have covered clean walls with subjects ranging from glorious religious frescoes to obscene pictures, mirroring both the times and their own state of mind.

Toy: In the foreground, note the two bone hairpins for small girls, embellished with mini-toys—a *tachibina* pair and a *daruma* tumbler. The amusing toy with the nodding head is known as *bosan kanzashi* (hairpin monk). A souvenir proper to Kochi Prefecture, it is a perfect representative of the "love umbrella." The monk Junshin was given the nickname when he was seen coming out of a comb and hairpin shop, where he had bought a present for his ladylove, Ouma. Obviously, a hairpin is an unneeded and suspicious purchase for a Buddhist monk with a shaven head!

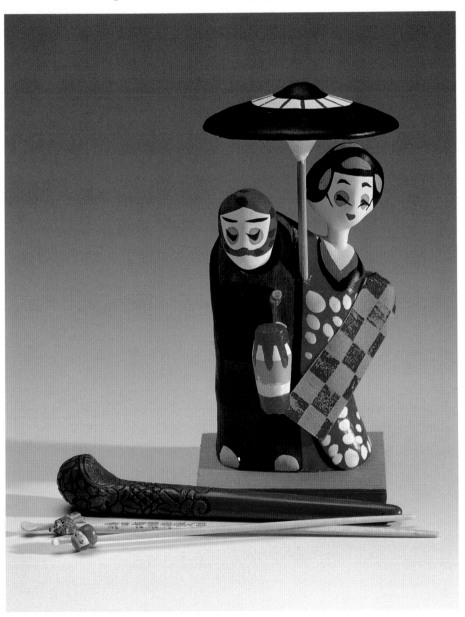

Toyohara KUNICHIKA 1835-1900

Actor and Benkei Puppet

Oban / Signed: Kunichika hitsu (Painted by Kunichika)
Toshidama seal of the Utagawa school / c. 1866

In this print, an actor-puppeteer holds a fierce warrior representing Benkei, one of the greatest heroes in Japanese military history. After suffering defeat at the hands of the warrior Yoshitsune, Benkei becomes Yoshitsune's faithful friend and retainer, following him into battle and misfortune until they die together in a last stand against their enemies. For this, he symbolizes unswerving loyalty to a master and often features in military displays for Boys' Day.

The print depicts a scene from the celebrated kabuki play *Chushingura* (League of Loyal Retainers), a play with this same theme of loyalty to a master. Better known in English as *The Forty-Seven Ronin*, it is the true story of 47 masterless samurai (*ronin*) who in 1701 vowed to avenge their dead master, Lord Asano, provoked by the wicked and avaricious Lord Kira into drawing his sword in the palace of the Shogun. For this act, his domain was confiscated and he was sentenced to commit *seppuku* (ritual suicide). On the snowy night of December 14 1702, the 47 men attacked the mansion of Kira, killed him, and placed his severed head on the grave of their master. They themselves were sentenced to commit *seppuku* and were all buried at the temple Sengaku-ji with their master. The youngest *ronin* was just 15 years old. Pilgrims from near and far still flock daily to this temple to stand quietly among the graves and offer prayers for the spirits of the men. It is a heartrending story and the perpetually rising incense smoke at the temple seems to saturate the atmosphere with a silent but palpable sorrow.

Color and composition are beautifully balanced in this print. Compare this vividly colored image with the delicate but faded version by Toyokuni I on page 42. The black and white triangles framing the print represent the 47 *ronin*, thereby reinforcing the theme of loyalty.

The 47 *ronin* became popular heroes and their story was on the kabuki stage only a few months after the real-life drama. It soon became one of the most famous kabuki plays of all time. While it was common for kabuki theater flagrantly to borrow its plots and and themes from the more popular *bunraku* puppet theater, in this case the puppet theater borrowed from kabuki, and it was only in 1748 that the story was first turned into a puppet play by Takeda Izumo, a pupil of the greatest Japanese playwright, Chikamatsu Monzaemon. More recently, in 1986, the theme was transposed into modern dance by the great choreographer Maurice Béjart for the ballet titled *Kabuki,* created specially for the Tokyo Ballet Company.

Puppetry came to Japan from China via Korea in the course of the ninth century. The earliest puppets were *tezuma* (hand puppets), worn over the hands and performing simple actions like cymbal playing. They were used by itinerant puppeteers, men and women who played at markets, shrine festivals, and remote villages. They carried their actor-puppets in boxes slung from the neck, the top of the box functioning as a stage. The puppet shown in the print was moved by a string-and-rod mechanism; the string was attached to the arms and a crosspiece inserted in a split bamboo stick supporting the figure. This permitted simple movement of the arms from side to side when the crosspiece was moved up and down.

Toyohara KUNICHIKA 1835-1900

The Lion Dance

Shishimai

Aiban / Signed: Hoshunro Kunichika and seal Toyohara
Publisher: Matsuki Heikichi / Meiji 25 (1892)

Said to be a portrait of the artist as a child, this extremely rare rebus print is of a young boy performing his own version of the lion dance (*shishimai*). He wears a blue quilted coat, richly decorated with red, green, and beige cherry blossoms, and a papier-mâché mask. Although the print is seemingly simple, it is rich in allusions wishing happiness for the new year.

The key to the print's meaning lies in the small charm bag the boy wears at his belt. It is marked with the Chinese character *fu* (good fortune), and countless references to the word can be found in the print. The bag itself is called a *fukuro*, while the boy's head is large (*futoi*) and whitened with powder (*gofun*). As part of his dance, he is touch-ing (*fureru*) the ground and shaking (*furu*) a leg. On the ground are the masks of Okame, also known as Otafuku, and Hyotoko, also known as Usofuki, the one who blows (*fuku*) lies. On the ground lie a flute (*fue*) and two (*futatsu*) drumsticks. As playthings were associated with specific months and seasons, these toys indicate wintertime (*fuyu*), perhaps the second day of the first month (*futsuka*), when dancing was the custom (*fuzoku*). This is indeed a print *full* of hidden *fun*, designed to bring laughter and happiness to those with a quick eye and a sense of humor.

Imported from China, the lion dance was performed in the streets or from house to house on New Year's Day to drive away evil spirits. In the

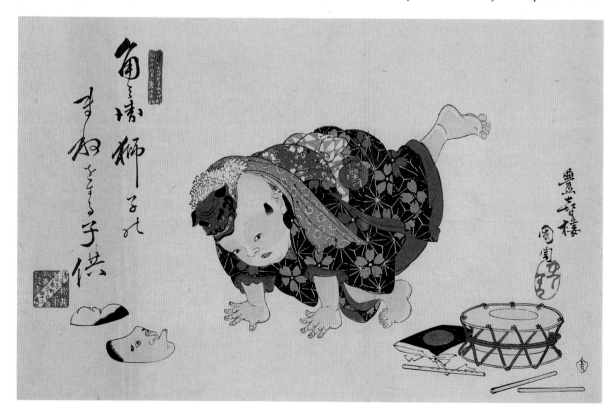

17th century, a single performer wore the mask over his head and beat a drum strapped across his chest. He was sometimes accompanied by a helper, who received donations of rice or money. In the 18th century, the dance was performed by two men, the red lacquered wooden mask with snapping jaws was worn by one, while the other, hidden by a green, white-patterned cloth, formed the hindquarters. The lion's body could be indefinitely elongated by adding more men under the cloth. The helpers now formed a small group, playing the drum and flute in a rousing rhythm and attracting an audience; others wore comical masks and did clownish tricks.

Toy: This intricate and sophisticated wood-and-ivory game box seems to be a Meiji-period invention inspired by the top and the roulette table. I have never seen this game in Japan, and only twice in Western auction catalogs, where it is described as a "mask game." It is too ornate and delicate for children and was possibly made for export as a fanciful "Oriental" betting game. The drum-shaped box contains six masks, smaller versions of which are reproduced on the spinning top. On his shoulder, the standing boy supports a well-carved *kara-shishi*, a Chinese lion's head mask. In his other hand he holds a pleated-paper pointer. The top is spun on top of the box, and the mask which comes to rest beneath the pointer is the winning (or losing) mask.

Strangely, a similar game which originally came from Europe may have been played by the Dutch at Dejima. A bastard and baroque Japanese version could therefore have been developed as a Meiji-period export.

Courtesy of Antiqvaria, Brussels, Belgium

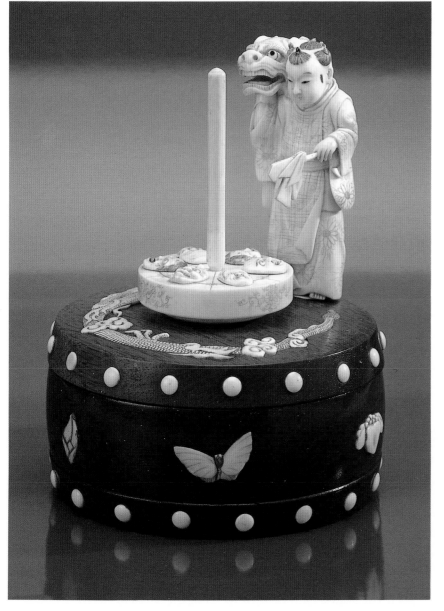

Toyohara KUNICHIKA 1835-1900

Playing in Water

Mizu asobi

Aiban / Signed: Toyohara Kunichika ga (Drawn by Toyohara Kunichika)
Publishers' seals: Fukuda Hatsujiro and
Gusokuya Kahei of Ningyo-cho / Meiji 30 (1897)

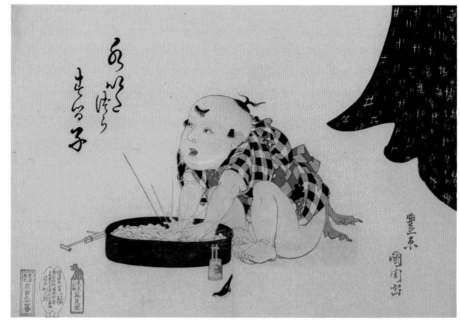

A favorite pastime of children during the hot summer months is splashing around in a basin or bucket of cool water, whether bathing, floating, or even drowning their toys to see how resistant they are. This checkered little lad with a shaven head, his long sleeves tied back and plump, rounded buttocks showing, is squatting on the ground and playing with a miniature wooden pail, a ceramic bird whistle, and what seems to be a bamboo water pistol, disguised as a fireman's pump and half hidden by the water container. His toys are scattered around him, and he splutters in surprise to receive full in his face the splashes which he himself has caused.

This and the previous print are from a delightful series of 12 episodes in the life of a child, imaginary self-portraits of the artist as a child, some with the words *motome ni ojite* (made on request).

Toys: A group of clay whistles: a *fugu* (blowfish) from Yamaguchi Prefecture, and a white dove from Saga Prefecture. Placed on the table, the two small pigeons from Aomori Prefecture were charms to ward off intestinal worms and to prevent children from choking on their food.

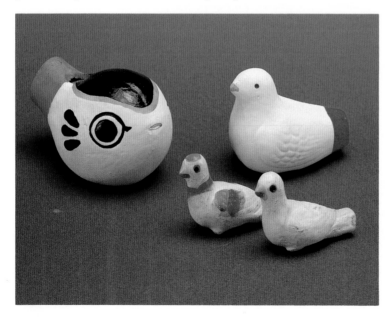

Toyohara KUNICHIKA 1835-1900
Watonai and Toy Tiger
Oban / Series: *Ichikawa Danjuro engei hyakuban*
(A Hundred Roles Performed by Ichikawa Danjuro) / Signed: Kunichika hitsu
(Painted by Kunichika) / *Toshidama* seal of the Utagawa school
Publisher: Fukuda Kumajiro / Meiji 26-32 (1893-1899)

The actor Ichikawa Danjuro IX in the role of Watonai, a heroic Japanese-Chinese pirate. Born in Hirado, Japan in 1624, Watonai was also known as Cheng Cheng-Kung, or Coxinga. His father was a pirate leader who fought for the Ming emperor against the Manchu conquerors but was bribed by the Manchus to turn against his lord. Cheng, however, remained loyal to the Ming court and in 1661 he captured the island of Taiwan from the Dutch, establishing Chinese control and an effective civil administration.

Kokusenya-kassen was a kabuki play originally written for the *bunraku* puppet theater by Chika-

matsu in 1715. The prints of this series are of excellent quality, many embellished with mica, burnishing, and blind printing. All have an inset by a different artist or poet with a poem or subject alluding to the personage. Here, the inset at top right shows a toy tiger and a small trumpet and is signed by Iijima Koga (1829-1900). It is used as a humorous reminder of one of Watonai's courageous exploits, a fight with a tiger, and illustrates the respective roles of the inset as counterpoint, double interest, and depth-giving device.

Toys: The sway-headed toy tiger is popular everywhere in Japan, with many regions having their own specific breeds and lucky charms. It is sometimes made from clay or wood, but more usually of papier-mâché with a swaying head mounted on a wire, like the one from Ibaraki (*left*). Some, like the threatening tiger from Shimane (*right*), even have a real moustache and a removable tail. The tiger in the print seems to be Shinno's tiger (*Shinno no tora*) of Osaka, a charm against illness sold attached to a bamboo twig. Tigers are essentially victory-bringing and protective toys.

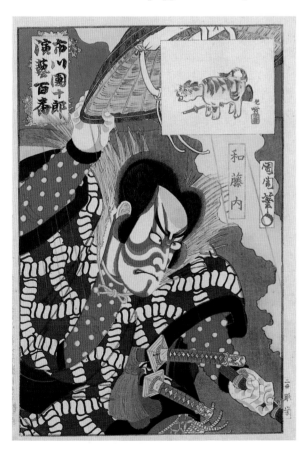

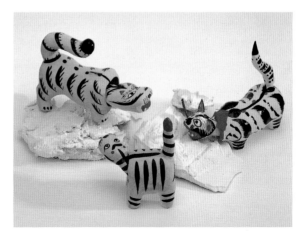

Toyohara KUNICHIKA 1835-1900
Bunraku Puppet Show
Triptych / Signed: Kunichika hitsu / oju (Painted by Kunichika / on request)
Seals: *Toshidama* and *aratame* (examined) for the fourth month of the
Tiger year (1866) / Publisher: Daikokuya

Kunichika, the last of the great actor-print artists, came from a poor Edo family. His start as an artist was in the toy-making business, where he worked for some time painting portraits of famous actors on the popular New Year's *hagoita* (decorative battledores). He was a pupil and collaborator of Kunisada, after whose death he became the foremost designer of kabuki actor prints. It is interesting to note that he often used richly colored and patterned borders for his prints, giving them a dynamic gaiety and a decidedly turn-of-the-century atmosphere. He must have been an eccentric and energetic man, for it seems that he moved house 83 times and married 40 times.

A complete triptych representing a *bunraku* performance held at the theater Yuki-za of Yonizu-machi during the Keio period (1865-1867). The names of the master-puppeteers, their puppets, and their assistants, as well as those of the narrator (*gidayu*) Takemoto Masako, are given in cartouches next to them. The puppeteer holding the female puppet, Yaegiri, is Toyomatsu Kunihachi; the one handling the male puppet, Tabakoya Genshichi, is Fujii Jusaburo. The name of the play is *Komochi Yama-Uba* (The Motherhood of Yama-Uba), an adaptation of the legend of the Woman of the Mountains who adopted Kintaro. An interesting feature of this triptych is the painted screen behind the narrator and the *shamisen* player, which is signed "Chikashige hitsu" (painted by Chikashige) by one of Kunichika's pupils.

Puppet: A *bunraku* puppet representing an imposing nobleman. His formal court costume consists of a long, trailing trouser-skirt and stiff shoulder wings of gold brocade.

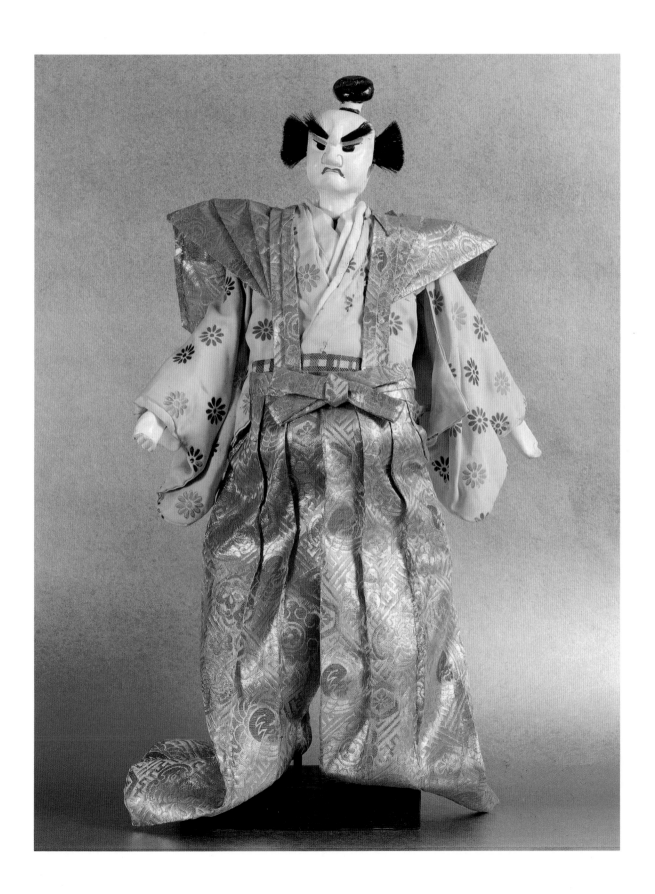

Toyohara KUNICHIKA 1835-1900

Playful Kimono Motifs

Aiban / Signed: Kunichika hitsu (Painted by Kunichika)
Seal: *Toshidama* seal of the Utagawa school

A well-composed print in which the round frame and radiating spokes of the parasol call attention to the girl's face. The extravagant kimono is decorated with playing cards picturing the Hundred Poets (*hyakunin isshu*). Another plaything used in the textile design is a *yakko* kite, a talisman against fire, for the kite cuts through wind and diminishes its power to fan flames. Kite flying and card games are New Year's pastimes, so this kimono would be most suitable for the cold season.

Kimono reveal much about their wearers. Traditionally, young girls wear bright colors, sprightly motifs, and almost ground-length sleeves. Married women wear soft and sober hues of gray, beige, brown, and black, and their sleeves are short, "cut" for doing household chores. Courtesans tied their *obi* at the front, "honest" women at the back.

Toy: This type of *yakko* kite is sold at Tokyo's Oji Inari Shrine at New Year. A *yakko* was a lowly servant who brutally cleared commoners out of his nobleman master's way during travels. Flying this kite at New Year is supposed to ensure that the *yakko* will clear the way to a happy and fire-free year. Kept indoors, it is believed to protect the home against fire.

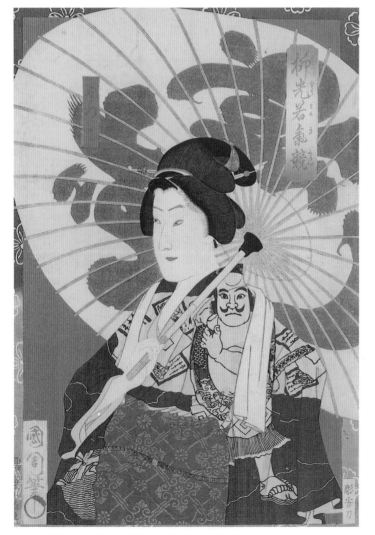

Toyohara KUNICHIKA 1835-1900

Woman Holding Hand-Drum

Oban / Series: *Fifty-Four Reflections of Genji's Women (a Modern Version)*
Signed: Toyohara Kunichika hitsu (Painted by Toyohara Kunichika)
Dated: Meiji 17 (1884)

A poor woman nurses her baby, while a richly dressed lady and her daughter hold out a small hand-drum to the infant. It is a moralizing print which compares the lives of rich and poor women, implying that although "modern" times and new-era lifestyles copied from the West are superficially better than before, poverty still exists, and it would be better to give work to the mother and food to the baby instead of a mere plaything. As proof of lazy printing and "dropping" standards—although I can imagine naughty apprentices trying out startling effects—the rich woman's eyes are seen to be literally falling out in surprise; the pupils have been printed off register, and form two beauty spots just under her eyelids! Here, too, the gaudy scarlet and aniline colors take their toll.

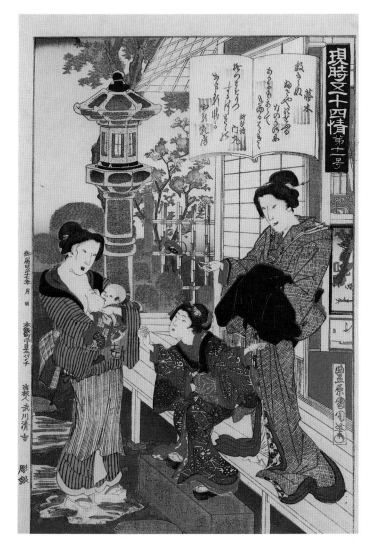

Toy: In Japan, the drum-on-a-stick (*den-den taiko*) with two thread and bead attachments has always been one of the cheapest and most popular toys for small children. It is shaken or twisted between the fingers and thumb so that the beads strike the stretched paper sides of the drum. Often decorated with lucky toys and auspicious symbols, its noise amuses children and was believed to ward off evil spirits.

Toyohara CHIKANOBU 1838-1912
Girl with Ichimatsu Doll
Oban / Series: *Jidai kagami* (A Mirror of Epoques: The Meiji Period)
Signed: Yoshu Chikanobu and seal Yoshu
Publisher: Matsuki Heikichi / 1897-1898

Chikanobu was born in Takeda, Echigo Province, (present-day Niigata Prefecture). He went to Edo and first studied Kano-style painting. After studying print making under Kuniyoshi and Kunisada, he worked under Kunichika, using the last character of his master's name to form his own art name. Both men are known as the last traditional *ukiyo-e* artists.

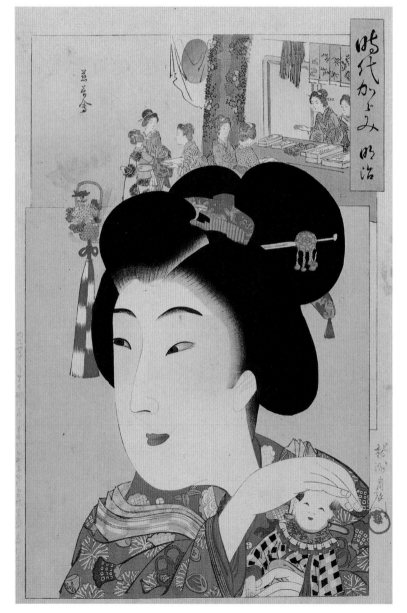

The series *A Mirror of Epoques* consists of close-ups of women's faces, somewhat in the manner of the earlier *okubi-e* (large-head print). The prints were undoubtedly an excuse for showing the various hairstyles of the beauties of different periods of Japanese history, this one showing the intricate hairpins used by young girls during the Meiji era.

Typical of the era depicted here, a confectionery stall is included to give background interest. This elegant young lady is holding the popular *ichimatsu* doll with its checkered clothes and pleated collar. Perhaps it is raining, for the girl is spreading a tenderly protective hand over the head of her doll, as its delicate paint-on-*gofun* features could easily be damaged or washed away by raindrops. *Ichimatsu* dolls exist in three versions: the first was made in homage to the famous kabuki actor Sanogawa Ichimatsu, an 18th-century idol. The second was a realistic baby type, the third is the *yamato ningyo*, dressed in traditional Japanese costume.

Toyohara CHIKANOBU 1838-1912
Playing Ladies and Child
Triptych / Series: *Tokugawa jidai kifujin nozu*
(Pictures of Aristocrats of the Tokugawa Era) / c.1890

This charming triptych shows a young girl of the upper class being entertained by her ladies-in-waiting. The one on the left holds the child's large and beautiful *ichimatsu* doll. It is interesting to note that, besides being the name of the handsome kabuki actor Sanogawa Ichimatsu (1722-1763), *ichimatsu* also means "checkered" or "lattice," a pattern seen on the kimono of this doll. Sanogawa Ichimatsu won fame and approval in the Nakamura theater production *Love Suicide at Koya-san* while wearing a checkered kimono, and this fashionable costume became an established part of his image.

Ironically, the actor's portrait doll soon received a female counterpart, which became more popular than the male. Dressed in the traditional costume of Japan, she is known as the *yamato* (the ancient name for Japan) or *furisode* (a long-sleeved kimono worn by unmarried young women) doll. The child is pulling a red *tai*-fish cart, symbolic of wealth and good luck. The color red was also believed to keep illness and evil spirits away. The elegant lady on the right holds a wicker basket, the covering for the pet bird on the stand. The captive songster is looking longingly in the direction of its two free companions on the wing, who, as a delicate detail, seem to have escaped from the sitting lady's kimono motifs.

Dolls: One of the treasures of the Ethnographic Museum of Antwerp is this magnificent pair of *yamato* or *ichimatsu* dolls, made in the 1930s. Although it is also the ancient and poetical name of Japan, *yamato* here refers to the traditional

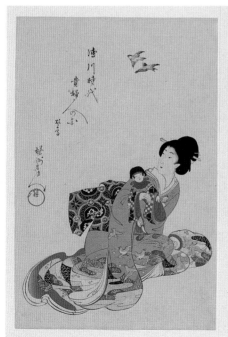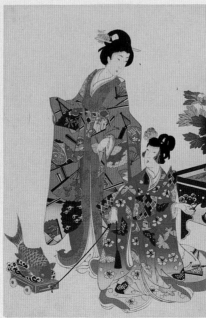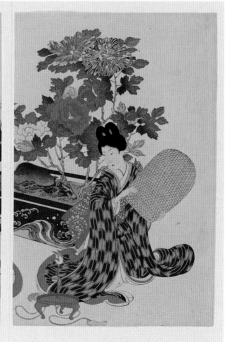

Japanese costume. With their finely molded heads and exquisitely painted features, the couple are extraordinary for several reasons, primarily because they are probably the only dolls of this size (70 cm) made by the Living National Treasure Hirata Goyo (1903-81) in a European museum today. Hirata was the son of an artisan who had learned his craft with Kamehachi Yasumoto, a 19th-century master dollmaker. Although he was to strike out in a personal, distinctive direction later, he first worked as his father's apprentice in the traditional Japanese way. At the time when these dolls were made, Hirata was also working for the shop of the 10th generation Yamada Tokubei, one of the most famous dollmaking concerns in Tokyo. Now Yoshitoku Toys, the shop's name tag is still affixed to the dolls' bases. Yamada was an enthusiastic doll historian, particularly promoting Japanese dolls by organizing exhibitions in foreign countries and always

looking for talented young artists—thus some of the 58 *yamato* dolls chosen for the celebrated 1926-1927 "friendship doll" exchange between the United States and Japan came from his shop. In November 1934, the Society for International Cultural Relations (Kokusai Bunka Shinkokai) organized an exhibition of dolls in Antwerp, and the dolls were donated to the Museum of Folklore at the closing. In 1953, this museum became concerned with national folklore only and made over the dolls to the Ethnographic Museum. The receivers could not then know that they had acquired supreme examples of traditional doll-making art from the hands of a

future Living National Treasure, a title conferred on Hirata Goyo in 1955 for his costumed dolls of carved wood.

Courtesy of the Ethnographic Museum, Antwerp, Belgium

Toyohara CHIKANOBU 1838-1912

The Doll Festival

Hina matsuri

Oban / Signed: Yoshu Chikanobu hitsu (Painted by Yoshu Chikanobu)
Toshidama seal of the Utagawa school / Dated: Meiji 20 (1887)

Two ladies celebrating Hina Matsuri (Doll Festival). On the right is a corner of the red-covered dais on which the dolls are displayed along with their accessories. The top part of the print shows a woodworker's tools and a wooden box on which is written *kyo ningyo* (Kyoto doll). Many Japanese doll types originated in Kyoto. Known as the most beautiful and sophisticated of Japan, they constitute a prized present and souvenir from the city.

Hina dolls were presented to a girl at birth, and when she married she always took her dolls with her, passing them on to her own girl children. Valuable collections of dolls and their accessories could be built up over generations. The standing lady is holding up one of her most precious acquisitions for the admiration of the sitting lady, whose kimono shows a pattern of origami (folded paper) boats, a fitting motif for a children's feast. This is a typical Meiji print: technically well-done but overloaded with detail and colored with the harsh red and purple aniline dyes imported from the West after 1860.

Dolls: A set of dolls for Girls' Day comprising all 15 figurines: Emperor and Empress (*dairibina*), three ladies-in-waiting, five musicians, two ministers, and three lackeys.

Toyohara CHIKANOBU 1838-1912
Comical Puppet Show
Saruwaka kyogen
Two oban / Series: *Chiyoda no oku* (Inner Quarters of Chiyoda Castle)
Publisher: Fukuda Hatsujiro / Meiji 28 (1895)

Two leaves of a triptych showing a comical puppet performance by two ladies handling large hand puppets. This is not a classical *bunraku* play but a court entertainment, as the silhouettes of the exalted personages behind the rattan screen (*sudare*) cannot be clearly seen. The women, fashionably dressed and wearing costly tortoiseshell hair ornaments, could be either ladies of the aristocracy performing an amateur puppet play or celebrated female puppeteers, who were sometimes called to the mansions of the rich and noble to give a private performance. This explains the *sudare*, for commoners were not allowed to look on the countenances of the highborn. This is perhaps a parody, a reversing of roles, for in *bunraku*, pupils sat behind such screens to study the techniques of their masters. This diptych, the third leaf missing, is from the *Chiyoda no oku* series, representing the amusements and yearly festivals of the highborn ladies confined to the inner quarters of Edo Castle, also known as Chiyoda Castle, where only women were allowed.

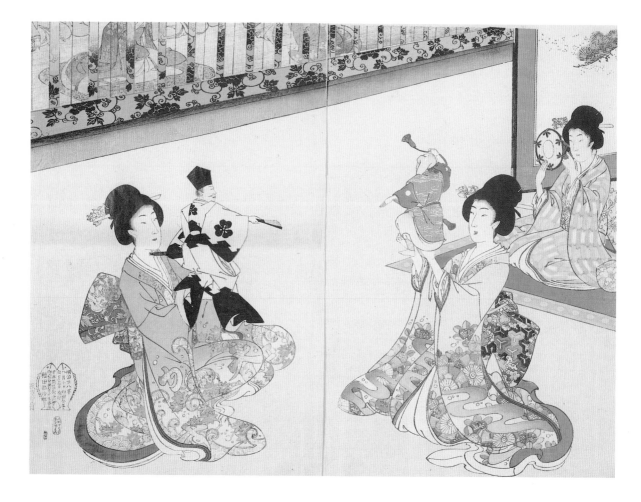

Utagawa KUNITOSHI Fl.1847-1899

Horseracing at Shinobazu Pond

Oban / Series: *Views of Tokyo* / Signed: Kunitoshi ga
(Drawn by Kunitoshi) / 1886-1889 / Dated Meiji 19 (1886)

Fireworks... the taming of fire and gunpowder into an explosive art! Who does not remember the awe and suspense, the high-pitched whistle, the dull thud, followed by the fantastic flowering burst of form and color, against the black immensity of a midsummer night's sky? Probable prototypes of modern fireworks were the bonfires and signal smoke signs used along the Great Wall of China during the reign of Emperor Shih in 211 BC. His colored flares served to notify the army of invading nomads from the north.

"Fire flowers" (*hanabi*), as fireworks are known in Japan, came from China in 1543. The Japanese, of course, improved on the theme and made better ones! The first varied fireworks display in Japan is recorded as having been given for Tokugawa Ieyasu in August 1612, when he met the Englishman John Saris, who carried a letter from King James I requesting trade facilities. Saris founded a trading house at Hirado, which proved an unhappy choice, for the English presence in Japan only lasted a decade (1613-1623). Judging by the dazzling displays on many woodblock prints of the late Edo period (1600-1868), fireworks had by then become a popular attraction for city-dwellers seeking to escape the summer heat. The *noryo hanabi*, (coolness-in-summer fireworks) became organized, long-awaited festivities. Ryogoku Bridge, built in 1659, became the site for firework spectacles and pleasure boat cruises. An ideal and idyllic spot, it ruled out the danger of fire and mirrored the lovely fire flowers in the waters of the Sumida River. In 1897, the bridge began splitting in two under the combined weight of the stalls and spectators, and from then on, it was closed to the public during the summer shows.

This print is unusual because it shows a daytime fireworks display during the horseracing around Shinobazu Pond at Ueno Park. It seems that betting was not allowed, so people went to admire the horsemanship, supposedly in the interests of national defense. To add something special to the prestigious event, small dolls and toys have been released in the air; they appear to be flying before descending among the crowd—an unexpected thrill for the spectators and an extra souvenir for those able to catch them.

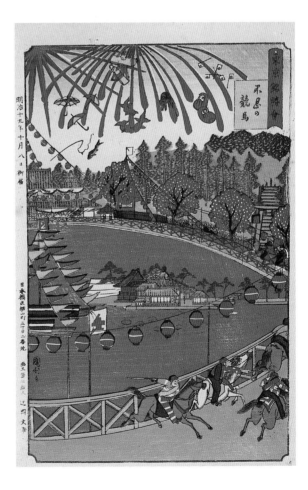

Toyohara CHIKANOBU 1838-1912

Horseracing at Shinobazu

Ueno Shinobazu dai-keiba zu

Triptych / Signed: Yoshu Chikanobu hitsu (Painted by Yoshu Chikanobu)
Toshidama seal of the Utagawa school
Publisher: Kobayashi Tetsujiro / Dated: Meiji 17 (1884)

This version by Chikanobu of the same sporting event depicted by Kunitoshi shows that the Emperor's opening of a race track must have made a lasting impression on the population of Tokyo, since both artists produced various prints to commemorate the occasion. Chikanobu differed in his work in that he portrayed many events, both historical and contemporary, attended by the Emperor and the Empress, subjects which had been strictly forbidden in Tokugawa times.

From 1884 until 1894, a horseracing track functioned at Ueno Park around the Shinobazu Pond. Note that the horses are running counterclockwise, according to the rules, although Chikanobu also produced prints with horses going clockwise. The presence of the Meiji Emperor and Empress, just visible in the grandstand, shows that the event must have been an illustrious highlight of the times, although horseracing along the dry bed of the Kamo River in Kyoto had been known since Heian times.

With the importation of Western technology in the Meiji period (1868-1912), fireworks became ever more colorful and complicated, and it is recorded that the national railways started putting on special trains for displays in 1874. Amusingly evident in this print is that the Japanese were copying Western-style sports attended by royalty and fashionable people, although the stiffly standing crowd of dignified bowler-hatted and black-clad men gives a glimpse of the conventional "don't be different" group decorum of the Japanese. Despite the Western dress of spectators and jockeys, an unmistakable Japanese touch is visible in the perspective and the toys floating down from the sky. Recognizable in the exploding flash are carp, cranes, *daruma*, national flags, a *tachibina* couple, Ono no Tofu and his frog, Daikoku, god of wealth, his white rat, and other trinkets.

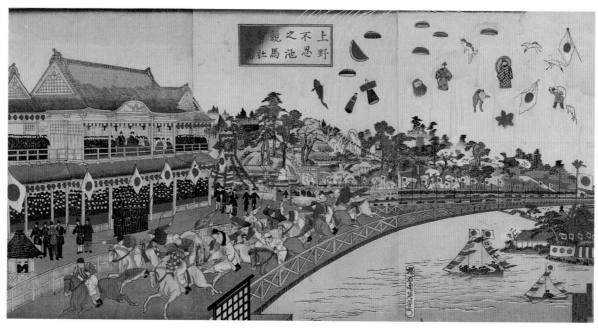

Toyohara CHIKANOBU 1838-1912

Monthly Events in Japan: October

Oban / Seal: *Toshidama* seal of the Utagawa school / Dated Meiji 23 (1890)

This is a print that gives a feeling of having been lovingly made. The registry is carefully done; the lady's collar embellished with blind printing; the kimono patiently burnished with matt and polished black lozenges (here visible, thanks to the art of the photographer); and the hair roots of mother and child are extremely delicately cut.

Essentially, the Japanese people live in rhythm with the changing seasons. There are many occasions for aesthetic appreciation of nature's enchanting gifts, cherry blossom viewing, moon viewing, and snow viewing among others. This tenderly portrayed pair are on their outing for autumn leaf viewing, and the mother is visibly enjoying a late afternoon's rest and a refreshing cup of tea, seated on the typical red cloth-covered bench of a teahouse. Among a smattering of windswept maple leaves, she is perhaps already reflecting on the transience of life and youth. Less interested in falling leaves, her young son laughs with joy at receiving a much coveted toy and tightly clutches the string of a red balloon with one hand, clinging to his mother's fingers with the other. The balloon is absolutely flat; no attempt at shading has been made to give it any relief. The lady radiates the dignity and maturity of her married status, deductible from her blackened teeth, refined hair ornaments, and rich but sober kimono. Perhaps not a masterpiece, but a picture conveying an inner stillness and a serene atmosphere, making it a lovely and joyous print.

Toys: Two old-fashioned and colorful inflatable paper balls. Although light, they are made from strong paper and can be used many times over.

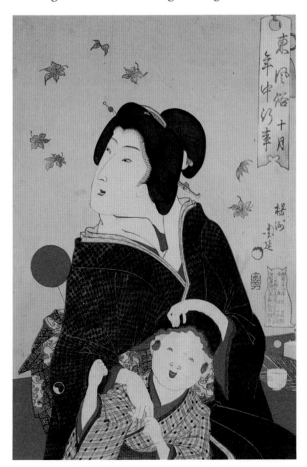

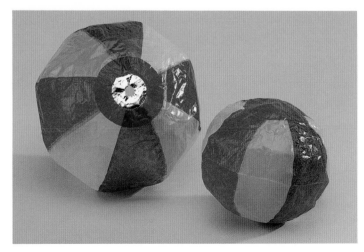

Tsukioka YOSHITOSHI 1839-1892

Sketches by Yoshitoshi

Yoshitoshi ryakuga

Chuban / Sketches: *Yoshitoshi's Sketches* / Signed: Yoshitoshi
Seal: Taiso / Publisher: Funazu / c.1882

The series consists of 40 humorous subjects originally published as two *chuban* prints per uncut *oban* sheet. In a scene from the play *Kanjincho* (The Subscription List), the giant monk Benkei pretends to have permission to collect funds for his temple and "reads" a blank scroll, making up the names of subscribers. He thereby saves the life of his master, the great military hero Yoshitsune, when challenged by guards at the Ataka Barrier.

This print of Benkei has a large calligraphed title reading *Shinnyo no tsuki,* a Buddhist term which can be translated as "the light of absolute truth, like the moonlight, penetrates the darkness of human ignorance." This perhaps relates to Benkei's luminous idea or, satirically, to his broad, lantern-shaped posterior. It must be said that a back portrait is an established Japanese convention, for the Japanese say that a back reveals as much as a face, and, furthermore, can hide nothing. Kuniyoshi, Yoshitoshi's teacher, always depicted himself from the back. The artist here applies the concept to an original and somewhat irreverent rear view of Benkei.

Kanjincho is one of the most famous kabuki

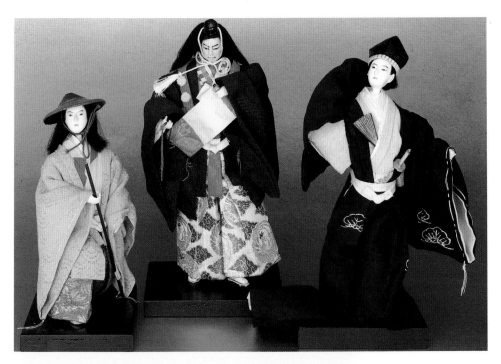

plays and one of the 18 favorite plays reserved for the Danjuro family. As the greatest historical examples of a heroic master and his faithful servant, Yoshitsune and Benkei are popular characters for prints of kabuki actors in role. As military dolls, they are often included in displays for Boys' Day.

Dolls: *Ishobina* costume dolls (*above*) representing the famous *Kanjincho* scene played by kabuki actors, and a close-up of Benkei's face (*below*).

Another print from this series shows children painting Hotei's belly to look like a giant *mochi* cake. Hotei, one of the seven gods of luck, is the Japanese god of happiness, for in his huge sack he carries toys and treasures for the flocks of children who swarm around him everywhere. He is very tolerant and allows the boisterous bevy many

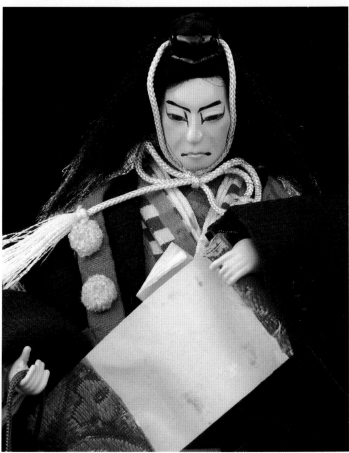

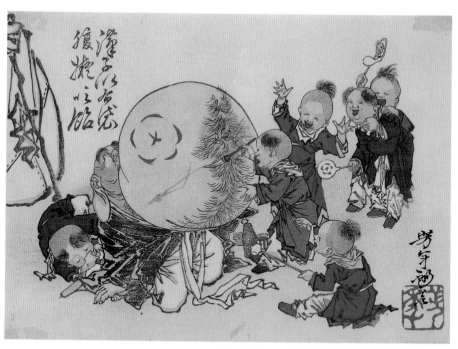

liberties, while pondering sleepily and not too seriously on the deterioration of today's morals. Here, after having received paint and paintbrush, a mischievous youngster is trying out his artistic talents on Hotei's immense hairy stomach to the joy of the others who are accompanying his efforts with jumping, laughter, and brandishing of toys. A plum blossom and a pine needle adorn the patient Hotei's grotesque belly, which is being blown up through a natural channel, to put it euphemistically, by a daring juvenile delinquent with a long bamboo pipe.

Doll: A joyously dancing Chinese child (*karako*). The exotic costume was typically worn by street performers and acrobats. That street entertainers wore fanciful Chinese dress is perhaps one more proof that the first public performers were immigrants from Korea, who copied Chinese clothing.

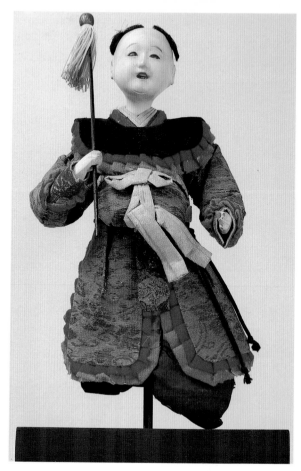

Tsukioka YOSHITOSHI 1839-1892

The Courtesan Shiraito

Oban / Series: *Shinsen Azuma nishiki-e* (New Brocade
from the Eastern Capital) / Signed and seal: Yoshitoshi
Publisher: Tsunashima Kamekichi / 1885-1889

This print is the left side of a diptych with the title *Shiraito of the Hashimoto-ya*. The courtesan Shiraito was known for her great passion for the samurai Suzuki Mondo. The right side of the diptych shows Mondo's wife visiting the Hashimoto house dressed as a man. The chronicles do not say whether this was out of feminine curiosity or with murderous intent. Probably both.

Part of a luxury edition, it is an example of many sophisticated techniques requiring skill which are applicable in woodblock printing. The series pictures murders, legends, historical events, and famous episodes from life in effervescent Edo. *Nishiki-e* (brocade pictures) was another name for colored woodblock prints.

On a base just inside the door are visible a tiered food box, a kettle, and what seems to be a simplified tea-serving doll holding a cup in its hand. These automatons carried a small cup of tea to a customer, stopped when the cup was lifted, and returned the empty cup to the sender when it was replaced. They were costly and complicated, totally handcrafted gadgets. There are several woodblock prints showing the courtesans of the Yoshiwara amusing their customers with puppets and various *karakuri*

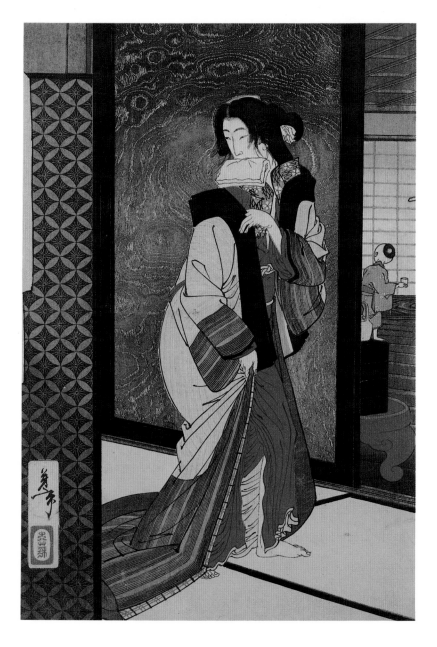

(trick dolls). Such intricate automatons, perhaps presents from rich admirers, reflected the prestige of the house.

The *Karakuri zue* (Collection of Mechanical Designs), a woodblock-printed book written by Hosokawa Hanzo Yorinao in 1796, shows a Japanese clock and pictures of nine ingenious automatons, including the *chahakobi* tea-server (*below*) and the saké cup with an automatic tortoise floater (*facing*). Detailed instructions for making them and drawings of all the parts are included.

Toys: A working *chahakobi* tea-server (*right*) totally handmade by Yamasaki Kosei, following the sketches and diagrams in the *Karakuri zue*.

Courtesy of Yamasaki Kosei, Tokyo

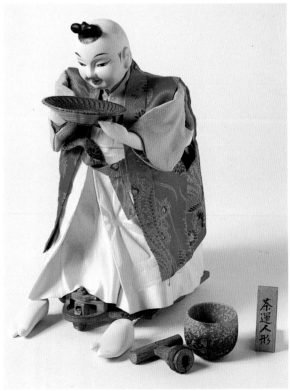

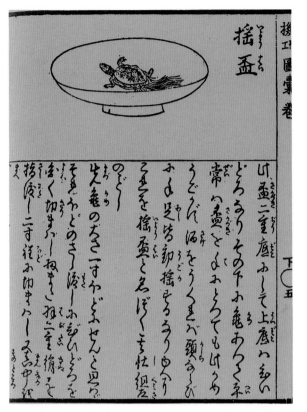

揺盃

機工圖彙巻

下〇五

Looking through the Europalia catalog *Assignment Japan* of the Leiden National Museum of Ethnology, I came across a picture of a most enjoyable toy for adults—a saké cup decorated inside with a tortoise in relief (*below*). It was in white Hirado porcelain, and the tortoise was a mobile floater. I had a sense of déjà vu and suddenly remembered that a drawing of the cup and instructions for making the tortoise mechanism were shown in *Karakuri zue* (*left*). Philipp Franz von Siebold, Dejima's doctor, scholar, and botanist, must have found it an ingenious gadget, and perhaps drunk his "saki" from it. At any rate it was deemed worthy of being included in his extensive and eclectic collection. A small but satisfying discovery—for him, long ago; for me, now.

Courtesy of the National Museum of Ethnology, Leiden, The Netherlands

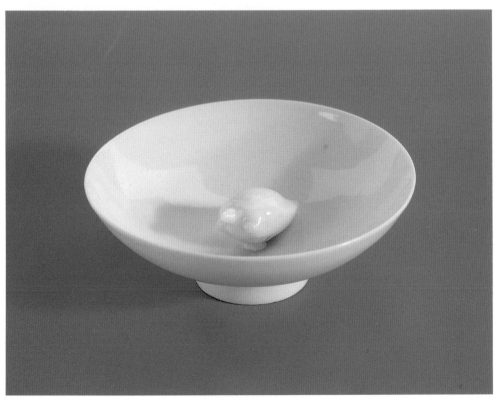

Tsukioka YOSHITOSHI 1839-1892
The Yotsuya Ghost Story
Yotsuya kaidan
Oban / Series: *Shingata sanjurokkaisen* (New Forms of Thirty-Six Ghosts)
Signed and seal: Yoshitoshi / Publisher: Sasaki Toyokichi / 1889-1892
Courtesy of Kunsthandel Klefisch, Cologne, Germany

The Yotsuya Ghost Story is a blood-chilling play written by Tsuruya Nanboku (1755-1829). Famous since it was first produced on the kabuki stage in 1825, film and television versions are still regularly shown, and all actors invariably visit Oiwa's grave to placate her spirit with prayers.

The sad story of Oiwa is based on true happenings. Her husband, Iemon, wanted to marry a rich young woman and tried to poison Oiwa. She did not die, but the poison left her horribly disfigured. He then began abusing her, hoping to drive her away, but the pitiful woman committed suicide with his sword. Iemon then murdered Oiwa's faithful old servant, Kohei, who was a witness to his cruelty, tied both bodies to a plank, and threw them in a river. He married his new bride, but when he removed her head covering after the wedding, he thought he saw Oiwa's ghastly face, and, taking his sword, he killed her. While running away, he met his new father-in-law who he took to be the dead servant, and in a frenzy, cut him down too. Walking by the river, he saw the macabre plank with the two corpses surface and heard ghostly voices crying and accusing him. Driven mad by all his atrocities, he drowned himself. In this peaceful print nothing suggests the horror and violence of the story, except the disquieting uprearing form of the sash with a pattern of snake-like green scales. It embodies the

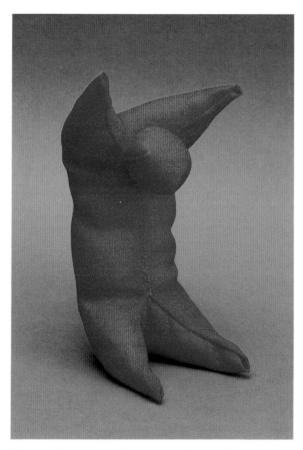

threat, the nearing danger, while the future victim dozes and daydreams, comfortable, contented, and totally unaware of the hideous deeds in store. A red stitched monkey doll (*kukuri-zaru*), made from a single scrap of cloth, lies by her small son, possibly an indication that the child will be protected from the coming evil by his talismanic toy.

Toy: The oldest ancestor of the *kukuri-zaru* is the *hoko*, a white stuffed textile doll which was placed near a newborn baby to act as a decoy and absorb all evil threatening its life. A red doll (*above*) was particularly efficacious during small-pox epidemics, as the spirit believed responsible for this illness was thought to be afraid of the color red. Sometimes the featureless doll was dressed and its four extremities sewn together. This faded Edo-period figure (*right*) is a very rare example because of its large size and rich clothes.

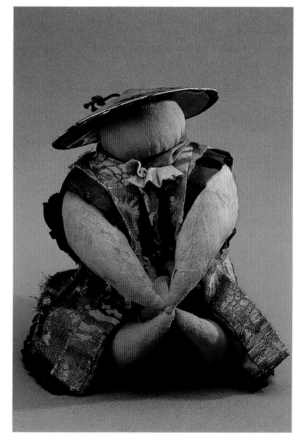

Kobayashi KIYOCHIKA 1847-1915

A Hundred Victories, a Hundred Laughs

Hyakusen hyakusho

Oban / Series: *Nippon banzai* (Hurrah for Japan)
Signed: Kiyochika

A bearded Japanese officer is juggling with six small pig-tailed Chinese men in the form of dolls. To show how easy it is to defeat the Chinese, he plays with one hand. With the other hand he balances a cannon and two rifles on a stick. A young bugler provides music for the act.

The series was a popular portrayal of episodes from the Sino-Japanese War (1894-1895) and the Russo-Japanese War (1904-1905), showing dramatic events turned into tragi-comical caricatures. In some prints from this series, Kiyochika uses various toys, games, and puppets to express his personal outlook on the two wars. Here, the Chinese are only playthings in the hands of the Japanese. Other prints in the series show children with a bursting balloon representing Russia; two Japanese toy soldiers in the form of sway-headed umbrella ghosts frightening a Chinese; a Japanese soldier crushing the toy soldiers of a weeping Chinese child underfoot; and yet another of the Russo-Japanese War depicts the enemy as broken puppets.

Kiyochika came from a samurai family which had lost its hereditary privileges during the Meiji Restoration. After some years of wandering, he studied Japanese-style art under Kyosai and Zeshin and Western-style painting under the English artist Charles Wirgman (1835-1891), the correspondent for the *Illustrated London News* who lived in

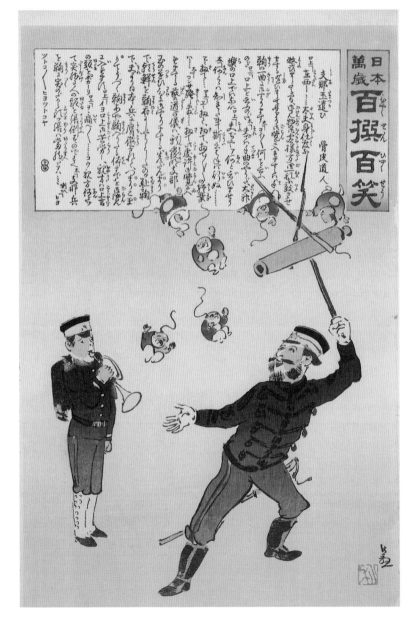

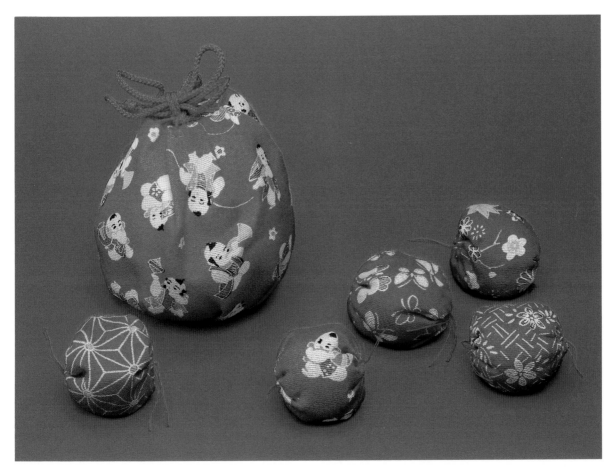

Yokohama and was the pioneer publisher of *Japan Punch*.

In the main, Kiyochika was self-taught. He was keenly interested in all aspects of Western art techniques—studying etching, photography, and lithography—and these different disciplines helped him become a well-known illustrator and cartoonist for magazines and newspapers. Coming from the military caste, it is obvious that he had only contempt for a vanquished enemy, and his satiric war prints tend to be extremely racist. In many cases, his caricatures are in downright bad taste, devoid of either subtlety or a fine touch of real humor. Yet his draftsmanship was versatile and capable, his evening views have atmosphere, and his trains are quite poetic.

The print is an interesting one for our study because the officer is playing a popular children's game called *o-jamma* (or *ote-dama*), which involves throwing small rag dolls or bags stuffed with peas, rice, or grain in the air and catching them alternately in a regular and continuous movement. It is not surprising that the Chinese were mocked, for a Japanese samurai's highest aspirations were to be indifferent to suffering and to die for his master without hesitation. In this light, the print echoes Johan Huizinga's words in his book *Homo Ludens*, "The Japanese samurai held the view that what was serious for the common man was but a game for the valiant."

Toys: The requisites for the game of *ote-dama*: a doll-decorated holder bag and five small grain-filled balls. Chubby little dolls may be used instead, but as their production is more time-consuming, they are rarely used nowadays.

Ogata GEKKO 1859-1920
Puppeteer and Children
Shikishiban / Signed: Gekko / Seal: Tai / c.1900

Although generally not as well-known as Zeshin, many connoisseurs consider Gekko to be on a plane with the illustrious master. He was awarded a gold medal for artistic merit at the Saint Louis World Fair of 1904. Not only was the self-taught Gekko one of the most versatile illustrators and print artists of the Meiji period, but he was also a famous painter and founding member of Bunten (Art Exhibitions of the Ministry of Education) held in 1907. Like Zeshin, he was an expert decorator of pottery and lacquer ware. These arts are evident in his airy compositions which are never cramped or overworked.

The itinerant puppeteer, equipped with a box slung from his neck which served as stage and storage space, was a popular figure at markets and local festivals. He attracted adults and children to simple and comical little dance-plays easy enough for one person to produce. Here, for an audience of three enchanted children, a miniature *sanbaso* dancer with fan and bells is performing his auspicious New Year's dance. The dancer's motive power comes from under the cloth draped over the puppeteer's box—it has openings at the back to permit manipulation of one or two puppets. Decorating the front panel of the box is the image

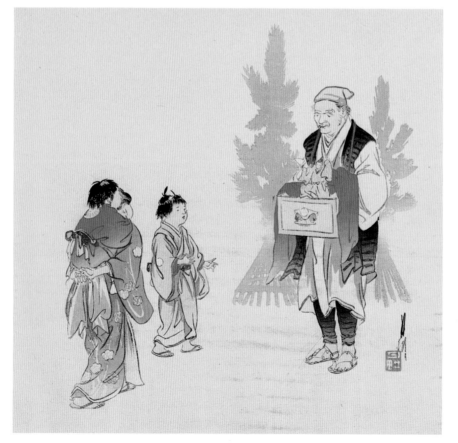

of Fukusuke, a lucky, large-headed dwarf who was a genial teller of humorous tales (*rakugo*) and was thus the perfect patron and protector of street entertainers. A festive atmosphere is given to this picture by the shadowy silhouette of the *kadomatsu* in the background. It is an emblematic New Year's display, combining pine, bamboo, and branches of plum blossom.

Doll: A beautifully made little *kimekomi* mother carrying her child on her back, as many Japanese women still do today. Children

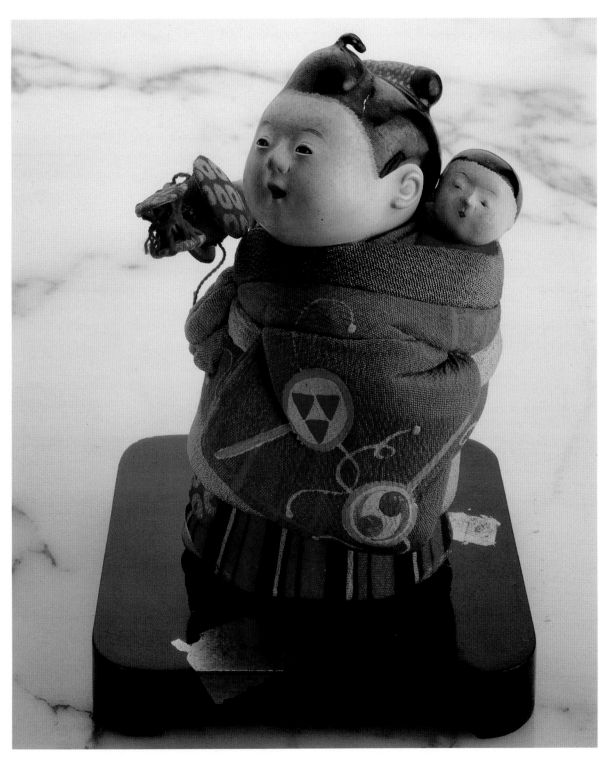

carried their younger brothers and sisters or dolls in this manner, too. The doll is finely made, with refined features and hand-painted clothes. The ticking drum (*den-den taiko*) motif decorating her delicately patterned silk clothes echoes the drum toy held in her hand.

Mizuno TOSHIKATA 1866-1908
Girls' Amusements
Three oban from the series *Sanjurokkasen* (The Thirty-Six Selected Women)
Signed and seal: Toshikata / Publisher: Akiyama Buemon / Meiji 24 (1891)

Three prints from the series *The Thirty-Six Selected Women* (Sanjurokkasen). This is a pun on the 36 celebrated poets of Japan (known as the *sanjurokkasen*), as the word *kasen* can also be written with characters meaning "flowers" or "beautiful young women."

One of Yoshitoshi's best pupils, Toshikata succeeded his master as illustrator for the newspaper *Yamato Shimbun* and studied Japanese-style painting under Watanabe Shotei. An Art Academy member who won many prizes at contemporary exhibitions, he was one of the best-known artists of his day. Although he was influenced by realistic

Western art regarding correct perspective, proportions, and movement, his subject matter still faintly reflects the old *ukiyo-e* style adapted to the modern trends of the time. His pictures certainly are well printed and have visual appeal, qualities which overrule the somewhat academic execution.

The three prints are delicately drawn with a sure hand, their colors clear but not gaudy. They represent stylishly dressed girls and women during popular festivities of the year, and the subtitle tells us that these girls personify the Keicho era (1596-1615). The first scene shows three pretty girls playing *temari* (handball) with a beautifully patterned silk-thread ball nearly hidden among the kimono motifs. The budding willow tree in the background is symbolic of youth, beauty, grace, suppleness—all virtues eminently desirable for innocent young maidens in the spring of life.

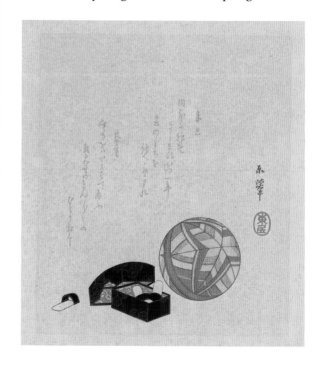

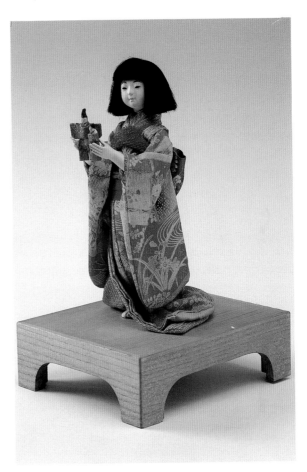

This *shikishiban surimono* (*facing*) depicts a thread ball and a black box with domed lid for the three ivory *koto* picks (*tsume*) used for plucking the strings of the *koto* and protecting the fingertips. They are worn on the inside of the thumb, index, and middle finger. Unread signature and seal.

The second scene (*above*) shows two young women preparing food on lacquer trays to place before the largest dolls of the display. It is Hina Matsuri, the Doll Festival or Girls' Day celebrated on the third day of the third month. On the customary red cloth are exhibited two pairs of *dairibina*, the sitting empress and emperor dolls, and a pair of *tachibina* propped up against the screen, for true to tradition, they cannot stand without support. Many small accessories decorate the stand, and there is food for the dolls and the small children who will soon arrive. Note the shell-game box behind the bending woman's elbow, and the flowering branch outside the window, an allusion to the festival's other name, the Peach Flower Festival (Momo-no-Sekku).

Doll: This doll is part of a series of five, representing the five great festivals of Japan: New Year's Day (1-1), Girls' Day (3-3), Boys' Day (5-5), the Star Festival (7-7), and the Chrysanthemum Festival (9-9). The doll, a young girl, is holding a *tachibina* couple, a distinct symbol of Doll Festival (Girls' Day).

Courtesy of the Ethnographic Museum, Antwerp, Belgium

The third print (*below*), titled *Keg Doll*, is an imaginative rendering of a dance under a flowering cherry tree. When the blossoms are at their most beautiful and the flower-viewing season is at its height, many Japanese pack a picnic and an ample supply of saké (rice wine) and go on a day excursion to shrines and parks famous for their masses of white or pink blooming trees. A space is delimited with cord and curtain, a rush mat spread on the ground, and until darkness falls, the day is spent in a leisurely manner, eating, drinking, singing, dancing, and composing seasonal poems.

Here, the talented young lady has improvised a puppet peep show with verve and versatility; the whimsical doll consists of a small straw hat, a wooden saké keg, and a cloth jacket. The neighboring, somewhat tipsy spectators have lifted the curtain to follow the show but seem more interested in the charms of the dancer, a lovely lady of the Enpo era (1673-1680), than in the doll itself.

Doll: I have tried to make a doll somewhat similar to the depicted example. I have never seen such a doll personally, except on this print titled *Keg Doll* and two others, one of a courtesan resembling this dancing lady, the other (probably) of a saké seller carrying a large saké keg on his shoulder, which he has clothed with his jacket and hat. It could be that the figure was made as an impromptu accessory for a popular song and dance of the time praising the virtues of saké, which would explain a seller advertising his product in this way — wine, women, and song?

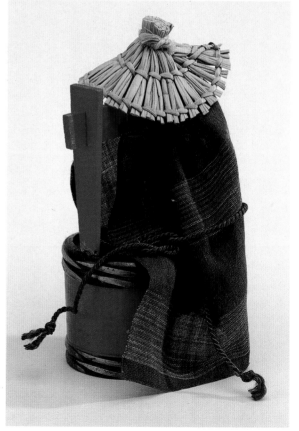

Tsukioka KOGYO 1869-1927

Chinese Wrestling

Kara zumo

Oban / Series: *Nogaku zue* (Pictures of Noh Plays) / Signed: Kogyo
Seal: Minami / Publisher: Matsuki Heikichi / 1897-1902

Kogyo had the benefit of two superb artists as teachers. His stepfather, Tsukioka Yoshitoshi, taught him painting and printmaking, while Ogata Gekko nurtured in his pupil the delicacy of line and refinement of color which remained characteristic of his work. Kogyo has a unique position in Japanese woodblock art in that he is the only artist to have devoted the greatest part of his oeuvre to depictions of scenes and characters from the *noh* theater. Kabuki, always a bestselling subject, had been exploited by virtually all the publishers and printmakers throughout the history of *ukiyo-e*, whereas pictures of the private performances of the esoteric and stylized *noh*, the privilege of aristocracy and court circles, were extremely rare. After the Meiji Restoration, commoners were admitted to the plays, and *noh* knew a certain popularity born of curiosity. Yoshitoshi, Kogyo's stepfather, practiced *noh* chanting, and it is possible that he encouraged Kogyo to venture in the direction of *noh* prints as a more intellectual alternative to kabuki.

This is a singular print, for it depicts child actors (*kokata*), boys of about ten years old who played certain roles in *noh* theater. The emperor, Yoshitsune of the Yoshitsune-Benkei duo, the lost son of a woman deranged by sorrow, and the boy discovering the elixir of eternal youth were such roles; the boys did not wear masks but kept an expressionless face. Here, masks are not worn, but lively poses and false beards are much in evidence, so the scene could be from the comical *kyogen* interludes between acts of the stately and slow-moving *noh*.

The title of this play is *Chinese Wrestling*, and except for the handsome victor standing on the backs of his two victims, all actors are dressed in ornate Chinese costumes.

The print could be a fanciful parody of the story of *Kanshin*, a poor Chinese prince who, to show forbearance, crept between a coolie's legs rather than fight a man of low birth. He later became a famous general and triumphed over his old enemies. Playing at Kanshin is a game where a boy creeps between the legs of a long file of others as quickly as possible and without touching them.

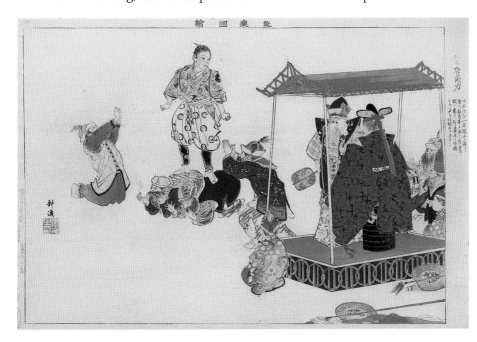

Tsukioka KOGYO 1869-1927

The Warrior Shibata Katsuie

Oban / Series: *Nogaku zue* (Pictures of Noh Plays) / Signed and
seal: Kogyo / Publisher: Matsuki Heikichi / 1899

A masked *noh* actor plays the role of the warrior Shibata Katsuie, wearing rich robes and holding a sword and fan. Besieged in his castle, Shibata is known for breaking the last water jars, so forcing his men to attack and defeat the enemy.

The intriguing part of this print lies in the square cartouche showing a wooden articulated toy. Known as an *ita sumo*, this board or plank sumo toy from Kumamoto Prefecture is capable of assuming the 48 throws of sumo wrestling through the manipulation of a stick (seen protruding into the picture) passed through the arms of the two champions. The association seems tenuous here but is probably a pun based on the

word *kowasu* (to break) and the redoubtable *kawazu* hold. Famous in sumo history, this hold was first used in 1176 by Kawazu Saburo to vanquish his opponent, Matano no Goro.

Another association could be that the province of Echizen (now Fukui Prefecture), where Shibata later ended his life by *seppuku* (ritual suicide) according to the samurai code, was also the birthplace of Yoshida Ietsugu. He and his family were given the right to umpire and apply one set of rules for sumo matches for all future generations.

Toy: A board or plank wrestler toy (*ita sumo*) from Kumamoto Prefecture. In the *Illustrated Lon-*

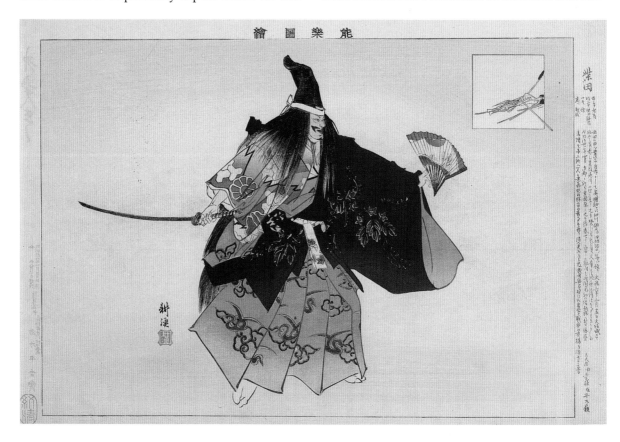

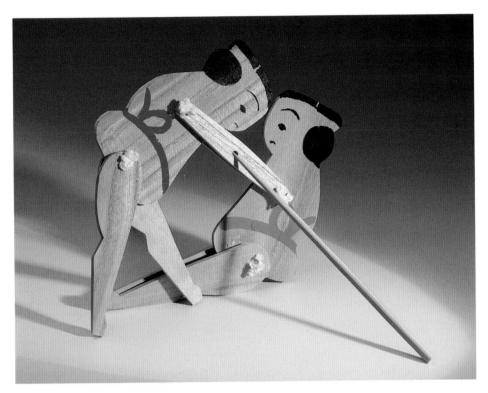

don News (1868), C. Wirgman gives a delightful commentary on the sport: "they put themselves into the position of FROGS...they pretend to go at the wrestling again, but want to throw salt and water..."

This print (*right*) is included because it gives a clear impression of both *noh* actors and Nara dolls. *Noh* actors wearing their stiff and ample brocade robes were the favorite subject of the *itto-bori* (one-knife carvers) of Nara, the birthplace of the classical *noh* drama. The *noh* play *Takasago* tells of a wandering priest's meeting with an old couple who are sweeping and raking the pine needles on the sea-shore (the Japanese say that Uba sweeps unhappiness out, Jo rakes happiness in). They are the spirits of Jo and Uba, who after a long and happy life together have entered two pines, their branches still entwined. Due to their rich symbolism, dolls representing the couple are popular as wedding and anniversary presents. Because of their beautiful costumes, *noh* actors are

often models for costumed dolls made by amateurs and professionals alike.

Jo and Uba, the Happy Old Couple of Takasago. Unread signature and seal / oban.

Dolls: Jo and Uba, Nara dolls made in the *ittobori* manner.

Costumed dolls (*ishobina*) of *noh* actors. Uba, carrying her brush over her shoulder, and Okina, a smiling ancient who dances to bring the blessings of peace and happiness to earth, both made by a well-known professional dollmaker, Nijo Seisen.

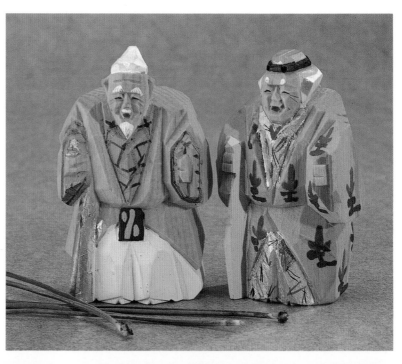

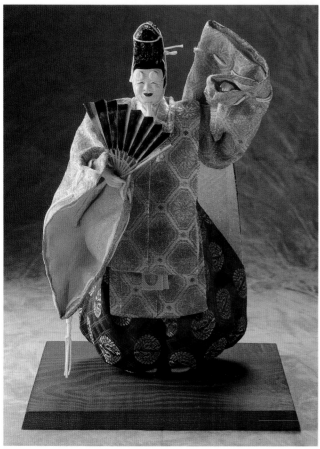

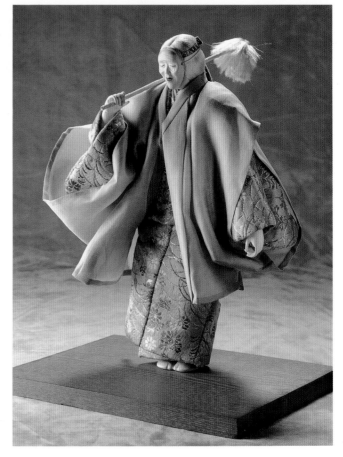

Miyagawa SHUNTEI 1887-1907

The Sixteen Soldiers Game

Juroku musashi

Oban / Series: *Kodomo fuzoku* (Children's Customs) / Signed: Miyagawa Shuntei
Publisher: Akiyama Buemon / 1896

The Sixteen Soldiers Game is a favorite New Year's pastime. It is a board game that resembles the Western game of Fox and Geese but with a military tint, for the fox has become a general (*taisho*) and his opponents are the sixteen soldiers.

One player holds the general, the other, 16 small, round paper pawns. The game is played on a board divided into diagonally-cut squares. The general is the strongest piece; he can move in all directions and captures soldiers when they are just next to him by jumping over to an empty square beyond. Vanquished soldiers are removed from the board. The general wins when only five soldiers remain. The soldiers may only go forwards and sideways. To win, they must surround the general so that he cannot move.

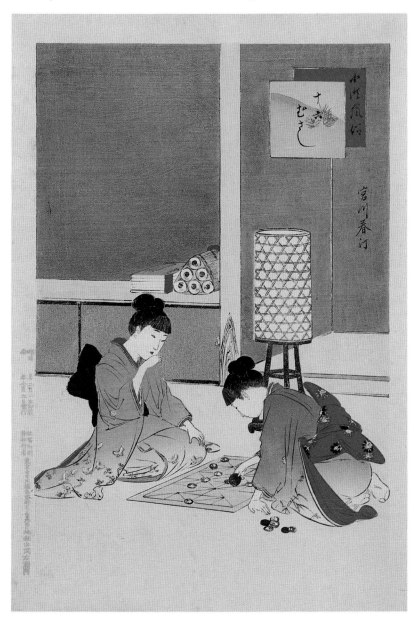

Yamamoto SHOUN 1870-1965
Playing Children
Chuban / Signed: Shoun in seal

This long-lived artist was born in Kochi Prefecture on the island of Shikoku. At the age of 13, he went to Tokyo to study under the Nanga painter Taki Watei. He became well-known not only as a painter but also as an illustrator for *The Pictorial Journal* (Fuzoku Gaho). A versatile designer, he drew fashion catalogs, beautiful women, and famous views of Tokyo. He received many awards for his *nihonga* (Japanese-style painting), and his series *Aspects of Women Today* is generally recognized to be the link between the traditional print of the Meiji period and the *shin hanga* (new print).

Indubitably among his strongest works were his books, albums, and pictures of playing children, in which his detailed and careful depictions of toys and kimono fabrics show that he was also active in the advertising and textile industries and well aware of what was on the market in the way of toys. Note that the young trumpeter has a *shogi* game counter motif on his clothes.

This delicately colored print with extremely deep contours shows a group of seven children

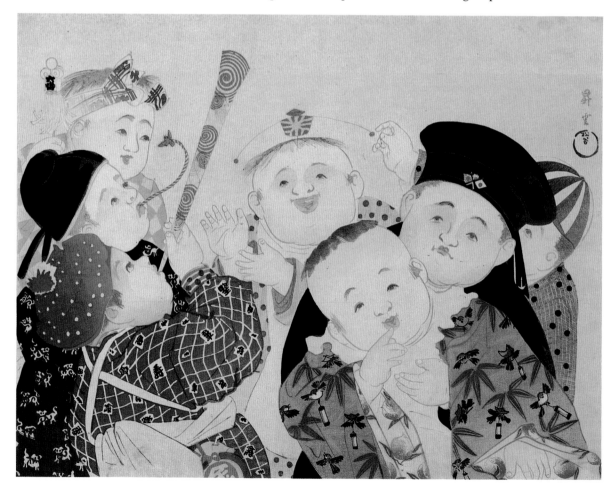

playing with various toys—a trumpet, a roll-up blow toy, and a miniature firemen's standard—universal as well as typical Japanese ones, while a little boy at the back balances the well-known *mamezo*, a swaying, weighted bean doll-acrobat, on his head. Although the children's clothes are strictly Japanese, the fashion for foreign headgear is amply illustrated, ranging from a black Chinese cap with ribbons and a Scottish tammy with a pom-pom, to a sailor hat, a British school cap, and a simple Japanese headband.

Game: Around two small dolls, male and female, made from the "gold" and "silver" *kinsho* and *ginsho* generals, is a fanciful upright grouping of the 40 counters of the *shogi* game. With the same Indian origin as Western chess, *shogi* is known as Japanese chess. *Shogi* is played on a board of nine by nine squares; the pieces are laid

flat, and some can be "promoted" to stronger "gold" pieces after reaching the last three lines of the opposing camp. Captured enemy pieces change sides and may be put back onto the board to do battle for their new possessor.

It is interesting to note that the Japanese word *narikin*, meaning a newly rich "big shot" whose wealth was acquired by somewhat dubious means, derives from the *shogi* term for a humble pawn promoted to a gold general. Also, the nickname of the Kannon Temple of Nikko is Kyusodo, named for the *kyuso*, the *shogi* pawn than can only move straight ahead. Expectant mothers go to the temple to borrow a large pawn as an aid to easy childbirth. If all goes well, they must donate a larger one than the one they borrowed. Needless to say, the temple is well stacked with oversized *kyuso*!

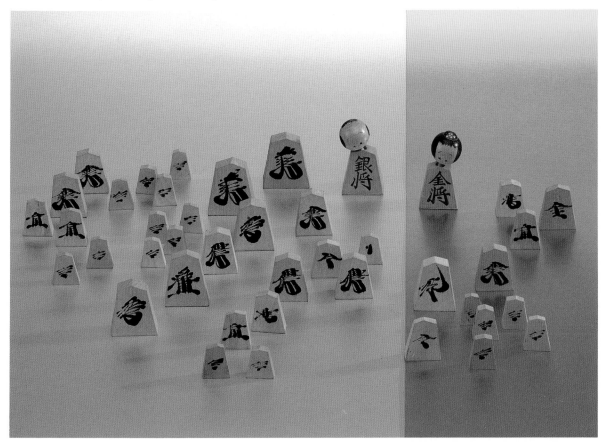

Kawase HASUI 1883-1957

Four Doll Prints

From a portfolio of dolls titled *Japanese Dolls: Gosho Ningyo*
Signed and sealed: Hasui / Publisher: Meiji Shobo / Engraver: Kato Junji

This series of 24 prints, titled *Japanese Dolls* and published by Meiji-Shobo of Kanda, was probably a limited edition for doll-lovers and foreigners, since the preface is entirely in English (of a kind). Although *gosho* (palace) dolls form the majority, other types of traditional Japanese dolls are included, as can be seen from the examples here. These are two *gosho* dolls playing with a small smiling dog, a *tsuchi ningyo* (painted clay doll) representing a kabuki actor; a pretty *ishobina* (kimonoed or costumed doll); a rare *Saga ningyo* (Saga doll) depicted as a trumpet-playing *karako* (Chinese child). Saga, a town near Kyoto, was formerly known for its precious head-nodding, tongue-showing dolls. These were carved from wood and carefully lacquered and gilded and are thought to have been made by sculptors of Buddhist statues or carvers of *noh* masks.

This doll series is, in fact, a rare and curious item for a woodblock artist who was the foremost *shin hanga* (new print) landscape specialist of his day, producing almost exclusively for the printer Watanabe Shozaburo. His grandiose plan of designing 12 series of prints of Kyushu came to nothing when the Great Kanto earthquake of 1923 struck, destroying most of his sketchbooks and the prepared blocks for some 60 prints already published. Hasui has, however, left us a large legacy of technically well-done and often sensitive prints, showing how the changing seasons passed over the towns and countryside of Japan before technology took over for good.

Doll: Gosho doll holding a treasure bag.
Courtesy Prince and Princess Takamado, Tokyo, Japan

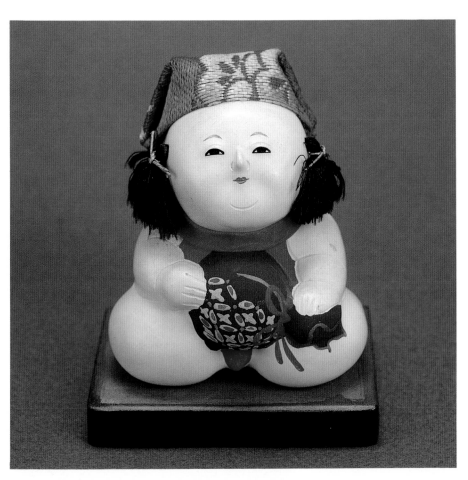

Yamakawa SHUHO 1898-1944
Kyoto Doll
Kyo ningyo
Picture envelope (*e-futo*) / 16 cm X 6 cm / Signed: Shuho / c. 1920

A neo-*ukiyo-e* artist who specialized in *bijin* (beautiful women) subjects, Shuho here uses an original way to represent a doll lady dressed in the rich and fashionable silks and brocades of Kyoto. He has placed her by the box of a prestigious *kyo ningyo* (Kyoto doll).

It was customary to pack an artistic or delicate object in its own made-to-measure wooden box (*tomobako*) for storage and protection from insect damage and temperature changes. The *tomobako* is a precious asset, for its lid usually carries the date, the name and seal of the artist, and a description of the object enclosed. In Japan, the wrapping of a gift is very important, so it is not surprising that an artistically valuable envelope was used for a card or letter to a friend or to discreetly enclose some small coins for a child. Such attention to detail would only add to the joy of the receiver.

Doll: A representative example of a modern *kyo ningyo*, a Kyoto doll with a stylish coiffure, dressed in the beautifully woven textiles for which Kyoto has always been famous.

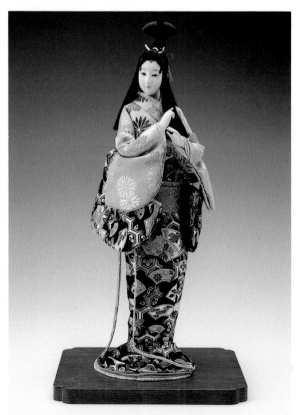

Unsigned
Boy Playing with Top
Koban

A simple yet delightful little picture showing the mastery of the woodblock cutters and printers in transposing the very essence of the print designer's brush drawings and sketches. The difference between this woodcut and a delicately colored painting is barely discernible. Not just a skilled exercise in line and color, the print also clearly conveys the joy and concentration of a young lad playing with his favorite toy.

Tops of many shapes and materials have been found all over the world, and they are certainly among the most ancient toys known. The top's origins are lost in the mist of time, but it possibly dates from many millenniums before Christ. Antique Greece and Rome knew the game, and the Roman statesman Cato recommended the pastime as an excellent alternative to dice throwing and betting. In all countries, top playing was a boys' game, bound to specific events and seasons; in Japan, spinning tops and flying kites were games symbolic of winter and the New Year.

In her book *Antique Toys*, Gwen White credits Japan with the probable invention of the top, derived from Korean wax-filled shells. If this is so—and it is a plausible theory, although I am inclined to think that this toy appeared spontaneously around the globe—the top is one of the few things that did not blow over to Japan from China! One thing is certain: as for variety and inventiveness, Japan surely has the largest assortment. They include Siamese twins; fanciful shapes; mini and maxi; rope and whipping; "thunder" or humming tops; do-it-yourself tops made from shells, acorns, or money; the lantern top (*chochin-goma*), which distends its pleated sides and grows taller when spun; the servant-top (*yakko-goma*), carrying a miniature balancing bean doll (*mamezo*); the child-bearing top (*komochi-goma*) which releases a flock of tiny ones as it spins; and wrestling tops (*sumo-goma*), made to jostle each other out of a wooden ring. Prints show nimble children and agile acrobats balancing the spinning top on heads, hands, noses, fans, *hagoita,* and stretched strings. For those who want to start a practically endless collection, Japanese tops are highly recommended!

Tops: A small selection of differently colored and shaped tops.

135

Miyagawa SHUNTEI 1887-1907

Paper Folding
Origami

Oban / Series: *Kodomo fuzoku* (Children's Customs)
Signed: Shuntei Gyoshi / Publisher: Akiyama Buemon

There is no doubt that ever since the invention of paper, paper folding has been a creative pastime throughout the world. Who does not remember the soldier's hat and the sailing boat of younger days?

Nowhere in the world, however, has this gentle art been brought to such a pinnacle of perfection as in Japan. Known as origami, it is taught in schools, and there are literally hundreds of books on the subject for the hobbyist and specialized clubs. Origami, like *haiku*, has found its way abroad, and there are now numerous enthusiastic practitioners of this paper art in many countries. The origin of origami can be traced back to Shinto and Buddhist rituals using paper silhouettes, ornaments, and offerings. Even now, strings of a thousand folded paper cranes (*senbazuru*) are offered at shrines and temples, usually for the repose of deceased relatives.

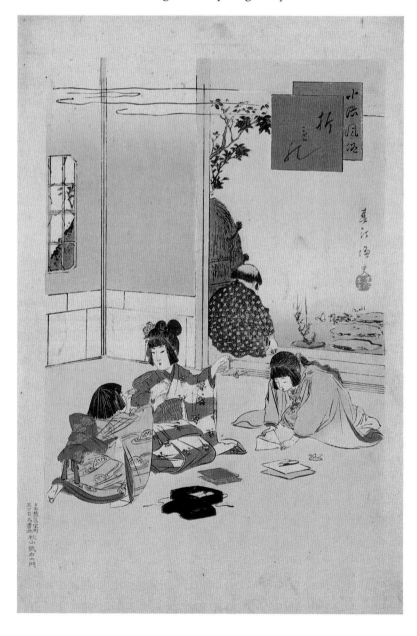

The two girls in this print are diligently occupied with their materials spread around them. Their simple equipment consists of a lacquer box containing colored paper and a pair of scissors. They have made two of the most representative toys of Japan: a crane, symbol of longevity, and a samurai helmet, emblem of *bushido*, the way of the warrior. While the smaller girl reaches for the crane, a little boy sits tranquilly in the doorway, lost in the contemplation of a bonsai tree and a butterfly.

Origami: Santa Claus and a friendly dog in the snow, under a starry sky—just a few examples of the art of origami paper folding.

Illustrations: Below are two rare examples of paper-folded dolls. From Kagoshima Prefecture, there is a Satsuma *itobina* thread doll (*below left*) made with *doro-e*, distemper-painted paper, which is folded round a hollow stem in which silken threads are inserted. Made in pairs as collectors' items, the wooden stem is painted red for the male and blue for the female.

In Stewart Culin's book *Games of the Orient*, it is noted that Korean girls made their own dolls from "a bamboo pipe-stem, into the top of which they put long grass, which they have salted and made soft." As the Korean immigrant influx was greatest in Kyushu, it is possible that these dolls are of Korean origin.

The simple triangular paper couple (*below right*)

with knotted featureless heads are known as Ryukyu dolls (*ryukyubina*), Ryukyu being the ancient name for the island of Okinawa.

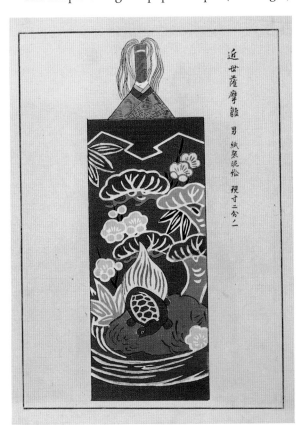

Unsigned
Three Gods Playing Kemari

Painting sumi ink and touches of color on beige paper / 24 cm X 35 cm
Courtesy of Ichiban, Gent, Belgium

Their abandoned attributes scattered around them, three of the seven gods of luck are playing a lively game of *kemari* (football). On the right, Hotei, the rotund god of happiness, has for once forsaken his large sack and rigid Chinese fan. Daikoku's rice bales, symbolic of wealth, are just visible behind the bag. On the left, Fukurokuju has flung his twisted staff to the ground, his wisdom and longevity forgotten in the pleasure and excitement of the impromptu match. As they are all "lucky" gods, we may wonder: who will be lucky enough to win the game?

Kemari, kickball or football, was a game imported from China in the middle of the seventh century. Originally, it was only played by the upper class, to the point that some emperors became veritable experts and impoverished noblemen taught the game to supplement their incomes. There were two versions of *kemari*: for one, a leather ball, stuffed with horsehair and shaped like two flattened ball halves sewn together, was kicked between goalposts of flowering trees. In the other version, the players sedately stood in a circle, wearing brocade robes and black lacquered court caps, and struck the ball with the side of the foot, the aim being to keep the ball in the air without letting it touch the ground. Later the game spread to all classes (there is even a Toyokuni diptych showing two courtesans playing), but it never became a truly popular pastime. Tachibana Minko (fl. c.1764-1772) illustrates two *kemari* makers at work in his book *Colored Pictures of Classified Artisans*. The game is now obsolete, played only by a folkloric society of Kyoto devoted to Heian-period customs. In 1963, for example, they played before King Bhumibol and Queen Sirikit of Thailand on the occasion of their visit to Japan.

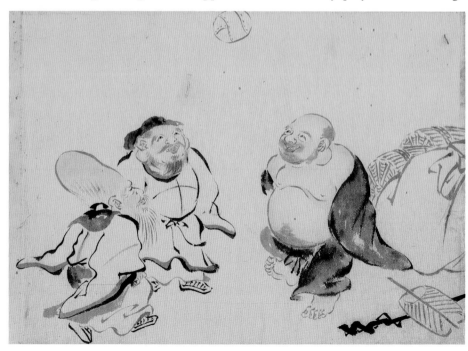

Unsigned

Woman with Drummer Toy

Kakemono-e / Painting sumi ink and colors on silk
Two small unread seals in lower right corner / 87cm X 31cm

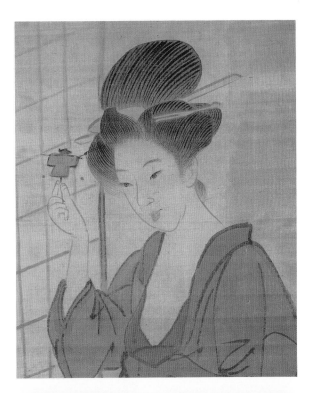

A charming indoor scene, one that might be seen anywhere in the world when a young mother plays with her child or gently teases it with some coveted new plaything. A standing woman holds up a small toy, while her baby sits on the ground at her feet, looking up. The *haragake*, a single red apronlike garment tied at neck and waist, and the shaven head are typical for baby boys. This hanging scroll, painted in soft hues of beige and brown,

enlivened with black and deep red accents, could well have been been a treasured gift received on the birth of a son.

Toy: The tiny toy is a colored cutout figure on a stick, holding a string with an attached bead in each hand. The mother spins it between her fingers and thumb, and the beads beat on the stiff paper silhouette like drumsticks.

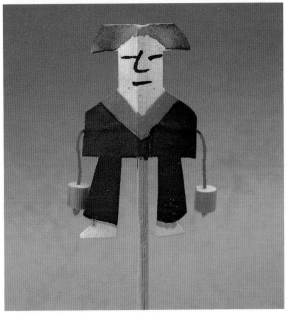

Unsigned
Children and Their Toys
Lithograph / 27cm X 37cm / Dated Meiji 26 (1893)

This print shows how deeply Western influence had penetrated Japan by the end of the 19th century. Etching, lithography, and photography had made their entry, and all Japanese artists were intrigued by the innovations, studying them openly or deriding them as foreign fads. This lithograph which seems to combine all three of these disciplines, serves as an elaborate exercise in classic Western technique and composition.

It is easy to imagine that a Western photograph was the model for this posed group. The most uninspiring form of photography ever, the group portrait is still exceedingly popular in modern Japan (confirmed by the scores of students and tourists standing on temple steps). The print is, admittedly, executed with the utmost care and patience of an artist who masters his technique with superlative skill, but it has the static quality of a frozen film still. Even the crawling child in the foreground is reminiscent of the sugary album snapshots of plump, naked babies on sheepskins so cherished by our grandparents.

Yet, penetrating the foreign veneer, we may catch a more convincing glimpse of the playing children of Yamamoto Shoun and the plump, big-headed *gosho* dolls of ancient times. The tops, train, trumpet, and pinwheel were all toys which might be seen anywhere in the world at that time, but the *daruma*, drum, fan, and fox mask are authentically Japanese. The toy train in the foreground occupies the place of honor, showing that it became a much prized novelty after Commodore Matthew C. Perry had brought a small-scale train which really ran as a present for the young Japanese emperor in 1854. As Mutsuhito (b. 1852) was only two years old at that time, the present was undoubtedly meant more to impress the Japanese with superior Western technology.

Although not great art, this print has veritable documentary value. It succeeds in capturing an old-fashioned atmosphere with the naive and nostalgic charm of our own faded and browned sepia photographs. The result is a puckish and playful combination of East and West.

Unsigned
Two Gosho Dolls with Hobbyhorses
Oban

This appealing print is a *mitate-e* (parody picture) of Boys' Day. The event, celebrated on the fifth day of of the fifth month was also known as the First Horse Day (*Tango no sekku*). On this occasion, dolls representing famous military figures complete with miniature armor, weapons, war helmets, battle banners, and accompanied by the white horse of the gods, were exhibited in and outside the homes of the warrior class for the edification of their male children. The custom (although curtailed by sumptuary edicts more than once) soon spread to all families with young sons. Two boys in the guise of *gosho* (palace) dolls are playing jumping horse (*harugoma*) near a *gosho-guruma*, a cumbersome, ox-drawn carriage reserved for the high-born. The wisteria blossoms decorating the roof of the vehicle are symbolic of youth, spring, and the month of May. The swords, court caps, and expensive toys indicate the noble birth of the

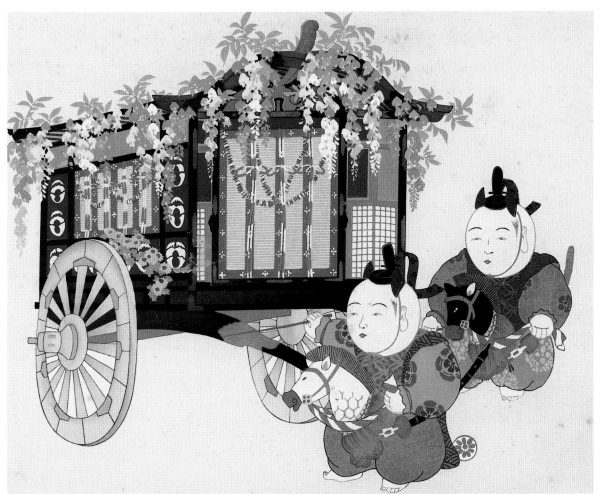

children. The story playfully pictured here is probably that of Minamoto no Yoritomo's two generals, Kajiwara Kagesue and Sasaki Takatsuna, who, to show their bravery, raced each other across the Uji river 1184 to be the first to meet the enemy forces. Kajiwara was first, but the sly Sasaki shouted to him that his horse's girth was loose. Kajiwara reigned in his horse, and by this somewhat dubious strategy Sasaki won the race to face the adversary. Legend tells that Yoritomo himself had given the white horse, Ikezuki, to his general Sasaki, and that the black one, Surusumi, had been given to Kajiwara by Yoritomo's half-brother, Yoshitsune.

Dolls: This superb, though sad-faced *kiri* wood *gosho* doll (*below*) has been signed by Yasukazu and embodies a wish for a long and happy life. The Manchurian crane it holds is symbolic of longevity.

Gosho dolls are synonymous with souvenirs of Kyoto, the imperial capital, where successive powerless emperors resided from the Heian period (794-1185) until the Meiji Restoration of 1868. It is a well-known fact that emperors and court nobles had these dolls made to give to visitors who brought gifts and came to pay their respects at the Gosho (Imperial Palace). There is even a story that the emperor and his impover-

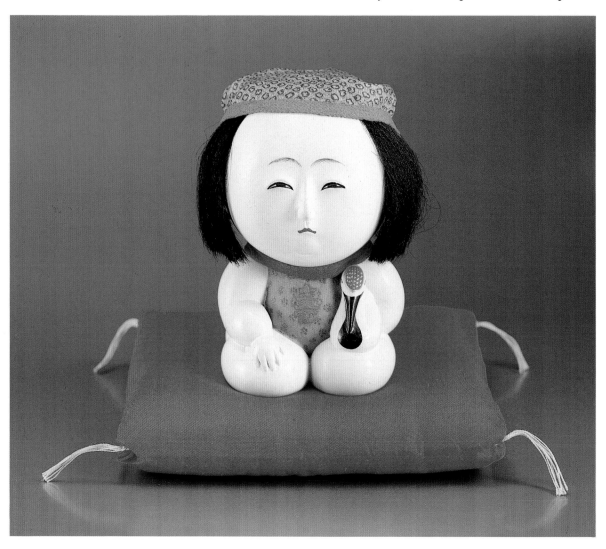

ished courtiers sold their old clothes to dollmakers to be used as dressing material. Perhaps the tale is not strictly correct, but the imperial court was at times so poor that the story might have been invented to show how badly off the nobles really were or to poke fun at them because the dolls usually wore a court cap and were dressed in small scraps of material.

The scantily clad baby boy (*below*) — the clothes are either painted or pasted on — has many different names, but the two that best typify it are *zudai ningyo* (big-headed doll) and *shira-jishi ningyo* (white-skinned doll). The proportions are eccentric, the head being one third of the entire figure, or even as large as the body, and the skin a pure glowing white, an effect obtained by burnishing the covering *gofun* layer, a mixture of glue and calcined, pulverized oyster shells. Naturally white skin or faces artificially whitened with paste and powder were signs of aristocracy. At first, *gosho* figures were made of mold-pressed clay or sawdust and glue, but the highest quality dolls were, and still are, carved from *kiri* wood (Paulownia imperialis).

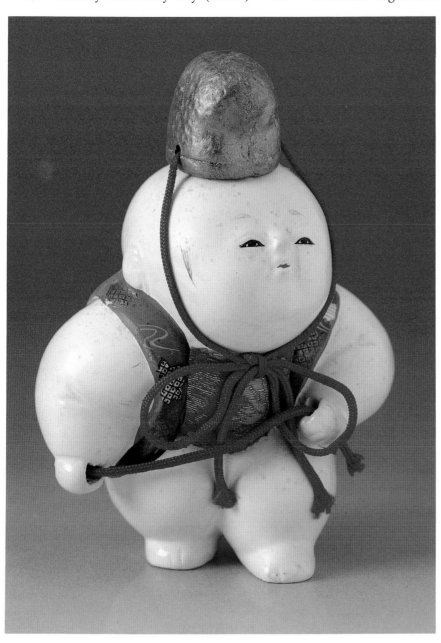

EISHUN
Elegant Parody of the Six Jewel Rivers
Furyu mitate roku tamagawa
Chuban / Signed: Eishun ga (Drawn by Eishun) / Round *kiwame* (approved) seal
Publisher: Moritaya Hanjiro / c.1830-1850

The six jewel rivers (*tamagawa*) were famous in Japan for their pure, clear waters. Although geographically far apart, they shared a common name, and their peculiarities and poetic pseudonyms were often used as the titles in series of six prints. The lady's fashionable *obi* shows an obvious allusion, for it is decorated with a jewel here and there in the shape of the *tama*, the jewel that grants all wishes and was often carried by Buddhist deities.

Many celebrated poets were inspired by the jewel rivers, and it is interesting to illustrate with a few examples, how they transcribed those limpid waters into word-pictures. From south to north, using the old names for the provinces, the six rivers and their associations are:

1. The Toi Jewel River in Settsu Province
kinuta - a fulling block, used to beat cloth to make it soft and shiny
"Whispering wind in ancient pines / desolate autumn / in the village by the Jewel river / where clothes are wrung."
Shunrai (1057?-1129)

2. The Ide Jewel River in Yamashiro Province
yamabuki - Kerria japonica, a deciduous shrub also known as mountain rose
"I halt my horse / to let it drink anew / of the yellow flowers reflected in / the Jewel river of Ide."
Shunzei (1114-1204)

3. The Koya Jewel River in Kii Province
Koyasan - Koya mountain, a place of burial and banishment for high-ranking personages
"Unknowing traveler, beware / of dipping water / from the depths of the Jewel river at Koya..."
Kukai (773-835)

4. The Noji Jewel River in Omi Province
hagi - Lespedeza bicolor, bush clover, one of the seven flowers symbolic of autumn
"Tomorrow I return" / said the sleepy moon, "to the Jewel river of Noji, / to rest amid reflections / of bush clover."
Shunrai (1057?-1129)

5. The Chofu Jewel River in Musashi Province
chofu - bleached cloth
"The cloth for the tribute, ah... / that is bleaching on the hedge / is soaked with the pink tint of dawn, / village by the Jewel river."
Teika (1162-1241)

6. The Noda Jewel River in Mutsu Province
chidori - plover, whose plaintive cry denotes longing and loneliness
"As night falls / a salt wind blows / above the Jewel river of Noda. / At Michinoku, the mournful plovers cry."
Noin (988-1050?)

The rivers were favorite subjects not only for poets, but also for print artists. In this print, the Noda river is very discreetly alluded to by plovers, an association seen in the last verse above. The plover is portrayed by the naive pleated-paper bird on a stick carried by the child.

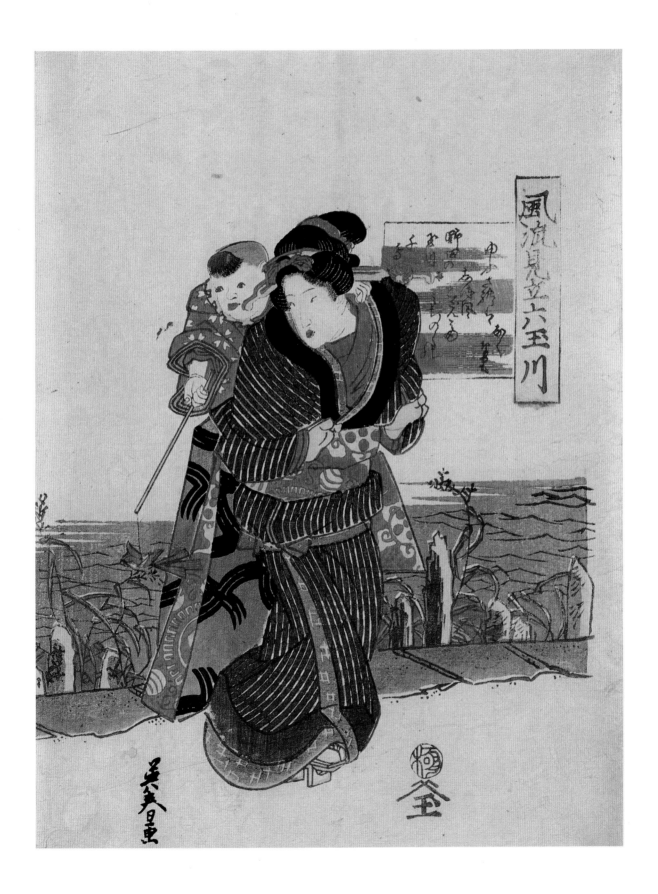

Unsigned
Two Book Covers
Signed Tsuruya ban (Printed by Tsuruya Kiemon)

Too far above us
was our love
poor Suma fishermaids.

The illustrations shown on the covers of these two small woodblock-printed books are *mitate-e* (parody pictures) of a ninth-century story. The beautiful young sisters Matsukaze (Pine Breeze) and Murasame (Passing Shower) were salt gatherers (*shiokumi onna*). They were loved by the noble Lord Yukihira, who had been banished to Suma-no-ura for some gallant offense. Granted pardon after three years, he was recalled to the Kyoto court. He left his luxurious clothes behind as a keepsake, promising to return for them.

Day after day, the two lonely girls went to the beach to wait for his return. All in vain, for fickle Yukihira, surrounded again by the refined pastimes and ceremonies of court life, forgot his love and his promises, forgot to keep his word. The sisters became deranged with grief and dressed up in his rich robes while going about their lowly work.

"Every time I see those clothes,
Vain thoughts come to mind.
For even the space a dewdrop holds
A leaf tip ere it falls,
I can't forget —
Ah, would that I could!"

Here, their saltwater containers have been replaced by the storage boxes of the shell game, carried by one of the sisters, while the other tries to find matching shells on the sands of the Suma seashore. The lacquered boxes represent costly gifts from the nobleman, for village girls would not possess such splendid objects. The girl searching for the matching shells, which symbolize fidelity, is sadly aware that it is near impossible to find two identical halves, half of any pair having probably been swept away by the waves of the sea forever. The tale was very popular during the Edo era, and a ballad, the *noh* play *Matsukaze*, and the popular kabuki dance Shiokumi were all based on the story.

Doll: A padded doll on a pointed bamboo stick (*oshiebina*) represents one of the sisters carrying her buckets of brine. She wears the clothes and court cap of Lord Yukihira. These flat, padded dolls, first produced around 1820, were a specialty of Matsumoto. Made mostly for Girls' Day and Boys' Day, over 500 different models were made, including entire scenes from *noh* and kabuki dramas. The dolls were also known as stick *hina,* since the pointed sticks beneath their clothes allowed them to be stuck upright into the ground or tatami mats.

It is also interesting to note that even *ukiyo-e* prints have been found with cut-out parts replaced by padded textiles.

FUJITA Tsuguji (or Tsuguharu) 1886 (Tokyo) - 1968 (Zurich)

Child with Fair Weather Doll

Woodblock print / 45 cm X 28 cm / Signed: Tsuguji (in Japanese) / Foujita (à la française)

A serious blue-eyed child, her hair tied in a pretty Japanese-style topknot, holds a sad-eyed and floppy fetish doll, a version of the *teru-teru bozu* (fair weather doll). The name translates as "shine-shine bonze" and refers to the shaven heads of Buddhist monks on which the sun reflects. The child's doll is not exactly true to type, as it is colored and wears a tiny cape, but it is certainly inspired by the fair weather doll. The latter was, in turn, perhaps based on the simple paper silhouettes hung up for Tanabata Festival, when fine weather is crucial. The doll could also be a Chinese immigrant who came to Japan together with Buddhism, a rustic representation of the Buddhist saint Jizo, who is the protector of children and always depicted as a shaven-headed monk.

Fujita means "field of wisteria" and Tsuguharu "heir to peace," explained the artist to first-time acquaintances. Fujita, after flitting from flower to flower in his "wisteria field"—three marriages and an authentic Bohemian life—became the "heir to peace" when he was converted to the Catholic faith in 1959. From then on, he adopted the first name Leonard, as his spiritual awakening had been caused by the sight of Leonardo da Vinci's famous painting *The Last Supper*. At the age of 80, he had a chapel built to Our Lady of Peace at Rheims, for which he painted the frescoes and designed the stained-glass windows. He was one of the few modern Japanese artists who achieved interna-

tional fame and success outside his homeland. He applied French oil techniques to his paintings and produced refined drawings and prints in many mediums. The characteristic pastel colors and del-

icate contours of his graphics clearly reveal his Japanese background. He was a friend and contemporary of such leading figures of modern Western art as Modigliani, Matisse, and Picasso. His woodcuts link him to the classical Japanese *ukiyo-e* by the line, the flat colored planes, and a minimum of perspective. It is known—and shown in many of his prints and paintings—that Fujita was an avid collector of old dolls, and that he built dolls' houses with all their miniature furnishings. This bewitching picture proves that although far from his country, Fujita still cherished the folk traditions of his youth. See, too, how well the artist has conveyed the intense mood of the owner, absorbed and reflected by the doll. The child's wide-eyed, hypnotic gaze is enthralling, making us believe that she and her doll possess supernatural powers and can work magic at will.

Doll: The true *teru-teru bozu* is made from a square piece of white rag or paper, some stuffing for the head, and a piece of string round the neck. It is indeed a crude and ephemeral doll, which is hung up to petition the gods for sunny weather on special occasions. If the sun shines, the doll is dipped in saké; if it does not, it is cut in two and the head left hanging to decay.

SHIBUYA, Eiichi b.1928
Miku Playing Ball
Color etching / No.3 of 50 prints / 24cm X 14cm / Signed: Eiichi Shibuya

Copper etching, a technique introduced by the Jesuits in the 16th century, had been dormant until it was reintroduced by the Dutch merchants at Nagasaki. Shiba Kokan (1747-1818), the copyist of Harunobu and an enthusiast of Western art and perspective, produced the first hand-colored etchings and reversed views for magic lanterns in 1783. Not a national tradition like painting and woodblock printing, it is a fairly rare discipline that has few adepts among present-day artists.

Playing ball is a game that started many thousands of years ago—no one knows how many thousands—and still continues. As long as there are children, they will play games, they will play with toys, and, in an attempt to recapture their childhood memories, artists will depict the joy of children at play. Before benevolent gods, a group of children playing ball with heart and soul probably has more value than all the Olympic Games put together.

Unlike tops and kites, of which there are countless varieties, balls do not seem to have enjoyed the same popularity in Japan as the

balls used in other countries for many familiar games. Indeed, before the Meiji Restoration, the only three ball games shown in documents were a kind of polo called *gitcho*, the Heian period *kemari* (football), and the pretty silk-thread *temari*, a handball game reserved exclusively for young girls. *Temari* were filled with hair, cloth, or paper, so they did not bounce; only when they were stuffed with tightly wrapped natural sponge did they become more elastic. There was, and is, also an inflatable paper ball, a fragile cross between ball and balloon, made of multicolored segments. Hobbyists make decorative brocade balls using the *kimekomi* method.

After World War II, many foreign ball games became popular in Japan, and it would be hard to imagine television sports news without the latest commentaries on golf, tennis, baseball, bowling, basketball, ice hockey, and table tennis tournaments. The few true Japanese ball games have long disappeared except in folkloric societies, and the silk-thread *temari* is now a purely decorative item, but, breathless and rosy-cheeked, his string ball unwinding and falling apart, young Miku continues his race with his friends and happily plays on...

Toys: Two traditional and colorful handmade *kimekomi* balls. They are too heavy and ornate to play with and are usually decorative items only.

BIBLIOGRAPHY
Doll and Toy Books

BARBICAN ART GALLERY. *Karakuri Ningyo: An Exhibition of Ancient Festival Robots of Japan.* London: Japan Foundation, 1985.

BATEN, Lea. *Japanese Dolls: The Image and the Motif.* Tokyo: Shufunotomo, 1986.

BATEN, Lea. *Japanese Folk Toys: The Playful Arts.* Tokyo: Shufunotomo, 1992.

CAIGER, G. *Dolls on Display.* Tokyo: Hokuseido Press, 1933.
Still one of the best documents on Girls' and Boys' Day festival dolls; also good for identifying historical and legendary personages.

CASAL, U. A. *The Five Sacred Festivals of Japan.* Monumenta Nipponica Monograph. Tokyo: Sophia University and Charles E. Tuttle, 1967.
Some unusual doll drawings from Kottoshu (Collection of Curios) by Santo Kyoden are used as illustrative material.

CULIN, Stewart. *Games of the Orient.* 1895. Reprint Rutland, Vermont and Tokyo: Charles E. Tuttle, 1958.

GRIBBIN, Jill and David Gribbin. *Japanese Antique Dolls.* New York and Tokyo: Weatherhill, 1984.
A good general survey, with the accent on clay dolls.

GRUNFELD, Frederic V., Léon Vié, Gerald Williams, and R.C. Bell. *Spelletjes uit de hele Wereld.* Amsterdam: Kosmos, 1975.

GULICK, Sidney L. *Dolls of Friendship: The Story of a Goodwill Project Between the Children of America and Japan, 1926-1927.* New York: Friendship Press, 1929.

HIBI, Sadao (photographer). *Japanese Tradition in Color and Form: Pastimes.* Tokyo: Graphic-sha, 1992.

HILLIER, Mary. *Automata and Mechanical Toys.* London: Jupiter Books, 1976. Reprint. London: Bloomsbury Books, 1988.
Contains an authoritative chapter on karakuri.

HIRATA, Goyo. *Hirata Goyo ningyo sakuhin shu.* (Collection of dolls made by Hirata Goyo). Tokyo: Kodansha, 1972.
Beautiful illustrations of dolls made by a Living National Treasure.

IWADO, Tamotu. *Children's Days in Japan.* No. 12. Tokyo: Tourist Library, 1936. Reprint 1941.

JICC. *Hanabi: The Fireworks of Japan.* Tokyo: Japan Publications Trading, 1986.

KATONAH MUSEUM OF ART. *Asobi: Play in the Arts of Japan.* New York, 1992.

KITAMURA, Tetsuro. *Ningyo* (Dolls). Nihon no bijutsu (Arts of Japan) No. 11. Tokyo: Shibundo, 1967.

KOKUSAI BUNKA SHINKOKAI. *La Poupée Japonaise.* Tokyo, 1940.

KYOTO NATIONAL MUSEUM. *Dolls of Kyoto.* Kyoto, 1970.

KYOTO SHOIN. *Toy Museum.* 24 vols. Kyoto: Kyoto Shoin, 1992. (Japanese language only.)

McFARLAND, Horace N. *Daruma: The Founder of Zen in Japanese Art and Popular Culture.* Tokyo and New York: Kodansha International, 1987.

MUSEE DES ARTS DECORATIFS. *Jouets traditionnels du Japon.* Paris, 1981.

NISHIZAWA, Tekiho. *Dolls of Japan/Poupées Japonaises.* Tokyo: Kokusai Bunka Shinkokai, 1934.
An interesting bilingual descriptive book/catalog of the November exhibition at the Stedelijke Feestzaal, Antwerp, Belgium.

NISHIZAWA, Tekiho. *Japanese Folk-Toys.* Tourist Library No. 26. Tokyo: Tourist Library, 1939.

NISHIZAWA, Tekiho and Kampo Yoshikawa, eds. *Celebrated Dolls East and West.* Kyoto: The Kyoto Press, 1951.

NISHIZAWA, Tekiho. *Nihon no ningyo to gangu.* (Japanese dolls and folk toys). Tokyo: Iwasaki, 1957.

SAINT-GILLES, Amaury. *Mingei: Japan's Enduring Folk Arts.* Tokyo: A. Saint-Gilles, 1983. Reprint. Rutland, Vermont and Tokyo: Charles E. Tuttle, 1989.

SCHAARSCHMIDT-RICHTER, Irmtraud. *Japanische Puppen.* München: R. Piper & Co. Verlag, 1962.
Mini-book, well illustrated, with a concise general introduction to Japanese dolls.

SEKI, Tadao. *Yugigu* (Games). Nihon no bijutsu (Arts of Japan) No. 32. Tokyo: Shibundo, 1968.

SHISHIDO, Misako. *The Folk Toys of Japan.* Trans. Tatsuo Shibata. Rutland, Vermont and Tokyo: Japan Publications Trading, 1963.
Contains 50 drawings of representative folk toys.

SONOBE, Kiyoshi and Kazuya Sakamoto. *Japanese Toys: Playing with History.* Trans. Charles A. Pomeroy. Tokyo: Bijutsu Shuppansha and Charles E. Tuttle, 1965.
Recommended for the book's artistic black and white photography.

STARR, Frederick. *Miss Dorothy.* Tottori: Ita, 1929.
A small two-volume set, one volume about an American blue-eyed doll, Dorothy, that Starr sent to Mr. Ita in Japan for his daughter. A naive and amateurish privately printed edition.

STREETER, Tal. *The Art of the Japanese Kite.* New York and Tokyo: Weatherhill, 1974.
An interesting study of kites and kitemakers by a noted American sculptor.

SUWA, Shigeo and Shizuko Suwa. *Japanese Paper Dolls.* Tokyo: Shufunotomo, 1976.

TAKEUCHI, Chizuko and Roberta Stevens. *An Invitation to Kokeshi Dolls.* Tsugaru Shobo, 1982.
Valuable for the drawings of the identifying features of kokeshi dolls.

THURSTON, Clara B. *The Jingle of a Jap.* Boston: H. M. Caldwell, 1908.
A collector's item, bound in pictorial silk-covered boards, a small ichimatsu doll attached to the front cover.

UNO, Chiyo et al. *Ningyo* (Dolls) Nihon no kogei (Japanese Crafts) vol. 5. Kyoto: Tankosha, 1966.

VOS, Ken. *Japanse Poppen.* Leiden: Rijksmuseum voor Volkenkunde, 1989.

WHITE, Gwen. *Antique Toys.* London: Chancellor Press, 1971.

WYLE, Edith. *Traditional Toys of Japan.* Los Angeles: Craft and Folk Art Museum, 1979.
Small catalog with 24 good color plates.

YAMADA, Tokubei. *Nihon ningyo shi.* (History of Japanese dolls). Tokyo: Fuzambo, 1942. Reprint. Tokyo: Kadokawa Shoten, 1961.

YAMADA, Tokubei. *Japanese Dolls.* Tourist Library, 17. Tokyo: Japan Travel Bureau, 1955. Reprint 1959.

YAMADA, Tokubei. *Zusetsu Nihon ningyo shi.* (Illustrated history of Japanese dolls). Tokyo: Tokyo-do, 1991.

YOSHIKAWA, Kampo. *Nihon no ko ningyo.* (Old Japanese dolls). Kyoto, 1975.

YOSHIOKA, Sachio et al. *Dolls of Japan and the World.* 6 vols. Kyoto: Kyoto Shoin, 1986.

Mention must also be made of the following woodblock-printed rarities, toy and book collectors' items in their own right.

Edo nishiki. (Edo brocade, or Two colors of Edo). *Illustrated by Kitao Shigemasa and dated Anei 2 (1773), this small book shows about 80 different toys in color accompanied by topical poems.*

Hina hyakushu (Doll compendium). Kubota et al., eds. Kyoto: Unsodo, Taisho 4 (1915).
Three volumes of color woodblock prints, 116 in all, detailing the immense variety of hina *dolls. One volume of text. This publisher also produced a famous 10 volume series on Japanese toys,* Unai no tomo *(The child's friend).*

Japanese Dolls: Gosho-Ningyo.
A luxury edition of 24 woodblock prints of dolls by the famous landscape artist, Kawase Hasui; published by Meiji-Shobo, Tokyo, not dated. Although most dolls are gosho *dolls, other kinds are also represented.*

Karakuri zue (Illustrated compendium of mechanical designs) by Hosokawa Hanzo Yorinao dated Kansei 8 (1796).
Includes a Japanese clock and nine ingenious mechanical toys with detailed drawings of all the parts and instructions for assembling them.

Kites of Japan: A Vanishing Art. Tokyo: Unida, 1971. A numbered edition of 100 copies.
A portfolio containing a woodcut reprint by Hokusai, a blank kite, and 18 original kite paintings by Master Kato Tatsusaburo of Shizuoka.

Yakusha e-zukushi (Performances at the puppet theater). c. 1685.
Illustrated by Furuyama Moroshige, who worked between 1678-1698. An intriguing black and white illustrated book, a link between the first Edo puppet shows and the adventures of the legendary giant, Kimpira, as told and acted by street narrators using dolls.

Books on Woodblock Prints and Varia

As there are, to date, over 6,000 publications entirely or partly in English concerning specific artists and aspects of the woodblock medium, the following titles are intended as introductory, background, and general reading on the subject only.

ABE, Yuji. *Modern Japanese Prints: A Contemporary Selection.* Rutland, Vermont and Tokyo: Charles E. Tuttle, 1971.

BINYON, Laurence and J. J. O'Brien Sexton. *Japanese Colour Prints.* London: Ernest Benn, 1923. Reprints. Faber and Faber, 1960; Robert G. Sawers, 1978.

BOWIE, Theodore, in collaboration with James T. Kenney and Fumiko Togasaki. *Art of the Surimono.* Indiana University Art Museum, 1970.

BROWN, Yu-Ying. *Japanese Book Illustration.* London: The British Library, 1988.

DE BECKER, J.E. *The Nightless City or the History of the Yoshiwara Yukwaku.* Anonymous edition published in Yokohama: Z. P. Maruya, 1899. Revised edition. Yokohama and Shanghai: Max Nössler, 1905. Reprint. Rutland, Vermont and Tokyo: Charles E. Tuttle, 1971.

EARLE, Joe. *An Introduction to Japanese Prints.* London: Compton Press and Pitman House, 1980. Reprint. Her Majesty's Stationary Office, 1982.

GONSE, Louis. *L'Art Japonais.* Paris: Librairie Gründ, 1926.

GREEN, William, compiler. *Japanese Woodblock Prints.* Leiden: Ukiyo-e Books, 1993. A bibliography of writings from 1822-1993 (all or partly in English) compiled for the Ukiyo-e Society of America.

GUNSAULUS, Helen C. "The Japanese New Year's Festival, Games and Pastimes: As seen in surimono prints." Leaflet No. 11. Chicago: Field Museum of Natural History, 1923.

HILLIER, Jack. *The Japanese Print: A New Approach.* London: G. Bell and Sons, 1960.

HILLIER, Jack. *Source-Books for Japanese Craftsmen.* London: Han-Shan Tang, 1979.

HILLIER, Jack and Lawrence Smith. *Japanese Prints: 300 Years of Albums and Books.* London: British Museum Publications, 1980.

HILLIER, Jack. *Japanese Colour Prints.* Oxford: Phaidon Press, 1981.

HILLIER, Jack. *The Japanese Picture Book.* New York: Harry N. Abrams, 1991.

HUIZINGA, Johan. *Homo Ludens: A Study of the Play-Element in Culture.* Boston: Beacon Press, 1955.

ILLING, Richard. *The Art of Japanese Prints.* U.K. Omega Books, 1984.

KANADA, Margaret, M. *Color Woodblock Printmaking.* Tokyo: Shufunotomo, 1989.

KENNARD JOHNSON, Margaret and Dale Kocen Hilton. *Japanese Prints Today: Tradition with Innovation.* Tokyo: Shufunotomo, 1980.

KEYES, Roger and Keiko Mizushima. *The Theatrical World of Osaka Prints.* Philadelphia: Philadelphia Museum of Art, 1973.

KIKUCHI, Sadao. *A Treasury of Japanese Woodblock Prints.* Trans. Don Kenny. New York: Crown Publishers, 1969.

LANE, Richard. *Masters of the Japanese Print.* London: Thames and Hudson, 1962.

LANE, Richard. *Images from the Floating World.* New Jersey: Chartwell Books, 1978.

MICHENER, James A. *The Hokusai Sketchbooks: Selections from the Manga.* Rutland, Vermont and Tokyo, Charles E. Tuttle, 1958.

MUNSTERBERG, Hugo. *The Japanese Print.* New York and Tokyo: Weatherhill, 1982.

MUSEES ROYAUX D'ART ET D'HISTOIRE. *Sur les traces de l'enfant.* Also in Dutch: *Kinderen in de Kijker.* Brussels, 1979.

NEUER, Roni and Susugu Yoshida. *Ukiyo-e: 250 Years of Japanese Art.* London: Studio Editions, 1990.

NEWLAND, Amy and Chris Uhlenbeck eds. et al. *Ukiyo-e to Shin hanga: The Art of Japanese Woodblock Prints.* Mallard Press, 1990. London: Magna Books, 1990.

POMEROY, Charles A. *Traditional Crafts of Japan.* (Saiga shokunin burui). Illustrated with the 18th-century artisan prints of Tachibana Minko. New York and Tokyo: Walker/Weatherhill, 1967.

SEIDENSTICKER, Edward. *Low City, High City.* New York: Alfred A. Knopf, 1983.

SMITH, Lawrence, ed. *Ukiyo-e: Images of Unknown Japan.* London: British Museum Publications, 1988.

STATLER, Oliver. *Modern Japanese Prints: An Art Reborn.* Rutland, Vermont and Tokyo: Charles E. Tuttle, 1959.

STERN, Harold P. *Master Prints of Japan: Ukiyo-e Hanga.* New York: Harry N. Abrams, 1969.

STEVENS, Amy Reigle et al. *The New Wave.* London: Bamboo Publishing, 1993.

van RAPPARD-BOON, Charlotte. *The Age of Yoshitoshi.* Amsterdam: Rijksmuseum, Rijksprentenkabinet, 1990.

VOS, Ken. *Assignment Japan: von Siebold, Pioneer and Collector.* Leiden: National Museum of Ethnology, 1989.

INDEX OF NAMES
Figures in bold refer to illustrated works

INDEX OF SUBJECTS